SOURCES AND DOCUMENTS I
HISTORY OF ART SERIE

H. W. JANSON, *Editor*

Gustave Courbet, The Apostle, Jean Journet, Parting for the Conquest of Universal Harmony. *Lithograph, 1850. (Photo: Bibliothèque Nationale, Paris.)*

Realism and Tradition in Art

1848–1900

SOURCES and DOCUMENTS

Linda Nochlin

Vassar College

PRENTICE-HALL, INC.

Englewood Cliffs, New Jersey

Library of Congress Catalog Card Number: 66-23609

Printed in the United States of America C-76658

Current Printing (Last Digit):

10 9 8 7 6 5 4

PRENTICE-HALL INTERNATIONAL, INC., *London*
PRENTICE-HALL OF AUSTRALIA, PTY. LTD., *Sydney*
PRENTICE-HALL OF CANADA, LTD., *Toronto*
PRENTICE-HALL OF INDIA (PRIVATE) LTD., *New Delhi*
PRENTICE-HALL OF JAPAN, INC., *Tokyo*

Preface

"The tradition of all the dead generations weighs like a nightmare on the brain of the living." With these words, written in 1852, Karl Marx characterized the problem faced by innovators in all realms of thought and action in the middle of the 19th century.[1] In art, as in politics, pitched battles were waged between the proselytizers for the new and the upholders of established values, between those who sought to create with contemporary sensibility a new imagery appropriate to the modern age and those who clung desperately to the desiccated attitudes and outworn vocabulary of the past.

Yet at the same time, the boundary lines between innovation and tradition were far from being absolutely fixed during this period. If Courbet, the leader of the French realist movement, forcefully rejected the sterile academic formulas of his day, he nevertheless asserted that a thorough knowledge of the art of the past was necessary for creating the art of the present; in the case of the English Pre-Raphaelites, a return to an earlier, "purer" tradition was actually felt to be an essential condition for contemporary artistic renewal. For some artists, like Millet, the search for an appropriately meaningful subject matter did not necessarily involve a consistent renovation of pictorial form, whereas for others, like Manet, whose basic concern with art as an independent entity was itself novel, traditional art could serve as the basis for the most daring pictorial innovations.

In making my selections, I have tried to strike a balance between old, familiar, yet incontrovertibly central documents and less well-known, perhaps more peripheral ones, which nevertheless add to our understanding of the art of the second half of the 19th century. The views of contemporary critics, as well as those of the artists themselves, have been included in order to suggest a true picture of the state of affairs in the art world of the time. The chapter headings, while indicative of basic chronological, national, or ideological divisions, are by no means absolutely strict or mutually exclusive; they are intended as convenient, more or less flexible natural groupings of the material at hand, rather than as absolute or arbitrary categories imposed upon it.

All translations from foreign languages, unless otherwise indicated,

1 Karl Marx, "The Eighteenth Brumaire of Louis Bonaparte," in Emile Burns, ed., *A Handbook of Marxism* (New York: International Publishers, 1935), p. 116.

are by the editor of this volume. In preparing the translations, I received invaluable assistance in the German section, as well as constant aid and advice in the preparation of French texts, from Assistant Professor Olga Bernal, of the French Department of Vassar College. Miss Kim Levin offered excellent suggestions for the compilation of the Italian selections, and Miss Mauree Bernstein, as well as Assistant Professor Eugene Carroll of the Vassar College Art Department, assisted me with the Italian translations.

In addition, I wish to express my gratitude to: Mrs. Katherine Finkelpearl, Art Librarian, and Mrs. Barbara Caswell of the Vassar College Library staff for obtaining books, periodicals, and photostats; Misses Elizabeth Vinton and Sarah Plotz for their aid in typing and research; Miss Mary Delahoyd, my devoted and diligent assistant, for her invaluable help in all phases of the preparation of this volume, from research to punctuation marks; Mrs. Mary Ann Bruno, my typist; and those members of my family and my friends who helped in a variety of ways. I should also like to acknowledge the kindness of those who permitted me to reprint material from other volumes; this debt will, of course, be acknowledged in citations throughout the text.

Linda Nochlin

Contents

I

Traditional Art:
Its Supporters
and Its Critics

ACHILLE FOULD: 1800–1867

Address to the Prize Winners of the 1857 Salon

Achille Fould, a member of a famous family of bankers, was Louis Napoleon's Minister of Finance from 1849 to 1852 and Minister of State from 1852 to 1860. Attracted by Saint-Simon's ideas, Fould was a liberal in the realm of economics if a conservative in that of the Fine Arts. This speech was given upon the occasion of the distribution of awards to the prize winning artists of the Salon of 1857. First class medals were given to such nearly forgotten artists as Baudry, Pils, and Bouguereau; the Medal of Honor was accorded Adolphe Yvon, a popular hack painter of military subjects. The ceremony took place, with all due pomp and circumstance, in one of the halls of the Palais de l'Industrie on August 16, 1857. Present were not only the prize winning artists, but also the Comte de Nieuwerkerke, Director General of the Imperial Museums, the members of the Salon jury, many superior functionaries of the Ministry of State and the Imperial Household, and, as a surprise spectator, the Marshal Duke de Malakoff; many members of the public were admitted as well. "The speech was listened to with the liveliest interest and followed by applause," according to the report in the official organ, the Moniteur universel.

The Exhibition of 1857 was awaited with lively interest by all friends of the arts. The brilliance with which the French school had shone at the Universal Exposition[1] and the time allowed the arts to prepare themselves for a new effort gave rise to the happiest expectations. If these have not been completely fulfilled, one may at least say that they have not been completely disappointed, either. Actually, whether we consider the present Exhibition in its totality, or whether we compare it to preceding Exhibitions, we are forced to recognize that few of them have united so many works of real merit and revealed to France such a large number of new talents.

These new talents are the hope of the future. Faithful to the traditions of their illustrious masters, these talented young people will be able to devote themselves with perseverance to those serious studies without which the happiest genius remains sterile or goes astray; they will be capable of preferring the solid and lasting enjoyment of true glory to the ephemeral satisfactions which too easy successes give; they will know that one must sometimes resist the public taste and that art is close to being lost when, abandoning the high and elevated regions of the beautiful and traditional paths of the great masters to follow the teachings of the new

[1] Fould had been the organizer of the Universal Exposition in Paris in 1855.

school of realism, it no longer seeks for anything but a servile imitation of the least poetic and least elevated aspects of nature; they will know finally how to preserve themselves from the dangers I have already mentioned and those against which I cannot warn you too strongly: the presumption of youth which, in order to enjoy its talent too early, kills it in its bud; and that deplorable tendency to place art in the service of fashion or the whim of the day. Following the example of that young painter who, in order to achieve a work worthy of the high distinction he had just obtained, went to seek inspiration in the very places where our army earned its glory with such brutal labor, our artists will seek success under the only conditions possible: study, inspiration, faith in a great idea, devotion to a noble aim; and thus, there is not the least doubt that the next Exhibition will fulfill all the promises made by this one.

Neither encouragement nor subjects are lacking. What era, what government has ever done so much for the arts? Thanks to the fruitful plan of the Emperor, architecture transforms our cities and ceaselessly provides new tasks for painting. The fame of our schools has trained the eyes of all nations upon our artists, and their works are disseminated throughout the entire world. Thus, everything contributes, in this era of grandeur and prosperity, to the extension of their domain, and we may say that artists have never had such a bright future before their eyes.

In response to this encouraging situation, subjects will be no more lacking than rewards. Poetry, morality, religion, history—those divine wellsprings where the masters found inspiration—have in no way run dry for their successors, and at no other time has France provided more ample material for the chisel and brush of the artist. What great events, merely since the beginning of the reign [of Napoleon III]! What sublime and moving scenes! What acts of abnegation and heroism in all classes of society of the nation, from the most modest to that superior realm in which the Sovereign sets an example of complete devotion!

Our artists will be able to rise to the height of their task; the greater and more beautiful it is, the more effort it demands. They will not be alone in the arena; it is open to all talents. There they will recognize . . . worthy rivals in those foreign artists whose works we are happy to welcome and reward. Thus, gentlemen, you have a new reason to redouble your zeal in order to assure France supremacy in the arts.[2]

THOMAS COUTURE: 1815–1879

Conversations on Art Methods

First printed privately in France in the sixties, Couture's Méthode et entretiens d'atelier *gives a good idea of the viewpoint, technique, and doc-*

[2] Achille Fould, *Le Moniteur universel,* Sunday, August 16 and Monday, August 17, 1857, p. 898.

trines of the 19th-century academic artist: careful preparation of the pre-liminary drawing; use of dark underpainting; orchestration of color harmonies; establishment of a scheme of dominant lights and shadows; admiration for Raphael; the ultimate superiority of the idealized art of the past over nature (although he displays a certain winning uncertainty about the latter question). More interesting, coming from the painter best known for the gigantic "Salon machine," The Romans of the Deca-dence *(1847), is Couture's rather lengthy disquisition on workmen as sub-jects for art. Yet this need not be surprising if we remember that upon its first appearance, on the eve of the 1848 Revolution, the* Romans *had been thought by such left-wing critics as Théophile Thoré to contain overt references to the corruption of contemporary France, and accordingly was praised as social criticism both by Thoré and by the anarchist philoso-pher, P.-J. Proudhon.*[3] *Several of Couture's smaller, less pretentious can-vases, with their broad brushwork and rich, creamy texture, reveal his talent as a pure painter. These paintings remind us that the young Manet studied with Couture in the early fifties and that a perceptible influence is undeniable, no matter how much the student rejected his teacher's pre-tentiousness and conventionality.*

The First Principles of Painting

You ought not to commence painting until you are certain of your drawing; a sure hand is necessary to obtain good results.

I will not yet speak to you of the great resources of execution, which you will only be able to employ after much exercise; precision and dexterity of hand are the qualities which result from hard work and from time.

Simplify your means of action, work with system, and with your mind free from all irrelevant thoughts, for you need the use of all your faculties.

Do not chase, as they say vulgarly, two hares at a time; divide the force of an art which you are not able to understand entirely, and which, besides, would crush you if taken all at once. Study each of the parts sepa-rately. You will soon be able to unite them, and to master that which if attempted would have overwhelmed you at starting. This is nothing more [important] than Method.

LET US COMMENCE

Trace your drawing on the canvas with charcoal, which is preferable to chalk; your points well determined, you mix strong boiled oil and spirits of turpentine, half and half, making what is called "sauce"; but upon your palette the necessary color for the first preparation, such as ivory black, bitumen, brown-red, and cobalt.

With a tint composed of black and brown-red, you will obtain

3 See below, pp. 11–14, 54–56, 60–62 and 49–53, for the views of Thoré and Proudhon.

bister; bitumen, cobalt, and brown-red will give you nearly the same result.

Return now to your drawing.

Brushes of sable, a little long, are necessary to trace the design; your charcoal dust would spoil the effect of the color; therefore, with a maul stick strike the canvas as upon a drum; the charcoal falls, the drawings become lighter, but sufficient remains to guide you. Then you take the sable brush, dip it into your "sauce," then into the bister tint, and trace all your outline. These outlines being made, mass your shadows and you obtain a kind of sepia drawing in oil.

This first preparation must be allowed to dry; the execution will require a day's work. It will dry in the night, and the next day you work with the same preparation; wet your shadows and arrange your lights.

Clean your palette, and set it in the following manner:

Lead white, or silver white.

Naples yellow.

Yellow ocher.

Cobalt.

Vermilion.

Brown-red.

Lake (the madders are the best).

Burnt sienna.

Cobalt.

Bitumen.

Ivory black.

I leave you to your own inspiration in mixing your colors; experiment and make mistakes, but above all, acquire habits of accuracy. I cannot say any more to you. . . .

On Veronese

. . . This colorist has none of the tricks of the "luminarist." His pictures are full of light, which spreads itself everywhere. By establishing a highlight, he creates within the scale of values a dominant note to which all other elements [of the painting] must be related.

His painting is a great orchestra, and is remarkable for its harmony; he plays upon all the qualities of color with a master hand; in his immense pictures, the multiplicity might have the disagreeable effect of samples. What does he do? Like all strong workers he carefully simplifies; he arranges his flowers in groups. I say flowers because I love them, and with them it is easier to make you understand what I mean; he reunites and forms into bouquets the different reds, greens, yellows, etc. . . .

Light and Values

. . . Already, in speaking of the copy of a simple piece of nature, I have said to you that you must establish your "dominants" of light and

shadow. I now say you must do it in all pictures. There must be a principal light; all the others should be subordinate to it, and should become fainter toward the extremities of the canvas; the same principle holds good in shadows, but in an inverse way, that is to say, that the strong values ought to lessen in approaching the center. . . .

Of Workmen as Subjects for Art

Have you taken notice of the scaffoldings which are raised for the construction of monuments, and the immense derricks by which heavy stones are raised in the air? Have you remarked the faces of the workmen, who are no longer beasts of burden, but directors of the forces which mechanical genius has put at their disposal? Their bearing is more dignified, their clothes better fitting, having even a sort of elegance. Look at these young fellows, so well built, with their ornamental red belts, their heads generally fine, burned by the sun; see the rich amber color which sets off their silver earrings, their arms young and hairy, tattooed with symbols of their work, and above all see their hopefulness for the morrow, for all know that with work and economy at first, followed by intelligence and activity, they have the chance of rising in the social scale. These workmen are not like those of the Middle Ages, and of the Renaissance. They are more intelligent, more proud, and I see in them a patrician distinction.

Who are these men who walk two and two, three and three? They have a serious, reflective air, their bearing is simple, they appear very intelligent. They are the mechanics who are on a strike and are going to ask an increase of pay. Follow them: masters and workmen salute each other. The workman states his case, pleading for the daily bread of his family; the manufacturer, the impossibility of yielding to his demands. Look well at these uncovered heads, these veteran workmen, these men chosen from among their own class to defend their interests. How well they speak! I have heard many lawyers speak more correctly, but as they did not know so well what they wished to say, they were certainly less interesting.

These are new subjects. Our workmen have not been represented; they remain yet to be put upon canvas. . . .

Originality

Do not listen to those who say to you, these rules are useless, and even hurtful to those who have originality.

There are not two ways of painting; there is but one, which has always been employed by those who understand the art.

Knowing how to paint and to use one's colors rightly has not any connection with originality.

This originality consists in properly expressing your own impressions. Take for example the most personal and original: Raphael, Rubens,

Rembrandt, Watteau; these four great names are sufficient to make you understand.

RAPHAEL

Raphael expresses beauty in its sweetest form; he embellishes youth in such a way that it captivates us. Everything in his pictures is represented in the springtime of life; men, women, flowers; all are young; elegance, gracefulness, purity, simplicity of lines. This beautiful flesh, firm and round on the slender forms, the reserved bearing, this reminder of the flower which is opening, but not yet fully blown; the green turf enamelled with marguerites, the shrubs ornamented with small leaves, showing themselves against the pure morning sky; all is born, all breathes, but has not yet lived. All is perfect with this truly divine painter; here is life without its wear; this is what I wish you to feel, and what gives to the works of Raphael an angelic aspect.

You see he does more than copy: he chooses first, he develops afterward, then he throws aside all that is not in the domain of youthful beauty; this is what makes his style and originality. . . .

Is Art Superior to Nature?

A great question, often asked and never answered.

We can reply yes and no. The reason is:

If we pronounce the word art in this connection, we take in all its perfection. We know already by our conversations that the most gifted are the most impassioned; that they abandon themselves to that which captivates them, developing that which they love with so much force that they end by making us share their enthusiasm.

The word development is not very exact, it is enough for them to banish from their pictures everything that is not their idol.

Man has too feeble intelligence to admire at once all the splendors of nature; he is only able to understand it in detail; this detail, while it is deep, is indeed so immense that it requires a peculiar organization to fathom it, and to make others share the admiration.

The whole magnificence of God dazzles us. The feebleness of our minds can no more bear it than our eyes can bear the light of the sun; for this reason we should be as modest in our choice of subject as we are in our means of execution.

This simplicity of working cannot excel the object selected; a beautiful head of a young girl, chosen by Raphael as a model, will be superior to what he will paint; the splendid color of Titian loses very much when compared with the original.

So you see we can say: nature is superior to art.

Yes, that is true; but if we look at this question from a human point of view, we see that these simple effects, given by genius, surround us,

quiet us, and satisfy our intellectual desires; since we are satisfied, even overwhelmed, we can truly say: art is superior to nature, because art combines beauties which we can see in a way that nature never does.

It is what they call in literature unity of time [and] unity of place; it is a simple frame given to a sentiment or a passion. Everything must be subordinate to this thought. I have said yes and no. This is the doubt; I have developed as well as I could what I wished to make you understand and, like every writer, I believed it was conclusive. I find everywhere this wish to convince, and this affirmative tone toward those who taught; why not rest satisfied? It is better to leave your reader in a poetical uncertainty, rather than impose upon him a bad conclusion.

What I have just explained is far from satisfying me; there is in me a violent reaction, and freed from the uncertainty which I have expressed, I am sensible that certain chosen spirits of the Eternal seem to continue His work; these children of God recall us to the divine truth; they are more true than our terrestrial truths, which are always more or less injured by corruption; they reclothe creation in its original dress. This divine mission is manifested in Phidias and Raphael.

We can then say their works are superior to the nature that we see, since it is this same nature reclothed.[4]

WILLIAM-ADOLPHE BOUGUEREAU: 1825–1905

Address to the Institut de France

In this speech, delivered before the annual meeting of the five Academies of the French Institute on October 24, 1885, Bouguereau staunchly upholds the conservative position on the teaching of art. William Bouguereau and his colleague, Alexandre Cabanel (1823–1889), are often considered the very symbols of French official painting during the latter quarter of the 19th century. Bouguereau's career progressed with perfect regularity to the ultimate rewards of the academic artist: four years at the Ecole des Beaux-Arts, the highest Prix de Rome in 1850, a Medal Second Class at the Universal Exposition in 1855, Medal First Class in 1857, Chevalier of the Legion of Honor in 1859, member of the Institute in 1876, and Grand Medal of Honor in 1878. A teacher at the Beaux-Arts for over twenty-five years, he exhibited at the official Salons for over fifty. In an endless series of works notable for their meretricious conception and technical slickness—titillating nudes with classical titles and saccharine religious tableaux-vivants—Bouguereau managed to capture the favor of a relatively new and extremely important segment of the

4 Thomas Couture, *Conversations on Art Methods*, trans. S. E. Stewart (New York: G. P. Putnam's Sons, 1879), pp. 6–8, 152, 158, 177–79, 209–10, 235–37.

art public: the bourgeoisie, whose secret dreams and more overt demands for moral probity and a recognizable "story" he could amply satisfy at the same time.

The first organization of the Institute was distinguished by a prudent separation of its instruction into different academies, and by subdivisions within each academy—a method wise in its conception and happy in its results, and one which tends to become more and more accentuated. It was, therefore, not without regret that I saw the Ecole des Beaux-Arts react against this necessity of our era; it wants to emancipate itself from what some consider the narrow prejudices of our forerunners, and, believing that the initial difficulties in the study of painting, sculpture, or architecture are not enough when taken singly, it requires of its candidates examinations in all three arts at once, complicating the competition still further with examinations in history. I dread the mental exhaustion resulting from this innovation, and I seize this undoubtedly unique occasion to speak my mind before such an enlightened audience.

I believe that theory should not intervene in such a tyrannical manner in the elementary education of artists. It is the eye and the hand that must be exercised during the impressionable years of youth. As soon as our pupils know how to draw and to make use of the concrete procedures of their art, as soon as they have chosen the type of art toward which their tastes and aptitudes incline them, they will feel the need to undertake the special studies their work demands, and they will pursue them with far greater profit.

One can always acquire the accessory knowledge that goes along with the production of a work of art, but never—and I insist upon this point— can will, perseverance, or obstinacy in one's mature years make up for lack of practice. And can greater misery be conceived than that experienced by the artist who feels the fulfillment of his dream compromised by the impotence of his execution?

Whoever wants to learn everything from the beginning will remain a pupil all his life; he will undoubtedly become very learned, but he will never attain the goal of his art, which is to produce; he will stifle his originality and will not give his imagination time to develop. We must not be led astray by the will-o'-the-wisp of producing great men like those of the Renaissance. Leonardo da Vinci, Raphael, and Michelangelo, those robust caryatids who bore on their giant shoulders the weight of every branch of knowledge of their times, were the extraordinary products of unusual circumstances, the results of a mysterious force. But modern art, too, will leave behind names worthy of adding to the number of those preserved by posterity; for if the science of our artists is not universal, at least they search for the Beautiful, the Expressive, and the True in nature. . . .

There is no such thing as symbolic art, social art, religious art, monumental art; the only art that exists is the representation of nature by an artist whose sole ideal is to express its truth. Look at the *Venus* of Vienna. Who could doubt that it was the work of a great artist? One only needs to see the extraordinary love with which he carved the flesh, the extreme care with which he indicated the pressure of the heel upon the right thigh, hollowing an adorable dimple in the flesh!

Antiquity reveals what an inexhaustible source of variegated inspiration nature is. With a relatively restricted number of elements—a head, a bust, arms, a torso, legs, a stomach—how many masterpieces she has made! Then why seek out other things to paint or sculpture? . . .

I am very eclectic, as you see. I accept and respect all schools of painting which have as the basis of their doctrine the sincere study of nature and the search for the true and the beautiful. As for the impressionists, the pointillists, etc., I cannot discuss them, I don't understand them. I do not see the way they see, or claim to see. That is the only reason for my negative opinion about them.[5]

THÉOPHILE THORÉ [W. Bürger, pseudonym]: 1807–1869

The Decadence of Classical Painting

French academic art of the 1860s is now viewed through the eyes of one of its strongest opponents, the critic and art historian, Théophile Thoré (also known as William Bürger or Thoré-Bürger), the friend and champion of Millet and Courbet (see below pp. 54 to 56). Despite this commitment to contemporary values, Thoré, at the same time, was one of the first to study seriously the Dutch art of the 17th century, producing a two-volume survey of the museums of Holland. He is perhaps best known for his single-handed resuscitation of Vermeer in a series of three articles which appeared in the Gazette des Beaux-Arts *in 1866. Exiled after the fall of the 1848 Revolutionary Government, he fled to London, then to Switzerland and to Brussels, continuing his work in the museums of northern Europe and adopting the name of William Bürger. His* Salons, *written from the 1840s through the 1860s, reveal his ceaseless demands for an art dealing with contemporary subjects in a contemporary manner, his concern that artists reject the outworn formulae of the past—religious and mythological—as well as the impotent frivolity of art for art's sake, in favor of an art both modern and socially conscious: art for man's sake. Lively, intensely involved in the stirring political events of his time—he was offered the post of director of the Ecole des Beaux-Arts by Lamartine*

5 Marius Vachon, *W. Bouguereau* (Paris: A. Lahure, 1900), pp. 109–10, 132–33, 140–41.

*under the short-lived Provisional Government of 1848—the critic spent a
term in prison and wrote a political column for the left-wing* Revue
indépendante *of Leroux and George Sand. Théophile Thoré, in his later
apotheosis as William Bürger, became a connoisseur in the best sense of
the term. He was perhaps the first to realize that the time of the amateur
with his private collection and unsystematic personal delectation had
passed, and that the era of the scholar who, with the public museums as
his domain, attempts to reconstruct the entire* oeuvre *of a master by
means of historical methodology—the era of modern art history, in short
—had arrived.*

There is, in the Salon, a rather sought-after type of painter, peri-
odically sent to us in groups by the Midi. They come from the lower
depths of Italy or Greece. They were called *classics* at the beginning of
this century and at that time they still had a certain masculine strength.
Today this race has degenerated and no longer produces anything but
grotesqueries.

What a fall, from the Greeks of David to the Greeks of M. Gérôme!
Give us back David, Hennequin, and Lethière! [6] David represented
Léonidas at Thermopylae with an austere conviction; M. Gérôme offers
to the young ladies of Paris a doll undressed before disorderly, licentious
old satyrs, who smirk as though they had a real naked woman before their
eyes for the first time.

We are no more prudish than Diderot, who, in the end, became im-
patient with the indecencies of the Pompadour school and who wrote this
sentence which is as apt as it is original: "A naked woman is not indecent;
it is an undressed one who is." The lawyer who completely undresses his
courtesan-client, this shower of marionettes, is too risqué in taste. M.
Gérôme is praised as a learned archeologist of antiquity; there is nothing
antique, nor above all, Attic, in this wretched composition of *Phryne*. If
the scene, such as the painter has translated it, had taken place during
the period of the Roman decadence, which has certain analogies with
our own, it would perhaps be acceptable. But, in Greece, in the 4th cen-
tury before our era, it is a false interpretation.

The Greeks were avid for plastic beauty and they were accustomed
to seeing, in public games and everywhere, the models for Venuses, god-
desses, and nymphs, which their sculptors and their painters immortalized
in marble or on the dadoes of monuments and private houses. Thus,
everything is false in the painting of M. Gérôme: the melodramatic move-
ment of the lawyer, the bashful pose of Phryne, the intemperate and

[6] Jean-Léon Gérôme (1824–1904) was an academic artist who achieved great re-
nown for meticulously painted, provocative nudes "ennobled" by classical titles. Philippe
Auguste Hennequin (1762–1833) and Guillaume Lethière (1760–1832) were more sober
neo-classical painters of an older generation, the former a pupil of David himself.

ridiculous physiognomies of the members of the areopagus. It is true that the courtesan has nothing to be proud of when she exhibits her paltry torso and swollen legs. As for the areopagists, one would take them for a gathering of alumni of that brotherhood today occupying the criminal courts. As for execution: thin drawing, crude color, no chiaroscuro at all.

Criticism has . . . a word with which it lights up at the slightest pretext, but which goes out as soon as it is turned back to the works of art it is supposed to illuminate: the Ideal.

What is the ideal? Is it in the subject or in the manner of interpreting it? If there is something of the ideal in Raphael's *School of Athens,* is there any in Rembrandt's *Anatomy Lesson?* Why is a landscape by Poussin more ideal than a landscape by Ruysdael? [7] We will not burden ourselves with being the sphinx of these aesthetic mysteries.

If a symbolic intention constitutes the ideal, it would be enough for the simplest naturalist to entitle the figure of a sleeping woman: *Sleep.* Then the critics would be able to indulge in the most ingenious speculations about this: "Death is sleep . . . yet, on the other hand, it is perhaps an awakening!" etc., just as the beautiful group of shepherds near an antique tomb, in the *Arcadia* of Poussin, provokes serious thoughts about "the instability of happiness and the brevity of life."

Everyone can practice these philosophic amusements before a *Smoker* by Brouwer, as well as by contemplating a Muse by Carracci.[8] A smoker—what a profound allegory! Alas, everything evaporates like smoke! Life is short, happiness is fleeting, only virtue is enviable. Here we are brought back to the *Arcadia* of Poussin—with a figure from a cabaret!

But to be honest, art is not as clever as criticism. The true artist is more candid. He is content merely to represent what he sees and to express what he feels—two inseparable terms of all truly artistic creation. It is the ego and the non-ego of philosophy, practiced naïvely and irresistibly: a real form, borrowed from the external world and animated by the feeling it inspires in the internal man. Nature and humanity are at once and indissolubly the object and the subject of all the arts, as well as of science and industry. Art shows the phenomena of universal life, science explains them, industry adapts them to the needs of man. Art proposes, science exposes, industry disposes.

But aside from the ideal, one cannot guess why artists like M. Cabanel[9] paint hybrids with cloven hooves instead of painting men. I know that Correggio painted his *Antiope* with a satyr contemplating her, and

7 Jacob van Ruysdael (1628/29–1682), a Dutch landscape painter famous for his bold naturalism.

8 Thoré is here drawing a contrast between the lusty naturalism of the Dutch genre painter, Adriaen Brouwer (c. 1606–1638), and the eclectic classicism of one of his near-contemporaries, the Bolognese Carracci brothers, probably Annibale (1560–1609).

9 Alexandre Cabanel (1823–1899), highly successful academic painter of the same type as Gérôme and Bouguereau.

that it is a masterpiece. But we are no longer in the 16th century, which sought to get rid of its Catholic devils by evoking the monsters of another mythology. Let us return to nature: it is less deceiving than any mythologies, religions, or systems whatever.

M. Baudry [10] was trained in Rome, like most of the artists in favor with the critics and with people of good breeding. He also has painted Venuses, Cupids, Fortunes, and Vestals. This time he has dared a historical painting: the *Murder of Marat by Charlotte Corday*. Let us hurry back to the *Marat* of David!

In order to show Charlotte Corday at the moment when she had just killed Marat, it would have been necessary to represent her from her own viewpoint of fanatical heroism, or from the more general viewpoint of universal morality. There is none of this at all in M. Baudry's composition: a little woman stuck against a cardboard wall; neither perspective nor space. The figures could not possibly fit into this room, which is not even a yard deep. Absence of chiaroscuro, of color, of drawing, no less than of character and of effect.[11]

[JULES ANTOINE] CASTAGNARY: 1830–1888

A Critique of Three Venuses

In this excerpt from his Salon *of 1863, the progressive critic Castagnary heaps scorn on the works of three popular academic painters of his day, two of whom had already been taken to task by Thoré in 1861: Paul Baudry, Alexandre Cabanel, and Eugène Amaury-Duval (1808–1885).*

Castagnary was as active in his support of the realist Courbet as he was staunch in his opposition to the official art of the fifties. (See pp. 47 to 49.)

Three *Venuses Coming forth from the Wave* contend for the apple and seem to call for a Paris. At first sight, I feel little inclination for this role. Nevertheless, the public flocks toward these canvases, which are one of the successes of the Salon; we must mingle with the public and form our own opinion of what interests it.

In M. Paul Baudry's painting, which he entitles, I don't know why, *The Pearl and the Wave: a Persian Fable,* Venus has just been deposited on the beach by the blue wave that already mounts and opens up as if to take her back. For my part, I should see no harm in her being carried back into the open sea. The young person is vigorous and fleshy: she

[10] Paul Baudry (1828–1886), another academic painter particularly adept at nudes and sentimentalized historical scenes.

[11] Théophile Thoré (W. Bürger, pseudonym), "Salon de 1861," originally published in *Le Temps* and reprinted in *Salons de W. Bürger, 1861 à 1868*, pref. by T. Thoré (Paris: Librairie de Vᵉ Jules Renouard, 1870), I, 124–125, 127–129.

must know how to swim. Presented as she is, from the back, lying on her left side, her arms wrapped around her wanton face, she has the effect of a bedroom Venus.

What I like is the wet appearance of the canvas, the grass, the shells, the dripping sinuosities of the strand; also, perhaps, that line of the body going from the shoulder to the knee, appearing in profile against the wave, which is not lacking in amplitude. But how much more at ease that pretty woman, with her air of a Parisian milliner, would be on a sofa! She, who lived so comfortably in her rich apartment of the Chaussée-d'Antin, must feel rather ill-at-ease on that hard rock next to those scratchy pebbles and prickly shells.

Another consideration: what is she doing here alone at this hour, rolling her enamel eyes and wringing her pretty hands? Is she looking out for a millionaire led astray in this wild spot? Would she no longer be the Venus of bedrooms but rather the Venus of ocean-bathing? Venus of ocean-bathing or Venus of the bedroom, her torso is badly modeled, her tibia short, her hair scanty. But she is pretty in tone, fresh, and damp; it is the best painted of the three *Venuses.*

Carried on the heedless breast of the sea, lying in a harmonious pose, one leg floating, the other folded back, one arm on her forehead, half veiling her face, accompanied by a group of cupids who fly above her blowing conch shells: thus appears M. Alexandre Cabanel's *Venus,* coming slowly forward to the crest of the tossing wave. Her long blond hair unrolls into the stream of water. All about her body foams the wave. From the depths of the canvas the procession comes toward us. One feels that the young goddess aspires to the moment when, landing on the shore, she will stand erect and reveal herself to men in her dazzling, immaculate, and naked beauty.

M. Alexandre Cabanel is not a painter at all; he knows nothing of color and its profound charm, its strength and its triumphs, but he is a skillful draughtsman. He has spread forth all the means at his disposal in profusion; every effect that is possible to obtain from pure and well arranged contours, from knowledgeably balanced lines, from happily contrasted movements, he has put into his work. His *Venus* is the best drawn of the three; and if drawing is worth something without color, he should triumph over his rivals.

The *Venus* of M. Amaury-Duval is represented standing in the attitude in which Alfred de Musset described her at the beginning of *Rolla:*

> Virgin, still shaking off her mother's tears,
> And fructifying the world by wringing out her hair.

Both the pose and the execution are traditional. Despite some lovely bits of drawing, the goddess's body seems long, squeezed in at top and

bottom, too violently arched in the middle. For the rest—no new accent, no new feeling.

In the classical school, where nature is ill famed, where truth is dismissed, where reality never sustains the painter's interpretation, when drawing and color are missing at the same time, then nothing is left. This is the case with M. Amaury-Duval's *Venus*.[12]

EDMOND AND JULES DE GONCOURT: 1822–1896; 1830–1870

The Death of Art in the 19th Century

While the Goncourt brothers, Edmond and Jules, are perhaps best known in the field of art for their researches in the art of the 18th century, which culminated in the series of monographs composing L'Art au dix-huitième siècle *(1859–1875), and, in the case of the surviving brother, Edmond, for his studies on Japanese art, they by no means neglected the art of their own time. Aside from their numerous remarks and discussions of contemporary art in the nine volumes of their* Journal, *they published a monograph on the artist Gavarni, whom they much admired; the hero of one of their early realist novels,* Manette Salomon *(1867), is the weak willed painter Coriolis, and the work itself presents a detailed and convincing picture of the art world of the time. The following excerpt, from a little known brochure entitled* The Revolution in Customs, *published in 1854, reveals their ultimate pessimism about the possibility of accommodating art to the dubious virtues of industrial democracy. It is perhaps difficult to reconcile the violent antipathy toward the popular and the contemporary expressed here with the Goncourts' own innovations as novelists and literary theoreticians. It is difficult to see the connection between the rather aesthetic thesis about art which follows and their more naturalistic views, such as those expressed in their famous preface to* Germinie Lacerteux *(1864), where they ask "whether there should still exist . . . in these times of equality, classes too unworthy, sufferings too low, tragedies too foul-mouthed . . ." to be depicted by the novelist, and where they assert that the novel had taken up "the studies and the duties of science."* [13] *On the other hand, it is possible to imagine that both their limitless perceptual curiosity about the suffering of the poor and their voluptuous acquisitiveness that led to the formation of their remarkable*

[12] [Jules Antoine] Castagnary, "Salon of 1863," originally published in *Le Nord* of Brussels, 1863, and reprinted in *Salons (1857–1870)* (Paris: Bibliothèque-Charpentier, 1892), I, 113–115.

[13] Preface to *Germinie Lacerteux*, trans. Eugen Weber in his *Paths to the Present: Aspects of European Thought from Romanticism to Existentialism* (New York, Toronto: Dodd, Mead and Company, Inc., 1960), p. 144.

collection of 18th-century art are products of the same chilly yet avid sensibility.

Industry will kill art. Industry and art are two enemies which nothing will reconcile, no matter what one does or says. Industry and art set out from different points and end up at different goals.

Industry starts out from the useful; it aims toward that which is profitable for the greatest number; it is the bread of the people.

Art starts out from the useless; it aims toward that which is agreeable for the few. It is the egotistic adornment of aristocracies.

When the subsidation of art passes from private to public hands, art is almost moribund. The democracies are too busy with good works to pay art what it wants to be paid, and it is necessary for prodigal millionaires to nourish this starving creature who nevertheless gives pleasure.

Since modern societies march with a steady step toward the satisfaction of the needs and appetites of the majority, the proponents of art in a short time will only be a subversive minority and art itself will become a parasitic and suspicious activity among the social activities.

"You slander the people!" someone cries. "The accession of the people will be the triumph of art! The People! Only see them at the theater! See them at the museum! They grasp everything! They understand the subtleties! They acclaim the sublime! They are the great public! the true public! the public from which authors, actors, painters, sculptors should take advice, orders, lessons!"

What! we poor studious folk who spend our lives reading, looking, scrutinizing, comparing, analyzing, who put all our time, all our thought, into appreciating and feeling, who consume our days and nights in tracking down the beautiful—the first man who comes along, a man completely formed by labor and the material—will he immediately overtake us in these realms? He catches on quickly, lucky man, to those beauties which have taken us so long to understand. He reads at sight what we have had to spell out! He has inborn taste! He has an innate critical sense! Let us imagine, dear sir, some good folk who were born and live in a dark room; all of a sudden, a trap door opens and reveals the daylight which they have never seen—and all at once they are ready to explain the nature of the sky!

I will not insist on this.

Art has nothing to do with the people. Hand over the beautiful to universal suffrage and what becomes of the beautiful? The people rise to art only when art descends to the people. Don't you see where certain people want to lead art, and to what point they debase it to make it popular? And this realism, which does not limit itself to being a portion of the work or an aspect of the talent, like the *Flea Searchers* in Murillo, like Falstaff in Shakespeare—harsh, raw, brutal realism—isn't this really

the art which abdicates out of deference to the gross instinct of the people?

I am quite aware that others still dream of the alliance of industry and art; it is one of the loveliest utopias that I know of, and that is all that I think of it, since I am not in the habit of taking windmills for anything else but windmills.[14]

Gavarni Expresses His Opinion on Art and Life

Further insight into the Goncourts' darkly cynical attitude toward the art and manners of their own era is revealed by their choice of statements by the artist and caricaturist Gavarni (1804–1866), in the monograph devoted to their idol. Although Gavarni, who became more and more misanthropic as the years went by, exerted a strong influence on the Goncourts and reinforced in them their disdain for the current democratic and humanitarian mystique, he, like them, insisted upon an unvarnished realism in his artistic productions.

It was the evening of a day when he [Gavarni] had been to the great Exposition of 1855 and, giving himself up to indicating his contempt for the moderns, at the same time as his admiration for the ancients, he said:

"It's scribbling on a paper screen. It looks like toilet-tissue and wallpaper. . . . Then, to top it off, the people who come to talk to the bourgeois of the *supernaturalism* of all that. . . . We are really in the decadent age of the word, in the splashing-time of speech."

He said, apropos of the progress brought about by the discoveries of modern science:

"Of what use is steam, the railroad train, to man if you have increased his need for speed tenfold?"

He said of philanthropy:

"What is philanthropy? You love a man, you love some men; can you love man? What is man, considered as the subject of affection?"

He said of women:

"See how they are made. No thoughts, a narrow skull; but a breast over the heart and all that flesh over the senses—it is obvious that this being is made to be taken with the hands. She does not think, she dreams; she does not talk, she sings."

From Gavarni's Journal

In every period, the great and beautiful ideas are the fruit of the minority. Prejudices are everybody's ideas; all truths are born in isolation and are always paradoxes.

[14] Edmond and Jules de Goncourt, *La Révolution dans les moeurs* (Paris: Dentu, 1854), n.p.

He who is called a learned man is the one who knows better than others how much we do not know, and who, raising himself with effort from the lower depths of our ignorance, has been able to perceive, beyond the simplest questions, that which limits the things around us: *the vast and discouraging horizons of the unknown.*

Humanity: a heap of dirty, slimy things, of stinking liquids, suspended on a vine-prop inside a bag of skin with holes in it; from the analytic point of view, a complication of mechanical arrangements that takes place between solid machines and imperfect fluids, in which the hydrostatic, mixed with the dynamic, are in a state of confusion.[15]

EUGÈNE FROMENTIN: 1820–1876

A Critic's Program

Renowned in his own time both as a painter (chiefly of North African scenes) and as a writer (the novel Dominique *and the travel book* A Summer in the Sahara), *Eugène Fromentin is today best known—to art historians, at any rate—as the author of the remarkable and ever valid* Old Masters of Belgium and Holland *(1875). Yet while this dazzling and intensely personal confrontation of the Dutch and Flemish painters of the 17th century may be Fromentin's masterpiece, he certainly gave considerable attention to the problems confronting the artists of his own time. Accomplished rather than distinguished as a painter, an admirer of the romantics, an adorer of Delacroix, whose style, in fact, determined his reactions to Rubens and Rembrandt to no small degree, Fromentin was unable to respond fully to the revolutionary art movements of his own day. Although he was contemptuous of official taste, Realism and nascent Impressionism—formless, sketchy, lacking in elevation or poetry—signified for him the ultimate decline of art. The following passage, giving voice to his views about the situation in the art of his own day, is taken from an unfinished and fragmentary manuscript,* Un Programme de critique, *probably intended to be used as notes for a public lecture in March, 1864.*

Appearances are seductive. France possesses a large number of artists —a very great number. I will not try to estimate this number for fear of terrifying you by the enormous amount of a production of which the regular, almost continual flow constitutes in itself an extremely curious problem in political economy. Viewed as a whole, with the relative homogeneousness which comes from its French spirit, this mass of talent gives

[15] Gavarni in Edmond and Jules de Goncourt, *Gavarni: L'homme et l'oeuvre* (Paris: Ernest Flammarion [1925]), pp. 267–268.

us on the surface a very real ascendancy. From its numerical importance, as well as by its originality and true merits, our school holds today the first rank in the world. Who then would dare to deny it, since facts prove it? At a recent gathering—why may I not say, at the last London exhibition —France must have voluntarily depreciated herself or have been very modest, to allow ideas so contrary to the truth to have been conceived concerning her uncontestable artistic worth. This mistake, moreover— which only proves once more that modesty often risks being taken at its word—this brief misconception is not of the least importance. Our French school is what it is—numerous, active, relatively brilliant, sending its rays afar; since all over the globe it is imitated, studied, anxiously considered, and adhered to, while everybody seeks to be incorporated with it; I will add that it is envied, which is one of the sure signs of strength.

At home the situation is no less good. The public and the artists seem in harmony on many points. If the latter, as I repeat, produce enormously, the public has insatiable needs; and the mechanism of this industrial fact is such that nowhere, except with short and temporary exceptions, is a surfeit perceived. Thanks to the liberal tax levied every year upon the budget of your fancies, everyone lives, or *almost* lives; and if this "almost," gentlemen, conceals here, as elsewhere, much suffering and deplorable misery, ought we to accuse ourselves of a misfortune, which may be one of the very laws of emulation, one of the necessities of life? The greater part prosper; some attain riches; a certain number will finish their career in opulence. Means of exhibiting abound: they are diverse, of every kind, and so regular that there is no longer, it may be said, any interruption in this continual current of business, or sympathy, which puts minds or interests into communication. Wherever there is any gap, it is filled. What the government's influence is not sufficient to accomplish, others finish. And as in this division, however equal, of favors, of publicity, or of honors, there are always found imperfections or forgetfulness or clashing interests or impatient ambitions, nothing being perfect in this world, you see there are also found ingenious speculators, or rather, sufficiently enterprising philanthropists, to dream of and to attempt the perfecting of a system of exhibitions already very complex. We may call these places of publicity markets, if we are talking business; if we change our point of view, we may name them centers of influence or instruction. Let us state, in any case, that very little is wanting to the methods of publicity of which artists can make use; and that in this relation their situation may well excite the envy of men of letters and musicians. . . .

People complain and utter recriminations and regrets. They want something better; they ask for something more. It is said that good works are rare; that great ones exist no longer; that talent diminishes in proportion as it multiplies; that the blood of strong schools becomes impoverished in proportion to the increase of their progeny; that characters weaken, consciences become austere, originality disappears beneath con-

ventionalities; that people are weary of mediocrity, and desire excellence. Then this growing wave of production fills them with uneasiness and terrifies them. They say that curiosity has its bounds; that the sincerest passion for works of the mind needs a time to rest, periods of repose; and that this periodical tide of six or seven thousand pictures, flowing every ten months into the same place, spreading over the same public, will end by submerging the taste for the beautiful, and drowning it in inevitable weariness.

On the other side, they [the artists] reason thus: We are not free; it is not we who rule taste; we direct nothing; we are governed. The favors of the public are despotic: we must pay dearly to get them, and more dearly to keep them. No man belongs to himself except while he is unknown. Hardly are you welcomed by the public before you become its slave. Success nowadays is at bottom but slavery. Be yourself, and who will understand you? Be everybody, and the crowd adopts you, and the men of refinement abandon you. Great works are asked of us, and it is time lost to undertake them: for nothing inspires them; no one believes in them, neither we nor others; and it is but a formula of vain condolence that condemns us to wear mourning for the great and noble habits of painting. Great painting is dead. That is understood. When it returns, mark the funereal effect it produces upon the joviality of the living.

Those who pretend to be delicate are only *blasé*. It is not commonplaceness which displeases: it is everything that bears too vivid a stamp. It is not the best that is wanted: it is the extraordinary. And the extraordinary is the work of those under the effects of hallucination. Painters are not opium-eaters. Of the free methods of production we shall never have too many, because in such a matter absolute liberty is only a right. We send seven or eight thousand pictures every year to the entrance of a palace which has not been prepared for us, but which is lent us.[16] Three thousand, at the outside, are received. This vast culling out is performed by a tribunal that we do not know, that we did not elect, which does not belong to our age; which has forgotten the ambitions, the ignorance, the intemperance, the manners, and the miseries of youth; which rules taste without understanding that taste may change, and which cheats the future by forgetting that it speaks in the name of the past. We are packed arbitrarily in the very poor places. The light is bad, the space too small, the surrounding odious. Bad works extinguish good ones, till the general level is lowered, and the mediocre equality of this confused conglomeration of pictures gives an impression which is enough to disgust one with painting. Oversensitive talents hesitate to cram themselves into this pitiless place, which seems to undress the pictorial art, and to lay bare only its vileness. Men who respect themselves keep away from it. The exclusive sulk, and ask themselves if there is no way to create elsewhere a

16 The Salons took place in the gigantic *Palais de l'Industrie*.

center more hospitable for newcomers. We want free exhibitions, associations, groups. Let us break up and create coteries. Let us admit into each group only the talents which esteem each other, understand each other, and render justice to each other. Assembled in this great palace, which becomes a tower of Babel, we make such a chaos that the world sees in it a new confusion of tongues; and this is a misfortune for everybody. Moreover criticism serves us ill, while giving itself much trouble. As an agent of publicity it has merit; as an intermediary between the public and ourselves, it forgets that it is we who create, and that it is the public which should be submissive. It hesitates between the two, representing in turn the ideas of each, and only half-serving the superior interests of art. If anyone has a right to influence opinion, to direct it, to lead it, to enlighten it when it is astray, who has this right and this power if not the men who govern it with their pen? . . .

I will suppose an honest artist, relatively enlightened and modest —such are not rare. I will suppose that you are in his confidence, and that on one of those days when certain moral defects make the conscience clear and sensitiveness very clairvoyant, this man, slightly disenchanted, has been led to reveal to you the depths of his thoughts. If he is in that condition of sadness and sincerity of which I speak, probably, gentlemen, he will say to you about what I am going to say.

We revolve in a vicious circle. Public taste is injured; that of painters is so no less; and we vainly seek to know which of the two should elevate the other. Sometimes we say that opinion ought to act upon the quality of work, and elevate it; and again, according to a new idea, it must be the works themselves that should act upon opinion, and convert it by good examples. Which is the better of these two ideas? Admitting that one of the two is correct, we must hope for a kind of miraculous purification in the atmosphere of society or in the air of studios. The evil is neither here nor there. We would be glad if it were local, in order to get at it more easily. The effects produced are manifest: the cause is uncertain. Not knowing where to seize it in its origin, we confine ourselves to combating it in its results, practicing thus a method used in therapeutics, which consists in treating a malady according to its symptoms, when in despair of finding a cause for it.

In reality we are all sick with a complaint of long standing, easier to name than to limit, of which the cause is profound, and which, you may be persuaded, is more inherent to the constitution of our times than is imagined. We are children of an emancipated and lawless epoch. We are all—will the acknowledgement be too harsh?—the product of a worthless instruction or a detestable education. . . .[17]

17 Eugène Fromentin in Louis Gonse, *Eugène Fromentin: Painter and Writer,* trans. Mary Caroline Robbins (Boston: James R. Osgood and Company, 1883), pp. 93–95, 98–100, 108–109.

A Letter to a Young Artist

In this letter, Fromentin gives advice to a young painter, Jacques-Fernand Humbert (1842—?), whose Delilah *was to appear in the Salon of 1873. The youthful artist had submitted the sketch for a projected painting of* Judith *to Fromentin, and it is to this work that the latter refers.*

SAINT MAURICE, SEPT. 6, 1872

Pardon me, dear friend, for having made you wait for my reply a few days longer than I ought. You ask me for a most important opinion, and the interest that you attach to it embarrasses as much as it honors me. I cannot be silent, since you beg me to speak; and, on the other hand, I do not wish, under a pretext of advice, to discuss a project which I have not before my eyes, to substitute my manner of seeing for your own, and to hamper the free conception of your work. All that I can do is to agree with you about its delicate character, and to indicate to you the standpoint from which I would undertake it, and where I should especially try to continue, during the whole course of its execution. It is a very beautiful subject, but very delicate. This is agreed. You feel as I do its resources, its charms, and its dangers. The difficulty arises at the moment when the literary spirit takes possession of it, and, the situation not sufficing, you pretend to make of it a symbol. It [the difficulty] increases with all the shades which you propose to put into it—attitudes, gestures, physiognomy, and expression. If you carry your analysis thus far, do not deceive yourself; that which for the romancer undertaking to write the scene, or the actress undertaking to represent it, would be a great and perilous problem, becomes a pitfall where the cleverest would lose his footing. Consider, on the other hand, that the local color which you will not deny yourself, the luxury of raiment, the undress of the woman, the atmosphere of the tent, the man asleep in the half light, in a word, the surroundings of this personage—becoming more equivocal as the sentiment which they express becomes more subtle and confused—consider, I say, that this dramatic situation may give to your subject the false appearance of a gallant adventure, or of a chamber tragedy, which is neither according to the spirit of the work nor to historical truth. For, in fact, Judith is neither a Delilah nor an Omphale. There mingles with the memory of her deed not only the bloody catastrophe which elevates it, but the idea of sacrifice, and the predetermination to surrender herself for a holy purpose. If you would absolutely produce a symbolism with your brush, and make of your work a true and instructive myth, this is the signification which you must give it: a woman devoting herself to a mighty cause; a victim offered for the safety of a people; a sort of daughter of Jephthah, or Iphigenia, yielding her honor in lieu of her life, and whose beauty is but an instrument of

vengeance. Represent to yourself a Charlotte Corday, finding Marat in his bed instead of in his bath. Compose the story of these modern heroines, and ask yourself if the tragic does not get the better of the romantic element, and if, into the imagination of the composer, faithful to the spirit of the legend, there could enter anything but the idea of a terrible act—august in its way, even sacred? There is no question here, I repeat, of the ancient or modern Delilah, nor of the enigmatical and mortal glance of the Jocondas of whom the world is full, for its delight and its despair. These are very exceptional circumstances in which the woman has found herself—weighted with special responsibilities, and clothed with the gravest character.

I may be mistaken, but in any case examine and verify, and if it be thus, you will see that the morality of the subject becomes quite another thing, and that it can only gain in truth or nobility from being treated in the most austere, the grandest, and most tragic style.

Now, I will not conceal from you that this singularly noble rendering alarms me a little for the nervous, living, dramatic spirit of a modern painter. Little by little the brazen cord will relax; and I can foresee in what subtle and charming rhythm you will write this page of pure Doric. You will have great success with it; but I would like something more. Am I wrong?

Now, see in your place what I should do.

In the first place I would suppress every mere prettiness, everything that represents luxury. One jewel shining in the shadow, like a sparkle on the necklace in a portrait by Rembrandt, will suffice to make people imagine that your Judith is covered with them.

I would try to find a gesture of *resolution;* one that shows the victim as the offerer of sacrifice, about to strike off an execrable head. Let there be little or no expression. If you found it, it would be a miracle: if you fail, your picture loses ground. Express an attitude, an assemblage of lines, but no *effect;* let light be upon her, shadow upon him; no real chiaroscuro. Let the half light and the draperies lead up to the alcove, and your Judith will have for title, *Dangers of a Successful Adventure.* Leave out all literature; be a painter, and breathe only a love for the grand, the beautiful, and the simple. Put and keep yourself in such a condition of soul that the idea will remain very simple, and let the plastic alone inspire you. Do not try to be expressive: your picture can dispense with profound meaning; and in any case it is better that it should have none than to pursue one that is chimerical or doubtful.

Seek not to make of it a *pastiche,* but keep yourself at those heights of perception where all danger of modern interpretation disappears; ask yourself how an Italian of the best period would conceive this picture.

A Venetian would certainly have represented his Judith lightly draped; he would have displayed her in her full relief and brilliancy—

white, large, and plump; the head would have been forgotten, even if he had taken pains with it. The dark red body of the man in armor would have been divined in the shadow. There would have been a total absence of expression, and entire commonplaceness of attitude. The subject would have become purely plastic; and the plastic itself would have furnished a favorable opportunity to paint two fine works in contrast—one amber, the other red. The result would be, even in the little surrounding objects, something like a nymph outraged by a Satyr. The figures would be barely clothed; and the picture would be possibly tragic, but assuredly admirably noble, and undoubtedly chaste. As to the Florentines, remember the Judith of old Mantegna—colossal and solemn, wrapped in her Sibylline draperies; a sort of Clytemnestra, minus the crime.

Amuse yourself with these thoughts; they are perhaps your best guide; and all my phrases can be reduced to this: Beware of the modern; think of Regnault's *Salome,* that you may accomplish its reverse; invoke the antique.

This is too long, too long. I read it over, and hesitate to send you this long-drawn argument. Extract from it what you can for your own use; or, if it disturbs or confuses you, throw it at once into the fire, forget it, go to work and—courage!

One more word. The times are bad; moral sense is very low; public taste astray, if not lost. Let each one of us work to elevate it. It depends upon you, with such a subject, to give a lesson in art, a lesson in style, and a lesson in taste.

E.F.[18]

JEAN-BAPTISTE CARPEAUX: 1827–1875

The Evolution of "The Dance"

Although overshadowed by the grandeur of Rodin, Carpeaux certainly deserves to be considered one of the outstanding sculptors of an age singularly devoid of talent in this field. His two masterpieces—the Flora *for the Pavillon de Flore of the Louvre and the fiery, frenetic* Dance *of 1869, for the new Paris Opera House, designed by Charles Garnier (1825–1898)—are, like so many official works of the time, more successful as modeled sketches, where the verve and brio of the master's conception are still evident, than in the chillier marble versions with which the public has become familiar.*

Garnier's description of the genesis of Carpeaux's sculptural group, Dance, *for the façade of his new building chronicles the struggle of each*

of the two men to achieve his own goals. The first sketch Carpeaux had
submitted to the architect had not been in harmony with the given pro-
gram of building decoration, so the latter submitted a more strictly de-
fined project to the sculptor.

Immediately he [Carpeaux] seized a pen, a bit of paper and, in a second, traced a few marvelously intersecting lines, making with a few movements the best composition in the world; in short, five minutes afterward, he had arrived at his group! It was almost the exact forerunner of the one that he executed later and that was to make so much noise in the world!

Carpeaux then made a sketch after this first drawing, but he added to it several figures, and even, I think, added one to it each day, in such a way that, at a given moment, there were *seventeen* of them! Then, of course, he had to cut down and come back to the first, more simple idea, although still full of action. Carpeaux then began the working model, always with a tendency to augment the number of figures, always with the same insistence on my part that he restrict himself to five or six; always with the same propensity to give his group incredibly exaggerated dimensions, always with the same opposition on my part to his going too far beyond the fixed measurements. The struggle was long and relentless! By now the sculptor scarcely saw anything but his work, without worrying about the [total] movement; the architect still saw the building, but let himself be carried away by the excitement of the sculptor! And the latter kept putting, to right and to left, above and below, floating garlands, disheveled draperies, whirlpools of flowers; the former kept insisting that the exterior lines be more sober, more calm, and demonstrated, in short, that all those giddy hooks, those spurts of accessories would infallibly get broken one day or another. Carpeaux was not fundamentally stubborn, and when he had grasped the practical reasons which militated against such and such a composition, he willingly returned to more restraint . . . for a few days at least, for his ardor still carried him away as soon as he found himself alone with his model. How many letters we wrote each other about this subject! How many meetings we had about this point! Finally, it transpired that, despite his wishes, I was able to have the width of the first group diminished by more than a meter, and that, despite mine, he was able to enlarge it beyond the given dimensions by more than fifty centimeters.

I do not know which of us made a greater sacrifice by giving in to the other in this way; all I know is that, as far as I was concerned, I had absolutely decided that if Carpeaux was unwilling to listen to me, I would let him have his own way. I found his models superb; I was amazed by his extraordinarily lively composition, by the palpitating modeling of his clay figures and, in short, I said to myself: "Oh well, if the monument

suffers a little from the exuberance of my sculptor it will only be a minor misfortune, whereas it would be a major one if I, stubbornly clinging to my ideas, deprive France of a great work that will certainly be a masterpiece." I thought this way when I saw the clay model, that model, in my opinion, quite superior to the execution; but I am still of the same opinion now, and I do not believe that I had the right, in the face of that kind of sculptural outpouring, to place myself in opposition to a powerful, personal creation and one which, despite le criticisms which can be leveled against it, is and will always be for everyone a first-rate work, and for some people, a masterpiece.[19]

PIERRE PUVIS DE CHAVANNES: 1824–1898

An Allegory of Letters, Science, and the Arts

Pierre Puvis de Chavannes was a painter uniquely qualified to satisfy the demands of both conservative and radical artists and critics during the last quarter of the 19th century. The reviewers of the right could approve, albeit with some reservations, his elevated themes and his traditional if somewhat flat and primitivizing handling of them, as well as his predilection for the grand scale of mural painting. On the side of the avant-garde, the Symbolists admired his anti-naturalism and the moody, vague, poetically suggestive cast of his allegories, half-classical, half-subjective, while the Neo-impressionists appreciated the radical simplifications of his compositions: Seurat, in fact, made a copy after Puvis de Chavannes' painting, The Poor Fisherman, *in about 1881.*

With his tepid palette and deliberately unequivocal line as well as the overliterary quality of his themes, Puvis de Chavannes may now seem dated and rather effete. Yet one can nevertheless respond to his genuine feeling for the flatness and simplification required by monumental decoration (cf. his murals for the Musée de Picardie at Amiens, and, later, his series of murals dealing with the life of St. Genevieve for the Pantheon, those for the great amphitheater of the Sorbonne, and finally the series of paintings for the Boston Public Library in 1894).

In the following passage the artist describes his mural, An Allegory of Letters, Science, and the Arts, *painted for the hemicycle of the large amphitheater of the Sorbonne, from 1887 to 1889. When questioned about the genesis of this work by his biographer, Marius Vachon, Puvis de Chavannes declared that, unlike the great artists of the Renaissance, he had had no assistance in inventing his iconography. Nevertheless, the meaning of this work is scarcely subjective and certainly not "untranslat-*

19 Charles Garnier in Ernest Chesneau, *Le Statuaire J.-B. Carpeaux: Sa vie et son oeuvre* (Paris: A. Quantin, 1880), pp. 110–112.

*able" in the way that, say, the meaning of many of Gauguin's composi-
tions is. Compare, for example, Gauguin's explanation of* Where Do We
Come From? What Are We? Where Are We Going?

Once having hit upon the idea of the secular Virgin [to personify
the Sorbonne], her physiognomy, her pose, and the place she was to oc-
cupy in the composition followed logically from the nature of what she is
in reality, the administration she personifies. She directs and watches over
everything. The figure must, therefore, dominate the composition. But
her social mission does not allow her to get involved in the discussion of
doctrines and theories; she will be placed at a distance from all the groups.
Her calm, impassive face and crossed arms indicate a serene impartiality.
Leaning unconstrainedly against her, two tutelary spirits await her orders
before carrying palms and laurel wreaths to the living and the dead. From
a rock in front of the central group there gushes a spring of cool water, at
which children and an old man come to drink: is not education the intel-
lectual fountain of all the ages of life? I had to represent Eloquence. In
my opinion it is the highest expression of the power of the human mind:
the first place was the only one suitable. But how was I to paint Eloquence
with enough character so that no one could mistake its identity? Should I
give it emblems and attributes, following the classical formula? It seemed
to me that nothing could represent Eloquence better than a standing
woman, speaking proudly, with a beautiful gesture, and to whom all the
figures that personify the various forms of human utterance—Lyric Poetry,
Epic Poetry, Drama, Satire, Fable, and Comedy—listen with admiration.
These are the groups to the left and the right of the Sorbonne. As for
Philosophy, two great general ideas divide the field: Materialism and
Spiritualism, about which gravitate Pessimism and Doubt. I thought that
in taking up the struggle of these two ideas about the problem of death,
I would sum up all Philosophy. A woman with a severe face holds a skull
in her hands and contemplates it, expressing, through her doleful expres-
sion and her attribute of deep sorrow, that death is the end of everything.
A lovely young girl with a fresh face and splendid costume smilingly ex-
hibits a flower, expressing earthly joys and the successive transforma-
tions limited to matter; Spiritualism, another woman, wrapped in a cloak,
replies with a gesture of fervent aspiration toward the ideal; Doubt, an
old man, listens and reflects. When Octave Gréard, vice-rector of the
Academy of Paris, saw my composition for the first time, he wanted to con-
gratulate me for the clarity of this allegory by saying to me: "Is it, then,
Plato and Aristotle?" What is History? A searcher who seeks and rum-
mages in the past so as to reconstruct its life by means of documents, the
most precious of which are offered her by the ruins of monuments: I com-
posed a group in which one sees a woman before whom a child pushes
aside the branches of a bush covering an antique inscription that she

turns to transcribe on tablets presented to her by a spirit. Some workers, busy clearing away an old wall, stop in the midst of their difficult work to listen to what History is saying; a boy, who is little interested by this, puts on an old brass helmet to amuse himself. This is Erudition defined and expounded. There remained the Sciences to symbolize. They are of three orders: the natural Sciences, the physical Sciences, and the mathematical Sciences. What better could I do than to represent together Geology and the Sea in the form of two women, their bodies simply veiled by a transparent gauze which allows us to admire their beauty; the one, crowned with a coral diadem, carries a conch shell in her hand; the other, decked in precious jewels, displays a piece of natural crystal. Mineralogy, a woman old as the world, but vigorous, made of limestone and sand, seated on the ground, leans against a piece of rock containing a fossil shell. Botany has a sheaf of flowers in her lap. A child, with a scalpel in his hand, prepares to catch a lizard to study it, while another examines a tube of microbe culture with curiosity. Physics is a kind of mysterious Isis, who only unveils herself to passionate, enthusiastic, convinced initiates: I placed her on a high pedestal, like a goddess; some young men, with a single movement, swear to consecrate themselves to her. The mathematical Sciences will be three men absorbed in the study of a geometry problem.[20]

[20] Pierre Puvis de Chavannes in Marius Vachon, *Puvis de Chavannes* (Paris: Braun, Clément et Cie, 1895), pp. 138–141.

2

Realism
and Naturalism
in France

GUSTAVE COURBET: 1819–1877

The Realist Manifesto

Gustave Courbet, leader and artistic embodiment of the Realist movement, had attracted scandal and controversy since exhibiting his gigantic Burial at Ornans *and* Stone-Breakers *at the Salon of 1850–1851. Courbet's determination to paint unelevated, familiar subjects (preferably those from around his native village of Ornans in the Franche-Comté) in a broad straightforward manner, on the grand scale hitherto reserved for historical or religious painting, was immediately equated with social anarchy and political revolution by public and critics during the period of conservative reaction following the downfall of the 1848 Revolutionary Government.*

When Courbet's major works, the Burial at Ornans *and the newly painted* Artist's Studio, *were rejected by the jury of the Universal Exposition of 1855, an infuriated Courbet withdrew the eleven pictures that they had accepted and had his own exhibition building constructed on the Avenue Montaigne, where, with customary bravado, he held a one-man show in competition with the official international exhibition.*

The so-called "Realist Manifesto," reminiscent of the political manifestoes of this stormy period both in its aggressive tone and in its concise setting-forth of a program, was actually the introduction to the Catalogue of Courbet's private exhibition. According to some authorities, Courbet's ideas were put into coherent form by the realist writer and critic Champfleury (see pp. 36 to 45), Courbet's staunchest supporter and initiator of the "bataille réaliste."

The title of Realist was thrust upon me just as the title of Romantic was imposed upon the men of 1830. Titles have never given a true idea of things: if it were otherwise, the works would be unnecessary.

Without expanding on the greater or lesser accuracy of a name which nobody, I should hope, can really be expected to understand, I will limit myself to a few words of elucidation in order to cut short the misunderstandings.

I have studied, outside of any system and without prejudice, the art of the ancients and the art of the moderns. I no more wanted to imitate the one than to copy the other; nor, furthermore, was it my intention to attain the trivial goal of *art for art's sake.* No! I simply wanted to draw forth from a complete acquaintance with tradition the reasoned and independent consciousness of my own individuality.

To know in order to be able to create, that was my idea. To be in a position to translate the customs, the ideas, the appearance of my epoch,

according to my own estimation; to be not only a painter, but a man as well; in short, to create living art—this is my goal.[1]

Art Cannot Be Taught

When, in 1861, Courbet received a petition from a group of dissatisfied Ecole des Beaux-Arts students requesting him to open a studio and teach them the theory and practice of Realism, the artist, who had always rejected academic training himself, was at first reluctant. But he then decided to open an unorthodox, democratic atelier, where an atmosphere of mutual aid and equality would reign among the students and their teacher and where the models were to include not only the usual nudes, but an ox, a horse, and a deer (presumably stuffed) as well.

Courbet explained his position in an open letter to his students, dated December 25, 1861, which appeared in the Courrier du dimanche. *His ideas about the impossibility of teaching art, his insistence on each individual's personal assimilation of tradition and unique interpretation of his own epoch, and upon the essentially concrete nature of painting itself make this letter Courbet's most important and far-reaching contribution to art theory; the artist was probably assisted in putting his thoughts into words by his friend and supporter, the critic Castagnary (see pp. 47 to 49), who was also in charge of running the studio and who later reprinted the letter under the title "Courbet: His Studio; His Theories" in* Les Libres Propos, *1864.*

PARIS, DECEMBER 25, 1861

GENTLEMEN AND COLLEAGUES:

You were anxious to open a studio of painting where you would be able to continue your education as artists without restraint, and you were eager to suggest that it be placed under my direction.

Before making any reply, I have to get things straight with you about that word *direction.* I can't lay myself open to making it a question of teacher and students between us.

I must explain to you what I recently had the occasion to tell the congress at Antwerp: I do not have, I cannot have, pupils.

I, who believe that every artist should be his own teacher, cannot dream of setting myself up as a professor.

I cannot teach my art, nor the art of any school whatever, since I deny that art can be taught, or, in other words, I maintain that art is completely individual, and is, for each artist, nothing but the talent issuing from his own inspiration and his own studies of tradition.

I say in addition that, in my opinion, for an artist art or talent can

[1] Gustave Courbet, *Exhibition et vente de 40 tableaux et 4 dessins de l'oeuvre de M. Gustave Courbet, avenue Montaigne* (7 Champs-Elysées, Paris, 1855), n.p.

only be a way of applying his own personal abilities to the ideas and objects of the time in which he lives.

Above all, the art of painting can only consist of the representation of objects which are visible and tangible for the artist.

An epoch can only be reproduced by its own artists, I mean by the artists who lived in it. I hold the artists of one century basically incapable of reproducing the aspect of a past or future century—in other words, of painting the past or the future.

It is in this sense that I deny the possibility of historical art applied to the past. Historical art is by nature contemporary. Each epoch must have its artists who express it and reproduce it for the future. An age which has not been capable of expressing itself through its own artists has no right to be represented by subsequent artists. This would be a falsification of history.

The history of an era is finished with that era itself and with those of its representatives who have expressed it. It is not the task of modern times to add anything to the expression of former times, to ennoble or embellish the past. What has been, has been. The human spirit must always begin work afresh in the present, starting off from acquired results. One must never start out from foregone conclusions, proceeding from synthesis to synthesis, from conclusion to conclusion.

The real artists are those who pick up their age exactly at the point to which it has been carried by preceding times. To go backward is to do nothing; it is pure loss; it means that one has neither understood nor profited by the lessons of the past. This explains why the archaic schools of all kinds are brought down to the most barren compilations.

I maintain, in addition, that painting is an essentially *concrete* art and can only consist of the representation of *real and existing* things. It is a completely physical language, the words of which consist of all visible objects; an object which is *abstract,* not visible, non-existent, is not within the realm of painting.

Imagination in art consists in knowing how to find the most complete expression of an existing thing, but never in inventing or creating that thing itself.

The beautiful exists in nature and may be encountered in the midst of reality under the most diverse aspects. As soon as it is found there, it belongs to art, or rather, to the artist who knows how to see it there. As soon as beauty is real and visible, it has its artistic expression from these very qualities. Artifice has no right to amplify this expression; by meddling with it, one only runs the risk of perverting and, consequently, of weakening it. The beauty provided by nature is superior to all the conventions of the artist.

Beauty, like truth, is a thing which is relative to the time in which one lives and to the individual capable of understanding it. The expres-

sion of the beautiful bears a precise relation to the power of perception acquired by the artist.

Here are my basic ideas about art. With such ideas, to think of the possibility of opening a school for the teaching of conventional principles would be going back to the incomplete, received notions which have everywhere directed modern art up to this point. . . .

It is not possible to have schools for painting; there are only painters. Schools have no use except for discerning the analytic procedures of art. No school is capable of pressing on to a synthesis in isolation. Painting *cannot,* without falling into abstraction, let a partial aspect of art dominate, whether it be drawing, color, composition, or any other one of the extraordinary multiplicity of means the totality of which alone constitutes this art.

I am, therefore, unable to open a school, to form pupils, to teach this or that partial tradition of art.

I can only explain to some artists, who would be my collaborators and not my pupils, the method by which, in my opinion, one becomes a painter, by which I myself have tried to become one since my earliest days, leaving to each person the complete control of his individuality, the full liberty of his own expression in the application of this method. To achieve this aim, the organization of a communal studio, recalling those extremely fruitful collaborations of the studios of the Renaissance, could certainly be useful and contribute to the opening of the era of modern painting, and I would eagerly give myself to everything you want of me in order to attain this goal.

With deepest sincerity,

GUSTAVE COURBET [2]

CHAMPFLEURY [JULES FRANÇOIS FÉLIX HUSSON]: 1821–1889

A Letter to Madame Sand About M. Courbet

The Realist writer Champfleury had "discovered" Courbet as early as the Salon of 1848. In the years following, he wrote a number of articles praising the painter, culminating in this letter of 1855 to the novelist George Sand. Courbet painted a portrait of Champfleury in 1853, and included him in the group of friends and supporters on the right-hand side of the Artist's Studio. *In a sense, the talents of the painter and writer*

[2] Gustave Courbet, Letter from the *Courrier du dimanche,* dated December 25, 1861 in Pierre Courthion, ed., *Courbet raconté par lui-même et par ses amis* (Geneva: Pierre Cailler, 1950), II, 205–207. Reprinted by permission of the publisher.

*complemented each other in building Realism into a burning issue, al-
though the actual accomplishments of Champfleury never really lived up
to his own theories, whereas Courbet's robust talents went beyond the
strictures of any given program. In any case, the painter certainly exerted
more influence on the writer than vice versa. A romantic (or pre-Marxian)
socialist, Champfleury in his views at this time strongly reflects those of
the anarchist philosopher P.–J. Proudhon (see below, pp. 49 to 53), whose
opinions he cites frequently.*

*In later years Champfleury rejected both Courbet, whose work he
felt had degenerated after the 1850s, and his own flirtation with revolu-
tionary ideas as a sort of youthful folly: "Realism was a democratic aspira-
tion, latent and unconscious, for certain spirits; for, around 1848, we were
driven by a singular kind of inspiration that made us act without apparent
reason," he said in 1877. His most important contribution to the study of
art in later years was his* History of Caricature, *in five volumes, which
traced the subject from antiquity through his own times. In addition,
Champfleury was one of France's most popular novelists from 1853 to
1860.*

[SEPT. 1855]

At this moment, Madame, there can be seen, right near the Exhibi-
tion of painting, on the Avenue Montaigne, a poster that reads like this:
REALISM. G. Courbet. *Exhibition of forty paintings of his work.* It is an
exhibition in the English style. A painter whose name has made an ex-
plosion since the February revolution has chosen the most significant
canvases among all his works and has had a studio constructed.

It is an incredibly audacious act; it is the subversion of all institu-
tions associated with the jury; it is a direct appeal to the public, it is
liberty, say some.

It is a scandal, it is anarchy, it is art dragged into the mud, it is the
booth of the mountebank, say others.

I admit, Madame, that I think the former, like all those who de-
mand the most complete liberty under all its manifestations. Juries, acade-
mies, contests of all kinds have shown more than once their powerlessness
to create men or works. If liberty of the theater existed, we should not see
a *Rouvière* [3] obliged to play *Hamlet* before peasants, in a barn, making
the shade of old Shakespeare grin and think itself, in the nineteenth cen-
tury, back in London presenting his plays in some dirty City hole.

We do not know how many unknown geniuses die who do not know
how to comply to the requirements of society, who cannot tame their wild-
ness, and who finally commit suicide in the dungeons of conventionality.

[3] Philibert Rouvière (1805–1865), French painter and actor, a pupil of the Baron
Gros. Baudelaire wrote a death notice on him in 1865; Champfleury based a short story,
Le Comédien Trianon, on his life.

M. Courbet hasn't reached that point yet; since 1848 he has shown, with-out interruption, in the different Salons, important works which always had the privilege of provoking arguments. The Republican government even bought an important canvas, the *After-Dinner at Ornans,* which I have again seen in the Lille Museum next to the old masters, holding its own quite well in the midst of established works.

This year the jury has shown itself to be miserly in the space it granted young painters in the Universal Exposition: the hospitality granted to the established men of France and to those of foreign nations was so great that youth suffered a bit. I have little time to spare for going around to the studios, but I have encountered rejected canvases which at other times would surely have received legitimate success. M. Courbet, confident in the public opinion that has favored his name these last five or six years, must have been hurt by the refusal of the jury, which fell on his most important works, and he has appealed directly to the public. He thought up the following reason: I am called a *Realist;* therefore I want to point out through a series of known paintings what I conceive *Realism* to be. Not content with having a studio constructed and exhibiting can-vases there, the painter has issued a manifesto and has written on his door: *Realism.*

If I write you this letter, Madame, it is because of the lively curiosity, full of good faith, that you have shown for a doctrine which takes shape from day to day and which has its representatives in all the arts. A hyper-romantic German musician, Mr. Wagner, whose works are unknown in Paris, has received extraordinary maltreatment in the musical journals, by M. Fétis who accuses the new composer of being tainted with *Realism.* All those who put forward new aspirations are called *Realists.* We shall surely see realistic doctors, realistic chemists, realistic manufacturers, re-alistic historians. M. Courbet is a realist; I am a realist: since the critics say so, I let them say it. But, to my great shame, I confess that I have never studied the code containing the laws according to which the first comer is allowed to produce realistic works.

The name horrifies me by its pedantic ending; I am afraid of schools as of the cholera and my greatest joy is to encounter clear-cut personalities. That is why, in my opinion, M. Courbet is a new man.

The painter himself, in his manifesto, has said some topnotch things: "The title of *Realist* was thrust upon me, just as the title of Romantic was imposed upon the men of 1830. *Titles have never given a true idea of things: if it were otherwise, then works would be unnecessary.*" But you know better than anybody, Madame, what a peculiar city Paris is when it comes to opinions and discussions. The most intelligent city in Europe necessarily includes the greatest number of idiots, of half-, third-, and quarter-wits. Indeed, we have to desecrate this fine word to adorn these poor chatterboxes, these silly debaters, these miserable creatures living off

the newspapers, these busybodies who insinuate themselves everywhere, these presumptuous people whom one dreads to see open their mouths, these scribblers at so much per line who fell into letters through poverty or laziness, in short, this horde of useless people who judge, reason, applaud, contradict, praise, flatter, criticize without conviction, who are not the great public and yet claim to be.

With ten intelligent people, one could get to the bottom of the question of *Realism;* with this mob of ignorant people, envious, powerless, critical, all one gets is words. I will not define *Realism* for you, Madame: I do not know where it comes from, where it goes, what it is; Homer might be a *Realist*—after all he observed and described with precision the customs of his time.

It is not sufficiently known that Homer was violently insulted as a dangerous Realist. "To tell the truth," says Cicero speaking of Homer, "all these are pure inventions of this poet who delighted in *bringing down* the gods to the human level; it would have been better *to raise* men to that of the gods." What else do they say every day in the newspapers?

If I needed other well known examples I would only have to open the first available volume of criticism, for today it is fashionable to reprint in book form the useless junk published by the newspapers week by week. One would see, among other things, that poor old Gérard de Nerval [4] was led to a tragic death by Realism. It is a gentleman-amateur who has written such nonsense; your country dramas are tainted with realism. They contain *peasants*. There is the crime. Lately, Béranger [5] has been accused of realism. How men can be carried away by words!

M. Courbet is seditious for having represented in good faith bourgeois, peasants, village women, in natural size. This was the first point against him. No one wants to admit that a stone-breaker is worth a prince: the aristocracy is infuriated to see so many feet of canvas devoted to common people; only sovereigns have the right to be painted full size, with their decorations, their embroideries, and their official faces. What! A man of Ornans, a peasant lying in his coffin, has the temerity to gather a large crowd at his burial—farmers, low-class people—and this representation is given as much space as Largillière had the right to give to magistrates going to the Mass of the Holy Ghost! [6] If Velasquez worked on a large scale, it was because his subjects were Spanish nobles, Infants, Infantas; at least there is silk, gold on the costumes, medals, feathers. Van der Helst

[4] Gérard de Nerval (1808–1855), eccentric, avant-garde poet and novelist who went mad and committed suicide.

[5] Pierre-Jean de Béranger (1780–1857), a writer of popular, sentimental, and patriotic songs, often with leftist overtones.

[6] Nicolas de Largillière (1656–1746), one of the most popular portrait painters of his time, achieved his greatest originality in a series of four large-scale portraits of the magistrates of Paris, of which only the one mentioned by Champfleury, the *Ex-Voto to St. Genevieve* at St. Etienne du Mont, has survived.

has painted burgomasters full scale, but these thick-set Flemings are redeemed by the *costume*.[7]

It would seem that our costume is not a costume; I really am ashamed, Madame, to pay attention to such arguments. The costume of each period is ruled by unknown, hygienic laws which penetrate fashion without this being realized. Every fifty years the fashions are overthrown in France; as with physiognomies, fashions become *historical* and as interesting to examine, as odd to look at, as the garb of some savage people. The portraits of Gérard, from 1800, which may have seemed vulgar in the beginning, later acquire an unusual aspect. That which artists call *costume*, that is to say, a thousand knickknacks (feathers, patches, plumes, etc.), can amuse frivolous minds for a moment; but the serious representation of present-day personalities, the derbies, the black dress coats, the polished shoes or the peasant's wooden shoes, this is interesting in a very different way.

I may be granted this and yet be told: your painter lacks an ideal. I shall answer that in a minute, with the help of a man who has been able to draw very sensible conclusions from M. Courbet's work.

The forty paintings of the Avenue Montaigne include landscapes, portraits, animals, large domestic scenes, and a work that the artist calls: a *Real Allegory*. It is possible to follow at a glance the developments that have taken place in the mind and brush of M. Courbet. Above all, he is a born painter, which means that no one can dispute his robust and powerful talent as a worker: he intrepidly attacks a huge piece of work; he may not charm all eyes—some parts may be neglected or clumsy—but every one of his pictures is *painted*. I consider that the Flemings and the Spaniards are, above all others, painters. Veronese, Rubens, will always be great painters, whatever opinion one may hold, whatever point of view one has. Thus, I know no one who would dream of denying M. Courbet's qualities as a painter.

M. Courbet never overdoes the *sonority* of his tones—since the musical language has since been carried into the domain of painting. The impression made by his paintings is all the more durable for it. It is up to every serious work not to attract attention by useless sonorities: a sweet Haydn symphony, homely and intimate, will still live when M. Berlioz's numerous trumpets are spoken of with derision. The uproar of brasses in music means no more than loud tonalities in painting. We clumsily call *colorists* those painters whose exacerbated palettes pour forth clamorous tonalities. M. Courbet's scale is imposing and calm. Thus I was not sur-

[7] Bartholomeus van der Helst (1611/12–1670), Dutch painter from Haarlem, particularly known for his group portraits of civic guards. His most famous work, often considered a *pendant* to Rembrandt's *Night Watch* by 19th-century critics, is the enormous and powerfully realistic *Banquet of Captain Bicker* in the Rijksmuseum, Amsterdam, a work which probably served as one of the prototypes for Courbet's *Burial at Ornans*.

prised to rediscover, now forever hallowed within me, the *Burial at Ornans,* which was the first shot fired by the painter, regarded as a rebel in art. It was almost eight years ago that I published about an unknown M. Courbet phrases that foretold his destiny: I shall not quote them, I am no more anxious to be the first to be right than I am to wear the latest Longchamps fashion. To discover men and works ten years before most people do is simply a question of literary dandyism which results in a lot of wasted time. Stendhal, as early as 1825, in his numerous critical articles, published many daring truths that did him much harm. To this very day he remains in advance of his times. "I would like to bet," he writes to a friend in 1822, "that in twenty years' time they will be playing a prose version of Shakespeare in France." *Thirty-three* years have already gone by, and quite certainly, Madame, we shall not have this pleasure during our lifetime. M. Courbet is far from being accepted today; he certainly will be in a few years. Wouldn't I be playing the role of a busy-body if I wrote twenty years hence that I had discovered M. Courbet? The public does not care about the asses that brayed when Rossini's [8] music was first played in France; the witty, the amorous Rossini was treated with as little circumspection on his first appearance as M. Courbet. A plethora of insults was printed about his works just as it has been about the *Burial [at Ornans].*

What is the use of being right? One is never right.

Two village beadles with red mugs, two winesacks, can provide the theme for those literary-minded critics I mentioned above; compare with them, in the same painting, the charming children, the group of women, the mourners, as beautiful in their grief as all the Antigones of antiquity —it is impossible to prove one's point.

The midday sun shines upon the rocks, the grass is gay and smiles at the sunshine, the air is fresh, there is plenty of room, you recognize the nature of the mountains, you breathe in their odors; a joker comes up who, having drawn his education and his cleverness from the *Journal pour rire* [a journal of rather coarse, satiric cartoons], will scoff at the *Demoiselles de Village.*

Criticism is a rotten business that paralyzes man's noblest faculties, extinguishes and annihilates them; thus, criticism has no real worth outside the hands of great creators: Diderot, Goethe, Balzac, and others who prefer bathing their enthusiastic sensibilities every morning to watering the thistles each critic keeps locked up on his window sill in an ugly vase.

I recognized, in the Avenue Montaigne, those celebrated *Bathers,* fatter with scandal than they are with flesh. Two years have gone by since the famous scandal has died down, and I see today nothing but a creature

8 Giacchino Antonio Rossini (1792–1868), Italian composer known for the spirited, forceful quality of his works, very popular in France and most famous for his opera, *The Barber of Seville.*

solidly painted which has the great fault, for the friends of convention, of not reminding one of the Venus Anadyomenes of antiquity.

M. Proudhon,[9] in the *Philosophy of Progress* (1853), seriously appraised the *Bathers:* "The image of vice like that of virtue belongs as much to the realm of painting as to that of poetry; according to the lesson the artist wants to give, every figure, beautiful or ugly, can fulfill the goal of art."

Every figure, beautiful or ugly, can fulfill the goal of art! And the philosopher continues: "May the people, recognizing itself in its misery, learn to blush at its cowardice and to hate its tyrants; may the aristocracy, exposed in its fat and obscene nakedness, receive, on each of its muscles, the flagellation of its parasitism, its insolence, and its corruption." I skip several lines and come to the conclusion: "And may each generation, leaving thus on canvas and on marble the secret of its genius, reach posterity with no other blame or apology than the works of its artists." Do not these few words help us forget the idiocies one ought neither to listen to nor hear, but which irritate nevertheless, like a persistently buzzing fly?

The *Painter's Studio,* which will be heatedly discussed, is not M. Courbet's last word; charmed by the great Flemish and Spanish masters who, at all periods, have grouped their families, friends, and patrons about them, M. Courbet has, this time, attempted to escape from the realm of pure reality: a "real allegory," he states in his catalogue. Here are two words that clash with each other and that bother me a little. One must be careful of bending the language to symbolic ideas that the brush can try to translate but which grammar cannot adopt. An "allegory" cannot be "real" any more than a "reality" can be "allegorical"; there is already enough confusion about that famous word "realism" without having to complicate it still further. . . .

Many people will share my opinion, those who dislike M. Courbet first of all. But I am not afraid to range myself with them for a short time, while I explain what I mean. In the field of art it is habitual to overwhelm the living with the dead, the new works of a master with his old ones. Those who, when Courbet was just starting, would have made the loudest outcry against the *Burial* will necessarily be those who praise it most highly today. Not wanting to be confused with the nihilists, I must say that the idea of the *Burial* is striking, clear to all, that it represents *a* small-town funeral and yet reproduces the funerals of *all* small towns. The triumph of the artist who paints unique entities is to respond to each person's intimate observations, to choose a type in such a manner that everyone thinks he has known him, and can exclaim: "That one is real: I have seen him!" The *Burial* possesses these qualities to the highest de-

9 P.-J. Proudhon (1809–1865), anarchist philosopher and social theoretician from the Franche-Comté (see below, p. 49).

gree: it moves, it touches, it makes one smile, it makes one think, and leaves in the mind, despite the open grave, that supreme tranquility which the gravedigger shares—a grand and philosophical type that the painter has been able to represent in all his beauty as a man of the people.

Since 1848 M. Courbet has been privileged to amaze the crowd. Every year we expect surprises and, until now, the painter has answered the expectations of his friends as he has those of his enemies.

In 1848, the *After-Dinner at Ornans,* a large painting of a domestic interior, won a real success without too much argument. It is always this way at an artist's beginnings. Then came the successive scandals:

First scandal.—The Burial at Ornans (1850).

Second scandal.—The Village Girls (1851).

Third scandal.—The Bathers (1852).

Fourth scandal.—Realism.—Private Exhibition.—Manifesto.—Forty paintings exhibited.—Meeting of various scandals, etc. (1855).

Now, of all these scandals, I prefer the *Burial* over all the other canvases because of the idea within it, because of the complete and human drama in which the grotesque, tears, egotism, and indifference, are handled in the manner of a great master. The *Burial at Ornans* is a masterpiece; since David's *Murdered Marat* nothing in the realm of ideas has been more strikingly painted in France.

The *Bathers,* the *Wrestlers,* the *Stone-Breakers* do not contain the ideas with which they have been endowed after the fact. I would find these ideas rather in the *Village Girls,* and in the numerous landscapes which show how attached M. Courbet is to his native soil, his profound local nationalism [i.e., regionalism], and the advantage he can derive from it.

People still repeat that old joke attributed to the painter: *Long live ugliness! Only ugliness is lovable!* It is surprising that they dare dredge up such stupidities, which were hurled thirty years ago at the head of Victor Hugo and his school. The pattern of the sad, old story will always spring up from its ashes. Progress is very slow, and we have not gone far in thirty years.

Thus, it is the duty of all those who fight to help each other, to attract if necessary the wrath of mediocrities, to be steadfast in their opinions, serious in their judgments, and not to imitate the prudence of the old Fontenelle.

I have a handful of truths, and hasten to offer them. . . .

I have criticized the *Painter's Studio* a bit, although it exhibits a real advance in M. Courbet's manner: it will no doubt gain from being seen more calmly at another time. My first impression has been such, and I generally believe in my first impression. Gossip, comments, criticisms in the newspapers, friends, and enemies then begin to disturb one's mind to

such a point that it is hard to rediscover one's ideas in their first purity; but above the impression, I place the mysterious workings of *time,* which destroys a work or restores it. Every work that is full of conviction is lovingly treated by time, which only wipes out fashionable frivolities, *pretty* imitations of the past, and conventional works.

If there is one quality M. Courbet possesses to the highest degree it is conviction. One could no more deny him this than the sun its heat. He walks in the realm of art with an assured tread, he proudly shows from where he started and where he has arrived, resembling in this that rich manufacturer who hung from his ceiling the wooden shoes that had brought him to Paris.

Portrait of the Author (Venetian study), he says himself in his catalogue; *Head of a Young Girl* (Florentine pastiche), *Imaginary Landscape* (Flemish pastiche), and lastly, *Lying in Wait* which the author jokingly entitles *Studio Landscape*—these are the wooden shoes with which he arrived from Ornans and which helped him to run after nature.

These few paintings belong to the realm of *convention;* what giant steps the painter has taken since that time in order to escape from this domain so dear to fashionable painters! Surely he would have found success in this realm if he had been lazy enough to remain there, and he would have added to the population of a hundred talented artists whose success is so great in the windows of the picture merchants of the Rue Notre-Dame-de-Lorette. What an easy job it is to produce *pretty* things, tender things, stylish, precious, falsely idealized, conventional junk for the use of kept women and bankers! M. Courbet has not followed this path, carried away from it, in any case, by his temperament. M. Proudhon announced his fate to him in 1853.

"The public," said he, *"wants to be represented as beautiful and believed to be so."*

"An artist who, in the work of his studio, followed the aesthetic principles formulated above (I make reference to the preceding axiom: every figure, ugly or beautiful, can fulfill the good of art), will be treated as subversive, driven out of the competition, deprived of State commissions, and condemned to die of starvation."

The philosopher treated this question of ugliness in relation to the *Bathers* from a lofty vantage point. He knows how heavily moral qualities weigh upon physical ones. Daumier, the caricaturist, saw the same fact from the grotesque viewpoint. The eternal bourgeois whom his pencil has immortalized and who will live down through the centuries in all their modern ugliness, cry out when they see one of M. Courbet's paintings: "Is it possible to paint such hideous people?" But, above the bourgeois who have been overly vilified we must place a more intelligent class which has all the vices of the old aristocracy without its qualities. I refer to the sons of the bourgeoisie, a race that has profited by the fortunes of doctors,

lawyers, and merchants, but which has done nothing, learned nothing, which has thrown itself into gambling clubs, which has a passion for horses and elegance, which has a try at everything, even at the writing desk, which even buys a mistress and a quarter of a Review, which wants to give orders to women and to writers. It was with the thought of this new race that the philosopher Proudhon concluded his remarks on M. Courbet:

"Let the magistrate, the soldier, the merchant, the peasant, let all orders of society, seeing themselves both in the idealism of their dignity and in their lowness, learn, through glory and shame, to rectify their ideas, to correct their customs, and to perfect their institutions." [10]

MAX BUCHON: 1818–1869

"As an Apple-Tree Produces Apples . . ."

Max Buchon, like Courbet and P.-J. Proudhon a native of the Franche-Comté, was one of Courbet's earliest friends and associates. The painter illustrated the poet's Essais poétiques *with naïve lithographs in 1839. Buchon's literary career offers striking parallels with that of Courbet as a painter: throughout his life Buchon was continually concerned with the relation of art to its social context; the context to which he refers is that of the rural proletariat. This underlying impulse is manifested in all Buchon's work: in his own "popularizing" poetry, his translations from the German, his collections of the local folk-songs of the Franche-Comté, and his polemical essays. Max Buchon, whose full length portrait Courbet painted in 1854 and who figured in the group of friends in the* Painter's Studio *of 1855, was one of the first to insist upon the importance of popular art and, indeed, to assert its superiority to so-called "high" art. According to Buchon, folk-songs and popular legends are the true masterpieces of realism. It is precisely due to the advantages bestowed upon Courbet by his popular origins, the advantages of spontaneity and intuitive, rather than intellectual, apprehension, that he is the great artist that he is.*

This is really one of the first times that the ignorance and lack of training characteristic of peasants are considered an asset in an artist; it is the beginning of a very modern conception of the artist who must divest himself of the impedimenta of culture in order to create, an idea perhaps implicit in romanticism but never before so baldly stated.

This appreciation of Courbet is taken from a rare pamphlet by Buchon, Recueil de dissertations sur le réalisme, *published in Neuchâtel*

[10] Champfleury, "Sur M. Courbet: Lettre à Madame Sand," *Le Réalisme* (Paris: Michel Lévy frères, 1857), pp. 270–285.

*in 1856, during the writer's political exile in Switzerland following his
activities in the 1848 Revolution.*

Aren't the great writers and the great artists always the intellectual
free-companies of their century? Outside of them, who are there? Profes-
sors who give birth to professors, who in turn never produce anything but
professors.

The most inexorable protest against professors and pastiches is popu-
lar art. The latter has the virtue of keeping silent unless it has something
to say and of saying straightforwardly what it thinks. Come now, let's not
be so afraid of being of our own times or even of our own province. If,
as artist and as writer, the painter Courbet and the philosopher Proudhon
figure so high among contemporary exemplars, isn't this due a great deal
to their powerful, Franc-Comtois breadth of shoulder? . . .

The most conspicuous advantage of Courbet, in the midst of the
chaos which surrounds him, is unquestionably his rich spontaneity. It is
this obvious spontaneity which gave him the right to say, as he has, that
he never had any master but himself. For him, there could never be a
question of either *success* or *inspiration,* for all this presupposes discon-
tinuities unknown to him, and his arm, no matter how vigorous it may
be, always gets tired before his brain. If you saw Courbet at work for an
instant, you would say that he produced his works (so many of which are
masterpieces) as simply as an apple-tree produces apples. For my part, I
never thought it possible to display greater strength and rapidity in work-
ing. In this respect at least, Courbet ought to be the greatest painter in
the world.

As rapidly as Courbet works, just as copiously does he sleep. Burst-
ing with energy as he is, you can set him to eating, to horseback riding,
hunting, swimming, boating, shepherding, billiards, croquet or put him
into a good bed, and you will see that he will do honor to the situation
magnificently. . . .

Courbet, who feels himself the equal of the greatest men, and acts
with them accordingly, has no difficulty in being matter-of-fact with the
simplest folk, as soon as he feels that they are honest and endowed with
some good innate qualities. . . .

A good number of Courbet's paintings have been accused of parti-
sanship. Attempts have been made to see them as so many ruses to capture
public attention. Such allegations could never have been made if their
authors had been capable of realizing to what extent Courbet's works are
the natural flowering of his personality, in the midst of his family, in that
lovely valley of Ornans. What a fuss has been made over the *Burial,* and
what work has ever breathed forth more calm: the calm of strength and
health. . . .

It is easy to see the material results of Courbet's work. Perhaps it is

less easy, for those who do not know him, to take account of the intellectual elaboration of his ideas. I have spoken about Courbet's spontaneity. Now let us talk about the sureness of his glance, the subtlety of his moral instinct, his great ability to follow and often even to dominate the current of healthy ideas surrounding him, aided only by his enormous power of intuition.

As a means of education and study, Courbet has never had anything but his magnificent eyes, and this was certainly enough.

To live with a perpetually tense and energetic liveliness; *to see* with a penetrating and dominating vision—here is the whole secret of this fine mind, servant of a great heart.

Courbet is not very familiar either with history or the sciences or books, which doesn't prevent him from having a profound knowledge of nature and men.[11]

[JULES ANTOINE] CASTAGNARY: 1830–1888

The Importance of Courbet

Castagnary became the official champion of Realism, defending the art of Courbet and Millet as well as that of Corot and Daubigny in his Salons from 1857 to 1879. Castagnary was one of the rare sympathetic critics capable of appreciating Courbet's style as well as his subject matter, and of seeing the necessary connection between the two. The critic remained loyal to Courbet throughout his lifetime, organized the large scale exhibition of his works at the Ecole des Beaux-Arts in 1882, prepared the catalogue for it, and was engaged in preparing a general catalogue of Courbet's works when he died. He contributed articles to various journals, like L'Audience, Le Courrier du dimanche, *and* Le Siècle, *of which he eventually became one of the editors-in-chief. Courbet's portrait of Castagnary, painted in 1870, is now in the Louvre.*

I would have preferred not to talk about Courbet because Courbet has been represented in the Salon only by two inadequate sketches[12] and because his major work, the *Return from the Meeting*, has not even passed beneath the eyes of the public.[13] But how can one neglect, in a review of

11 Max Buchon, *Recueil de dissertations sur le réalisme* (Neuchâtel, 1856), republished in Charles Léger, "Courbet, ses amis et ses élèves," *Mercure de France, CCI* (Jan. 1–Feb. 1, 1928), 13–16.

12 The *Fox Hunt* and a *Female Portrait*.

13 This large, scandalous painting, representing a group of tipsy priests returning from their weekly Monday night meeting in one of the parishes near Ornans, was rejected by the jury of the 1863 Salon and not even permitted to figure in the Salon des Refusés of that year. The painting was finally purchased by a fanatical Catholic who destroyed it; it is known to us only through photographs and a rough drawing, either a copy or a preliminary sketch.

French painting, the man who today seems to sum up its only existing strengths? How can one withdraw from that naturalistic gallery that I am sketching the bust of the man who, reacting with the greatest energy against the romantic tendencies, actually decided the course of the new movement?

I will, therefore, speak of Courbet with all the more pleasure because, no matter what one may say or think of him, he remains, because of the unquestionable vigor of his temperament, the excellence of his technique, and even the narrowness of his theory, one of the oddest originalities of the century.

Courbet is the first of the socialist painters. One finds him completely in each of his works. The liberty of his manner derives from the liberty of his education. He is the pupil of nature, as he puts it. He learned to draw at the Academie Suisse where he copied the living model, to paint at the Louvre, where he studied the technical procedures of the schools of the past. It is through this double study, long pursued, that he acquired that broad, easy, vigorous brushwork that distinguishes him.

From the *After-Dinner at Ornans* (1849), which is in the Lille Museum, to the *Return from the Meeting* (1863), which the Luxembourg Museum will doubtless neglect to buy, Courbet has never deviated an instant. He has walked on the same path, obeyed the same tendencies; all his works bear the stamp of the same preconceived system and carry the seal of the same personality. If he wanted first to acquire the complete knowledge of tradition, it was, as he himself wrote, in order to draw from it the reasoned and independent sentiment of his own individuality. "To know in order to be able to do," he said, "such has been my idea. To translate the ideas, the spirit of my times according to my understanding of them, to make, in short, a living art, such has been my goal." For my part, I do not know of a more elevated one, and I doubt that the great masters of all times have ever proposed another.

This singular artist, so different from all those who surround us, places extraordinary means in the service of his personal aesthetic. He is a painter in the precise sense of the word, PICTOR, *pittore:* he sees clearly and renders exactly. His technique, wonderfully varied, is supple enough to change itself with every object that he treats; his brush envelops with a single stroke and gives form and movement at the same time. Nothing that composes the visible world is foreign to him: figures, landscapes, animals, seascapes, portraits, flowers, and fruits—Courbet deals with everything, and with the same superior facility. Above all, submissive to things, he draws his impression from nature, which permits him to be as varied as she. For this power and this variety I would gladly compare him with Velasquez, the great Spanish naturalist, but with a subtle distinction: Velasquez was a courtier of the court, Courbet is a Velasquez of the people.

Courbet's great claim is to represent what he sees. It is, in fact, one

of his favorite axioms that everything that does not appear upon the retina is outside the domain of painting. . . .[14]

Courbet and the Palette Knife

You are familiar with the knife painters use to pick up the colors on the palette. I do not know whether great artists of the past have employed it as a supplement to the brush and have used it to paint with; what I do know is that in this century Courbet makes constant use of it, and that he achieves extraordinary effects with it. That amplitude of execution and that beauty of coloring that all the world recognizes in him come in part from this. Put in place with the knife, the tone acquires a delicacy, a transparency that the brush is incapable of giving it. Look at that *Roebuck on the Alert* which is one of the jewels of this Salon, and which already is out of its author's possession. Examine those terrains, that running water, that forest floor which is so bright and so light, that profound, precise harmony—all of this due to the use of the knife. Courbet, moreover, handles this instrument with an unequaled dexterity. He has, I think, improved it; he has lengthened it, given it two parallel edges, has made it so flexible and supple that one would think it a pen in his fingers. There are landscapes by him—and you know whether or not he is a good landscapist—where ground, sky, water, tree trunks, and leaves—everything —is made with the knife. It is only for the animals and the human figure that he takes up the brush, because then the brush gives him at the same time as the movement of the muscles, the tone, be it of fur or of flesh. I remember the time when Courbet had an atelier. His students, amazed by the nimbleness of his hand, all had knives made like the one they saw him manipulate with such ease. But alas! The art of the colorist is not completely within the instrument; it is also, it is above all, in the trustworthy mirror of the eye that distinguishes at first sight the tone and the values of tone. Few succeed in their attempt.[15]

PIERRE-JOSEPH PROUDHON: 1809–1865

Concerning the Principles of Art and Its Social Destiny

P.–J. Proudhon, poor, self-educated, and, like Courbet, from the Franche-Comté, was the foremost French socialist of his day. In 1840 he published What is Property? *and answered his own question with the famous phrase: "property is theft." His greatest work,* The System of Eco-

14 [Jules Antoine] Castagnary, "Salon de 1863," originally published in *Le Nord* of Brussels in 1863, and reprinted in *Salons (1857–1870)*, pref. by Eugène Spuller (Paris: Bibliothèque-Charpentier, 1892), I, 147–148.

15 Castagnary, "Salon de 1868," *ibid.*, pp. 272–273.

nomic Contradictions, or the Philosophy of Poverty, *was published in
1846. He was imprisoned for three years following the collapse of the
Revolutionary government of 1848, and later had to flee into exile in
Brussels.*

*Austere, upright, loyal, devoted to his family, he shared with Cour-
bet, whom he probably met in 1848, an aggressiveness, roughness, and ex-
aggeration of behavior sometimes lapsing into coarseness, yet redeemed at
other times by an amazing delicacy of feeling and expression. Friendship
between the two men grew; as Champfleury, who disapproved, sarcas-
tically put it:* "No-ideal and no-religion *shakes hands with* property is
theft." *By 1863 Proudhon and Courbet considered collaborating on a
book. Proudhon's treatise on art, originally intended as a pamphlet of
120 pages, eventually appeared as a volume of 376:* Du principe de l'art
et de sa destination sociale *(1865).*

*While Proudhon candidly admits that he knows nothing about art
and completely lacks any aesthetic intuition, his study, based chiefly on a
detailed examination of Courbet's works, clearly reveals how intimately
linked revolutionary and humanitarian ideas in art and in social thought
could be. His "analysis," for instance, of Courbet's* Stone-Breakers *should
be compared to the artist's own account of his reactions to his subject
when he came upon the two workers on the road to Mazières:* "It is rare,"
said Courbet to his friend Francis Wey in a letter of November 26, 1849,
"to encounter the most complete expression of misery, so immediately a
painting came to mind." *In 1865 Courbet painted the magnificent portrait
of the philosopher (now in the Petit Palais in Paris) as he remembered
him in 1853, seated in the garden in a simple working-man's smock, with
his two daughters.*

The Aim of Art

To paint men in the sincerity of their natures and their habits, in
their work, in the accomplishment of their civic and domestic functions,
with their present-day appearance, above all without pose; to surprise
them, so to speak, in the dishabille of their consciousness, not simply for
the pleasure of jeering, but as the aim of general education and by way
of aesthetic information: such would seem to me to be the true point of
departure for modern art. This does not exclude, in the future, exhibi-
tions more flattering to our vanity, more idealized, since it is thus that the
ideal is understood. But—and I don't hide it—I do not expect to see any-
thing of the sort; I do not think that nowadays either Courbet or anyone
else will succeed in it. Let us humble ourselves beneath the weight of our
unworthiness. It is really not such a trifling thing to be able to show us as
we are. In all these respects, I dare say that, aside from the finish of the
execution, . . . the painting of Courbet is more serious and higher in its
aim than almost anything that the Dutch school has left. . . .

It is against this degrading theory of art for art's sake that Courbet and, with him, the whole school called realist up until the present, boldly arise and energetically protest. "No," says he (I translate here Courbet's ideas as embodied in his works, rather than citing them from his speeches): "no, it is not true that the only aim of art is pleasure, for pleasure is not an end; it is not true that it has no other aim but itself, for everything sticks together, everything is connected, everything is conjoined, everything has an aim in humanity and in nature: the idea of a faculty without aim, of a principle without consequence, of a cause without effect is as absurd as that of an effect without a cause. Art has the objective of leading us to the knowledge of ourselves by the revelation of all our thoughts, even the most secret ones, of all our tendencies, of our virtues, of our vices, of our ridiculousness, and in this way it contributes to the development of our dignity, to the perfecting of our being. It was not given to us to feed ourselves with myths, to intoxicate ourselves with illusions, to deceive ourselves and lead ourselves into evil with mirages as the classicists and romantics would have it, as well as all the sectarians of a vain ideal, but rather, to deliver ourselves from these harmful illusions by denouncing them."

The "Stone-Breakers"

Others before Courbet have attempted socialist painting and have not succeeded. This is because it is not enough to desire to do so: one must be an artist. To reproduce realities once again is nothing: one must make people think; one must touch them, illuminate their consciousness with an ideal that becomes all the more forceful as it disappears from sight.

The *Stone-Breakers* is an irony addressed to our industrial civilization, which every day invents marvelous machines to work, sow, mow, harvest, thresh the grain, grind it, knead, spin, weave, sew, manufacture nails, paper, pins, cards; to execute, in short, all kinds of jobs, often very complicated and delicate, and which is incapable of freeing man from the heaviest, most difficult, most unpleasant tasks, the eternal lot of the poor. In general, our machines, masterpieces of precision, are more skillful than ourselves; they do better than we do, provided that what we ask of them requires intelligence or even dexterity; once they are in movement, they replace us with great advantage. They have only one fault: they do not go into motion themselves, but need someone to watch over them and control them and even to serve them. Who, then, is the servitor of the machine? Man. Man-serf—this is the latest term of modern industrialization. . . .

Now close your eyes. There are two personages represented in Courbet's painting: a young man of eighteen and an old man of sixty. Before

examining the painting, tell me which of these two men seems to you better able to express servitude and misery—the old one, surely; old age adds to misery and indigence, while there are no afflictions that youth does not compensate for. Indeed? You are mistaken. Now look at the painting.

That old man, kneeling, bent over his hard task, who breaks the stone by the side of the road with a long-handled hammer, certainly invites your compassion. His motionless face is heartbreakingly melancholy. His stiff arms rise and fall with the regularity of a lever. Here indeed is the mechanical or mechanized man, in the state of ruin to which our splendid civilization and our incomparable industry have reduced him. This man, however, has seen better days, since he has lived; if, for him, the present is without illusion, without hope, he has at least his memories, his regrets, to sustain him, and it is not a mere trifle to have something to remember; while that deplorable boy who carries the stones will never be acquainted with any of the joys of life; chained before his time to day labor, he is already falling apart; his shoulder is out of joint, his step is enfeebled, his trousers are falling down; uncaring poverty has made him lose the pride in appearance and the nimbleness of his eighteen years. Ground down in his adolescence, he will not live. Thus modern servitude devours the generations in their growth: here is the proletariat. And we talk of liberty, of human dignity! We declaim against the slavery of the Blacks, whose status as beasts of burden at least protects them against the excess of poverty! Please God that our proletariat may be at least as well treated on the material level as the Blacks! It would doubtless be not completely fair to judge a great nation with ten million sovereign voters by this sad sample; but is it less true that this is one of the shameful aspects of our society, and that there is not one of us, city dweller or peasant, worker or proprietor, who may not, one day, through an accident of fortune, see himself reduced to this? The condition of the stone-breakers is that of more than six million souls in France; then boast of your industry, your philanthropy, and your politics!

A critic of a school which is not ours, has said of the *Stone-Breakers* that this painting was "a masterpiece of its genre." I accept this judgment. The *genre* to which the *Stone-Breakers* belongs is today the most elevated genre, the only one that can be admitted. What would this canvas need to enable it to receive all the votes? Precisely, to be less perfect in its type. If Courbet, for example, had been as enamoured of antitheses as Victor Hugo, nothing would have been easier for him than to create a contrast in his painting: he would have placed the stone-breakers beside the iron gate of a castle; behind this gate, in perspective, a vast and splendid garden; in the rear, the master's habitation, with a terrace, a portico, marble statues representing Venus, Hercules, Apollo, and Diana. That would have produced its effect. Courbet preferred the open road, completely bare, with its emptiness and monotony; in this I am completely of his opinion.

The solitary road has a completely different kind of poetry than that of the affected contrast between opulence and poverty. It is there that dwell work without distraction, poverty without holiday, and dreary sadness.

Some peasants, who have had occasion to see Courbet's painting, wanted to have it in order to put it—guess where? On the high altar of their church. The *Stone-Breakers* is worth a parable from the Bible; it is morality in action. I recommend this peasant-idea to M. Flandrin: [16] it could enlighten him in his religious compositions. . . .

Courbet: An Expression of His Age

In summary, Courbet, a critical, analytic, humanitarian painter, is an expression of the times. His work coincides with the *Positive Philosophy* of Auguste Comte, the *Positive Metaphysics* of Vacherot,[17] my own *Human Right* or *Immanent Justice;* the right to work and the right of the worker, announcing the end of capitalism and the sovereignty of the producers; the phrenology of Gall and Spurzheim; the physiognomy of Lavater.[18] He owes an enormous amount to the good luck he had to live in Ornans; if he had been born or had grown up in an Academy, he would not be himself. It is liberty that taught him his path. He put his hand upon an elevated and fruitful idea; he has still not learned how to dominate it, enunciate it, although he has served it with brilliance. That idea, it is clear, has filled him; in the beginning it gave him a mad vanity that everyone talked about, but which, joyous and naïve at once, made the man and his idea suspect, and almost prevented people from taking them seriously. Then, contradiction and a fiery polemic came and pushed Courbet into eccentricity and paradox. Too glorified by people who didn't understand him, too belittled by others who didn't understand him at all, he had the misfortune of not being, from the very first, classified and brought back to his proper position; that would have calmed him down, and he would have made, with a true feeling for himself (a less exaggerated one), several more masterpieces while avoiding serious criticisms.[19]

16 Hippolyte Flandrin (1809–1864), painter of rather anemic religious murals and easel paintings.

17 Auguste Comte (1798–1857), French mathematician and philosopher, founder of positivism, one of the most influential doctrines of the 19th century. Etienne Vacherot (1809–1897), an anti-idealist French philosopher, author of *Metaphysics and Science* (1858), *Democracy* (1859) and *Religion* (1868), who opposed the world of reality to the idea of other-worldly perfection and maintained that God was simply an ideal created by the mind of man.

18 Both Dr. Franz Joseph Gall (1758–1828) of Vienna and his assistant, Johann Kaspar Spurzheim (1776–1832), formulated and developed a system of phrenology. Johann Kaspar Lavater (1741–1801) was a Swiss mystic, theologian, and world-renowned physiognomist whose work influenced many poets, painters, and thinkers. These pseudosciences were still quite respectable in Proudhon's time.

19 P.-J. Proudhon, *Du principe de l'art et de sa destination sociale* in *Oeuvres complètes de P.-J. Proudhon*, ed. C. Bouglé and H. Moysset (Paris: Marcel Rivière et Cie, 1939), pp. 171, 186, 194, 196–197, 228–229. Reprinted by permission of the publisher.

THÉOPHILE THORÉ: 1807–1869

Courbet and Millet

In praising the work of Courbet and Millet in his Salon *of 1861,*
Thoré clearly sets forth his own ideals in art: a feeling for nature and a
personal style are necessary; elevation of subject is unnecessary and even
detrimental to the painter who wishes honestly to create an art of his own
time. For Thoré, at least by this stage in his career, a truly social art is not
necessarily one with an overtly proselytizing or propagandistic theme, but
rather one in which the artist's natural responses to the landscape and hu-
man beings around him find their fullest and most individual expression.

There are two master painters in the Salon of 1861. Let us recognize
them at once, without further ado, and consider them separately from the
others.

One can be more or less in sympathy with the works of Millet and
Courbet; one can approve or disapprove of the subjects they choose; no
matter at what level one classifies them, they are real artists and even
masterly in their style.

In the case of these two painters, all the affectations, reticences, and
evasions of criticism are unimaginable, inappropriate. They have experi-
ence, it must be admitted; they cannot be reproached for drawing, color,
or effect; they carry out the work with a knowledgeable certitude; approxi-
mations are not for them. Their mistake is perhaps to show nature with
too much reality; but why don't they treat ingratiating subjects? Yes, their
pictures are the best painted in the Salon. But M. Courbet is a realist! M.
Millet a realist! Curses! . . .

What constitutes a master? An original feeling for nature and a per-
sonal execution are necessary at the same time. When a painter has these
two qualities, even if he applies them to the most inferior objects, he is a
master of his art and in his art. Murillo,[20] in his *Young Beggar,* is as much
a master as in his *Assumption of the Virgin.* Brouwer [21] or Chardin paint-
ing pots are as much masters as Raphael painting madonnas. Actually,
Raphael, tormented by the highest aspirations of humanity, is a genius of
a different order than Brouwer, surely incapable of creating the *School of*
Athens. But the sparrow must be accepted as well as the eagle.

[20] Bartolome Esteban Murillo (1618–1682), Spanish painter famous both for re-
ligious works and rather sentimental genre and low-life scenes, greatly admired by the
Realists.
[21] Adriaen Brouwer (1605–1638), Flemish genre painter, specializing in scenes of
smoking and carousing in taverns.

To be a master is to resemble no one. Otherwise one is only the pupil or the follower of someone else. Among the masters which the generation of 1830 produced, whom does Decamps resemble? and whom does Théodore Rousseau resemble? [22] They are themselves and don't proceed at all from another individuality; or at least their filiation is so complex that it is not directly connected to any determined paternity. Their subjects are as novel as the interpretation that they give them. And it is because they have found new aspects that they have been compelled to originality in their execution. If the landscapists had continued to erect Greek temples in Arcadian settings, they would never have needed to take up again the study of nature, to look at woods and lawns, land and water, and the variations of the sky.

In the same way, the uniqueness of Millet and Courbet, in the midst of the affectedness of contemporary artists, arises from their beginning to look at nature [which had been] deserted for vague and fallacious idealisms. In every era, the arts are always regenerated by the return to natural truth. Giotto substituted a new school for the old Byzantine schools by making himself a naturalist.

In certain—immoral—moral periods, the renewal can only take place by heroic efforts. A little savagery, or rather, barbarity, is not at all ill-suited to decadent periods. When the Roman empire was dying of consumption, the Northern barbarians often came to awaken it from its lethargy. Art is sick in France, and does not like these country doctors who come with solid recipes and unshakeable health. Where do they come from? Well, they come from the forests and mountains. Millet lives among the boulders of Fontainebleau and Courbet in the gorges of the Jura. That is why they don't have the same taste as the charming artists who paint with pink in the midst of boudoirs.

The decline of contemporary art is favored and perpetuated by a sentimental criticism which barks at the moon. The well brought-up critics love subjects that lend themselves to the ideal, to poetry, to a pretentious or delicate literature: *Virgins of Lesbos, Aspasie* or *Phryne,* the *First Discord, Nymph Carried off by a Faun,* etc. What a beautiful figure a *Stone-Breaker* or a *Sheep-Shearer* must make among these virgins, these nymphs, and these courtesans! And how can one allow these vulgar personages in the noble domain of art! O, Italy! Italia! Italia! and the public, naturally sensitive, shares these susceptibilities of criticism. It accepts monsters with goats' feet who carry off completely naked fat women, but it does not want to see the garters of the girls of the Seine.[23] It has adored

22 Alexandre-Gabriel Decamps (1803–1860), the best known of the romantic orientalist painters; Théodore Rousseau (1812–1867), leading figure of the Barbizon School of landscape painters, greatly admired by Thoré for his natural yet deeply felt treatment of forest scenes, especially those around Fontainebleau.

23 A reference to Courbet's controversial painting which had appeared in the 1857 Salon, *Les Demoiselles des bords de la Seine.*

the madonna with her little Jesus for centuries, but it is not interested in a peasant who nurses her child. . . .[24]

JEAN-FRANÇOIS MILLET: 1814–1875

A Letter to Thoré

Jean-François Millet, son of a Norman peasant, like Courbet turned to rural life and the peasantry for his inspiration; far calmer, less pugnacious, and more fatalistic than his fire-eating contemporary, he was also far better educated than the latter, well versed in the classics and Western literature in general. Though humanitarian in his views and briefly swayed by the passions of the 1848 Revolution, Millet was generally detached in his political outlook; nevertheless, the very fact that he painted peasant subjects with sympathy and often endowed farm workers with Michelangelesque dignity was enough to make Millet appear a dangerous revolutionary in the eyes of bourgeois public and critics. As such, his name was often coupled with Courbet's. Unlike Courbet, however, his works often seem to preach some sort of moral sermon about the superiority of the poor and humble and their ceaseless, uncomplaining labor.

This letter was written to the critic, Théophile Thoré, who wanted to prepare an article on the works of Millet exhibited at Martinet's gallery. Thoré had already commented very favorably on the three paintings by Millet that had appeared in the Salon of 1861: the Woman Shearing Sheep, Woman Feeding her Child *and* Waiting (Tobias and his Wife).

BARBIZON, FEBRUARY 18 [1862] [25]

MY DEAR THORÉ:

Since you are willing to concern yourself with my paintings on exhibition at Martinet's, I should like to tell you a bit about the idea which led me to do them. You will decide whether there is anything to be drawn from these notes. First of all, I should tell you that I try to express a rustic feeling in what I do; that my motto is: *rus!* [26]

In the *Woman Returning from the Well* I tried to make it impossible for one to take her either for a water-carrier or for a servant, but

[24] Théophile Thoré (W. Bürger, pseudonym) "Salon de 1861," first published in *Le Temps,* reprinted in *Salons de W. Bürger, 1861 à 1868,* pref. by T. Thoré (Paris: Librairie de Vᵉ Renouard, 1870), I, 91–94.

[25] Both Robert Goldwater and Marco Treves in *Artists on Art,* 3rd ed. (New York: Pantheon Books, 1964), p. 291 and Richard Friedenthal, *Letters of the Great Artists: From Blake to Pollock* (New York: Random House, 1963), p. 110, suggest a date of about 1860 for this letter.

[26] "The country" (Latin).

rather to show: that she had just drawn water for home use, water to make soup for her husband and children; that she was carrying a weight neither heavier nor lighter than the full baskets; that through the kind of grimace which is, so-to-speak, imposed by the weight pulling on her arms and the narrowing of her eyes caused by the light, one might surmise an expression of rustic goodness. I avoided, as usual, with a kind of horror, any suggestion of sentimentality. On the contrary, I wanted to show her going about a daily task, the habit of a lifetime, along with other household tasks, in simplicity and good humor, without considering it a burden. I wanted to convey an idea of the coolness of the well and to show by its ancient appearance that many women had come there before her to draw water.

In the *Sheep which Have Just Been Sheared* I tried to express that kind of bewilderment and confusion which sheep feel when they have just been clipped, and also the curiosity and stupefaction of those who have not yet been sheared when they see such naked creatures come back among them. I tried to make the dwelling place convey a peaceful and rustic air and to suggest that behind it is the little field where the poplars are planted which give it shade; finally to suggest that all this was begun long enough ago for generations to have lived there.

A *Woman Giving Lunch to her Children.* I wanted it to be like a brood of fledglings fed by their mother. The man works to feed this brood.

Then, in case you think it necessary to mention it, I like to make things look not as though they were brought together at random and for the occasion, but as though they had an indispensable and necessary bond amongst themselves, and that the beings I represent look as though they are pledged to their positions, so that it would be impossible to imagine that they could be different; in short, that people or things must always be there for some purpose. I want to show fully and forcefully what is necessary, but I profess the greatest horror for useless things and "fillers," which can only result in weakness.

I don't know whether there is anything useful in what I have just told you, but there it is anyway.

I send you a good handshake, my dear Thoré, with wishes for good health.

J.-F. MILLET [27]

First Thoughts for the Letter to Thoré

In the notes for or first draft of the preceding letter to Thoré, Millet exhibits a charming ingenuousness, a directness of feeling, and freshness of language not so apparent in the more self-conscious final letter itself.

27 Jean-François Millet in Etienne Moreau-Nélaton, *Millet raconté par lui-même* (Paris: Henri Laurens, 1921), II, 106–107. Reprinted by permission of the publisher.

It must, of course, be remembered that Millet was one of the most culti-
vated and best-read artists of his time, one who could quote from La
Fontaine, Burns, Milton, Dante, Shakespeare, the Bible, Theocritus, or
Virgil, and by no means an ignorant peasant, as the legend would have it;
nevertheless, he had a certain amount of difficulty getting his thoughts
about his paintings into coherent form. As he himself said in the same
letter: "What is sadder than talking art?"

It is not so much the things represented that create the beautiful as
the need one had to represent them, and the need itself created the degree
of power with which the task was carried out. One might say that every-
thing is beautiful, provided that it comes in its time and place; and, on
the contrary, that nothing can be beautiful which comes at the wrong
time. You can certainly praise someone for the beauty of her hair, but you
would have difficulty submitting to the same admiration for a lock of the
very same hair if you found it in your soup. . . . The beautiful is that
which is appropriate.

The Return of the Sheep to their Fold.—As soon as the little noises
of this last activity of the day are over, everything should remain calm
and silent. I would like to create anticipation of the peaceful reign of the
star called by country folk "the foxes' sun," and give my picture such an
appearance that you could hear the night noises in your imagination:
the choir of frogs and the distant barking of the farm dog; finally, to ex-
press the reign of silence. And, once more (I hold fast to it), I want my
moon to be "the foxes' sun."

A Peasant and his Wife Planting Potatoes.—Since their field is quite
far from the village, they could not dare to leave their child alone in the
house. They settled him in one of the donkey's baskets with the rest of
the load, and once arrived, put him in the shade of the apple tree, in the
basket in which he traveled. Then they covered him with the father's
jacket. The donkey, too, had to be tied up in the shade. I wanted to be
able to make the manner of work of these two intimately associated crea-
tures moving and to show that their two activities are so much in accord
that they are but a single effort. Apropos: why should the activity of the
potato or bean planter be less interesting or less noble than any other
activity? Let it be understood that nothing is noble or low except the
manner of understanding or representing things, not the things them-
selves. How many examples one could quote to support this!

The Impatience and Uneasiness of Waiting.—The sun has just set
again, yet no one comes! What could he be doing? If only nothing has hap-
pened to him! They cannot hold back any longer. They go off together,
but when they get to the street, the mother cannot help moving away a
little from the blind man, who nevertheless tries to step down from the
threshold, groping in the manner of the sightless. She, however, is afraid

to go too far from him. With her eyes, at any rate, she searches the road, which remains empty and cheerless. Worry has entered the house. Poor old folk, how sadly you will return! Let us admit that these people are the old Tobias and his wife; can their story be represented from any other viewpoint but that of human feelings? [28]

The "Man with the Hoe"

In this letter to his friend and biographer, Alfred Sensier, Millet states his position about the Man with the Hoe, *one of the most famous and, at this time, controversial paintings of the 19th century, and one of the* causes célèbres *of the Salon of 1863. It was considered an inflammatory "socialist" work, and the peasant was mockingly nicknamed "Dumoulard" after a peasant who had murdered the family of his employer. What most people failed to see was Millet's almost classical sense of the essential and eternal man of the soil inherent to the generalization and broad handling of his specific subject. The sense of resignation of this toiler, the melancholy, fatalistic overtones of the work convey a moral message quite different from the matter-of-fact objectivity of Courbet in his* Stone-Breakers, *for example.*

BARBIZON, MAY 30, 1863

The rumors about my "Man with the Hoe" still seem very peculiar and I am grateful to you for passing them on, since it gives me a fresh opportunity to wonder at the ideas attributed to me. In what club have my critics ever met me? Socialist! But really, I might well reply in the words of the countryman answering a charge made against him in his native district, "Folk in the village do be saying I be a Saint-Simonist; it bean't true, I doan't know what that be."

Is it impossible simply to recognize that certain ideas may enter one's mind at the sight of a man destined to earn his living by the *sweat of his brow?* Some people tell me I deny the charms of the countryside; I see far more in it than charm, I see infinite splendors. I see, just as they do, the little flowers about which Christ said "Verily I say unto you that Solomon in all his glory was not arrayed like one of these."

I see very clearly the haloes of the dandelions, and the sun, far away beyond the villages, suffusing the clouds with its glory. But I also see the steaming, straining horses on the plain, and the stony place where a man has been toiling and panting since morning, and now tries to straighten up for a short breather. The action is shrouded in splendors.

I have not invented all this; the expression "the earth groans" is an old one.

My critics are, I suppose, men of learning and taste; but I cannot put myself in their shoes, and as all my life I have seen nothing but fields, I

28 *Ibid.,* pp. 110–111.

do my best to tell what I saw and felt when I was working there. There is plenty of opportunity for those who would like to do better, of course.[29]

Theocritus and Burns

Millet's familiarity with, and admiration for, ancient and modern writers is brought out in this passage from a letter of July 20, 1863, to Michel Chassaing, a young man who had introduced the painter to the two poets he discusses.

Reading Theocritus proves to me more and more that one is never more Greek than when one uses completely naïvely the impressions one has received, no matter where one has received them. And Burns proves this to me, too. This puts me even more keenly in the mood for carrying out certain things from my own place, from the place where I have lived. . . . [Theocritus] has a naïve and peculiarly winning charm which is not found to the same degree in Virgil.[30]

THÉOPHILE THORÉ

On the "Salon des Refusés"

The year 1863 might well serve as the dividing line between the past and the present in the French art world. In this year complaints and indignation on the part of artists against the prejudice, pettiness, and injustice of a particularly harsh Salon jury came to the attention of Emperor Napoleon III himself; the Emperor took the unprecedented step of authorizing a second Salon to exhibit the works rejected by the official one. This "Salon des Refusés" [Rejected Ones] was considered a kind of circus or side show by the public and an occasion for facile mockery by conventional critics; it certainly must have included many crude, incompetent works and a good proportion of third-rate, academic pot-boilers. Nevertheless, the Salon des Refusés was of the utmost importance for the future of art in France in that it gave encouragement to artistic relativism, broke the absolute authority of the Ecole des Beaux-Arts, the Academy, and the official Salon, and established the right of painters to paint as they pleased and to exhibit what they pleased; it also was noteworthy in that it contained three paintings by the young Edouard Manet (1832–1883), the most ambitious of which, the famous Déjeuner sur l'Herbe, created a scandal. For Thoré's opinion of Manet himself, see below, pp. 68 to 69.

[29] Jean-François Millet in Richard Friedenthal, ed., *Letters of the Great Artists: From Blake to Pollock,* trans. Daphne Woodward (New York: Random House, 1963), pp. 112–114. Reprinted by permission of the publisher.

[30] Jean-François Millet in Moreau-Nélaton, *Millet,* II, 145.

The salon of the *Reproved* as they are called has taught us much more than the salon of the *Elected.* . . .

When one casts an eye around the galleries where the refused paintings are admitted—first separating from the group those which were probably rejected by chance, then a certain number of ridiculous colored prints, like the species of horses by a student of M. Yvon,[31] the painter of Imperial Battles—one notices, on consideration, that the major portion of the reproved paintings has a certain analogy in initial conception and in brushwork, an eccentricity whose characteristics are similar. A naïve foreigner who visited the salon of the Reproved, thinking himself in the official Exhibition, would doubtless believe that the French school is moving, with an apparent unity, toward the reproduction of men and of nature, such as they are seen, without preconceived ideal, without fixed style, without tradition, and also without personal inspiration. It seems that these artists are taking art back to its origin, without worrying about what civilized men have been able to do before them. An exhibition of American paintings at New Orleans would perhaps offer a similar spectacle. We recall the painting of Mr. Catlin, the introducer of the Yoways to Europe.[32] At St. Petersburg the exhibitions of Russian painting can still provoke the same impressions. The people who are starting out have, in their barbarity, a certain touch of sincerity and, at the same time, a bit of burlesque and imperfection. Novelty and singularity.

French art, such as one sees it in these proscribed works, seems to be starting out or starting afresh. It is baroque and savage, sometimes exactly appropriate and even profound. The subjects are no longer the same as those in the official galleries: little mythology or history; present-day life, above all in its popular types; little effort and no taste at all: everything is revealed just as it is, beautiful or ugly, distinguished or vulgar. And [there is] a method of working altogether different from the working methods consecrated by the long domination of Italian art. Instead of searching for the contours, what the Academy calls *drawing,* instead of insisting upon the detail, what lovers of the classical call *finish,* they aspire to render the effect in its striking unity, without worrying about the correctness of the lines or the minutiae of the accessories.

It must be noted that several contemporary masters, whose genius or talent have compelled public esteem after a stubborn battle—for example,

31 Adolphe Yvon (1817–1893), a painter specializing in large scale, extremely conventional battle scenes, especially of the Italian and Crimean campaigns; he was a favorite of Napoleon III.

32 George Catlin (1796–1872), an American painter who had spent eight years with Indian tribes and specialized in portraits of Indians and other scenes from their daily life.

Eugène Delacroix and Decamps, Diaz,[33] and Corot—were for a long time called in question in connection with finished *execution*. It is obvious that the admirers of Denner and of W. Mieris [34] consider broadly rendered paintings as sketches; Rembrandt and Velasquez have not been exempted from the same reproach on the part of the same *art lovers*. But this taste for the infinitely small is perhaps in contradiction with the very essence of painting which is an *artifice* very far removed from reality. Really, is it possible, is it necessary for the thousand little extrusions of bodies placed at all different distances to be indicated on that flat surface of a canvas? Let us say that painting can reveal the tiny details of a life size figure, isolated against a neutral background; but when the figure is at a distance, when the groups are more complicated, in the accessories and in the distant parts, in landscape, under the light with its gradations down to shadow, the *finish* disappears, and the artist no longer has anything to render but the general appearance, the complex image in its significant accents.

If the painters of the new generation take this direction, and if that is what makes them rejected, then they should hardly be worried about it. It is obvious that the sketches of Corot are worth more than the highly finished miniatures of M. Gérôme.[35]

As for the other point, the choice of subjects, the tendency to abandon old mythologies and old Arcadias and to adopt new symbols and contemporary characters in a real setting seems not at all reprehensible, except to the Institute. It is even good to descend, or, if you will, to rise once more to the classes that scarcely ever had the privilege of being studied and put into the light by painting, that of the Dutch school excepted. Instead of painting Apollo guarding his cows, it is more natural to paint a peasant shearing her sheep.[36] The portrait of a worker in his smock is certainly worth as much as the portrait of a prince in his golden costume. The customs of those who act and produce, who think, who love, who fight, and who suffer in their mediocrity are as interesting as the customs of useless or wicked people, whose luster is merely the result of a borrowed station in life. . . .

One must not take exception to a kind of return to nature and to humanity, if it is this that the uneasiness of art signifies, as attested to by

[33] Alexandre-Gabriel Decamps (1803–1860); see note 22 above. Narcisse Virgile Diaz de la Peña (1808–1876), member of the Barbizon School who painted gypsies and nymphs as well as sun-flecked forest scenes.

[34] Balthazar Denner (1685–1749), German painter and miniaturist, known for the meticulous exactitude of his works. Willem van Mieris (1662–1747). Dutch portraitist and genre painter who excelled in the precise rendering of silks, satins, and jewels.

[35] Jean-Léon Gérôme (1824–1904), French neo-classical painter, specializing in overrefined, chilly scenes from antiquity; winner of official honors.

[36] Thoré is here referring to Millet's painting, the *Woman Shearing Sheep*, which he himself had praised in his review of the Salon of 1861.

the attempts of many young artists. The misfortune is that they have scarcely any wit and that they despise charm. These precursors of the possible transfiguration of an old, exhausted art are, up to this point, for the most part, only inept or even grotesque. Thus they arouse the hearty laughter of the gentlemen who are well trained in sound principles. But should a few artists of genius, endowed with love of beauty and distinction, come to the same subjects with the same methods, then the revolution would be prompt. The public would be astonished at the confident admiration accorded to the nonsense that today triumphs in the official Salon, in the boudoirs, and even in wealthy galleries.[37]

[JULES ANTOINE] CASTAGNARY

1863: The Triumph of Naturalism

As early as 1863, Castagnary coined the term "naturalist" to distinguish the new generation of young painters from the older realists. Yet the major distinction was still to be drawn between the schools of the recent past—classicist and romantic—and the fresh creation of the present. Naturalism, from Castagnary's viewpoint, far from being a school with all the strictures and limitations this term implies, was simply a mode of liberation for the artist's vision and personality. In his Salon of 1868, *Castagnary further defines naturalism and sets it in an historical context: all art directly confronting contemporary life and striving to reproduce the visual material of its time honestly has been naturalist. Castagnary, in insisting upon the relativity of beauty and the necessity for turning to all aspects of the visual world without preordained system, is indeed one of the prophets of nascent Impressionism.*

What is the object of painting?

"To express the Ideal," a choir of enthusiasts will cry, "to set forth the Beautiful."

Empty words!

The Ideal is not a revelation from on high, placed before an upward-striving humanity forever obliged to approach it without ever attaining it; the Ideal is the freely conceived product of each person's consciousness, placed in contrast with exterior realities; and thus it is an individual concept which varies from artist to artist.

The Beautiful is not a reality existing outside of man and imposing itself on his mind in the form or appearance of objects; the Beautiful is

37 Théophile Thoré (W. Bürger, pseudonym), "Salon de 1863," *Salons de W. Bürger, 1861 à 1868,* pref. by T. Thoré (Paris: Librairie de Vᵉ Jules Renouard, 1870), I, 411, 413–416.

an abstract abbreviation, beneath whose label we group a host of different phenomena that act upon our organs and intelligence in a certain way; thus, it is an individual or collective concept which varies, in a given society, from epoch to epoch, and, within an epoch, from man to man.

Let us get down to earth, where the truth is.

The object of painting is to express, according to the nature of the means at its disposal, the society which produced it. This is the way a mind free from the prejudices of education should conceive of it; this is the way the great masters of all times have understood and practiced it. Society is actually a moral being which does not know itself directly and which, in order to become conscious of its reality, needs to externalize itself, as the philosophers say, to put its potentialities in action and to see itself in the general view of their products. Each era knows itself only through the deeds it has accomplished: political deeds, literary deeds, scientific deeds, industrial deeds, artistic deeds, all of which bear the stamp of its own particular genius, carry the imprint of its particular character, and distinguish it at once from the previous era and the era to come. As a result, painting is not at all an abstract conception, elevated above history, a stranger to human vicissitudes, to the revolutions of ideas and customs; it is part of the social consciousness, a fragment of the mirror in which the generations each look at themselves in turn, and as such it must follow society step by step, in order to take note of its incessant transformations. Who would dare to say—given the fact that each civilization, and within each civilization, each era, has left behind its image on the canvas and revealed in passing the secret of its genius—that we shall not eventually have within the total extension of time all the successive aspects that humanity presents to art, and that the destiny of painting will not be fulfilled?

Having made this first point about the destination of painting, at what point are we in France, at the present moment, as far as its realization is concerned?

I cannot hide the fact that I am in almost complete disagreement with my best friends and colleagues in criticism. Where the latter bewail decadence, I, for the same reasons, affirm progress. My pen, therefore, must not falter, and I must set forth my idea clearly.

No matter how radical and profound may be the difference separating our artists among themselves and no matter how vigorous that precious individuality which they all nowadays affirm and cherish, one may, without doing excessive violence to temperaments and tendencies, divide all the painters into three main groups: the classicists, the romantics, and the naturalists.

The classicists, followers of Louis David, their St. John the Baptist, and Ingres, their messiah, propped up to the left by the Ecole des Beaux-Arts and to the right by the Ecole de Rome, possessing in addition the

protection of power, rewards, and commissions, do not seem ready, despite the reiterated warnings of public opinion, to retreat and give up the game.

The romantics—decimated by death, abandoned by literature which had borne them so high in the past and which now devotes itself to other glorifications, discouraged by the general defection of minds, shaken in their own values—have become silent, and already dream of that capitulation which would force them forth with their arms and equipment from a position they can no longer defend.

The naturalists, young, ardent, convinced, heedless of blows given or blows received, rise to the assault on all sides; and already their venturesome heads appear on all the summits of art.

Two schools threatened, one school invading: this is the situation of the position we have come to inspect. In the Salon of this year, the three flags are still present. Let us salute the past and the present in them, and before proceeding to the enumeration of forces, let us elaborate a little on the characteristics that differentiate each army.

Classical school, romantic school, naturalist school: all three are in agreement about the point of departure: nature is the basis of art.

Only,

The classical school asserts that nature should be corrected by means of the indications supplied by antiquity or the masterpieces of the Renaissance. It is disturbed and frightened by reality. Under the pretext of purifying and idealizing reality, it weakens or deforms it; it is always a case of diminution, even if it is not always one of pure convention.

The romantic school asserts that art is free; that nature should be freely interpreted by the liberated artist. It is not afraid of reality, but escapes it in travestying it—according to the whims of imagination. It is always an approximation, when it is not just somnambulism.

The naturalist school asserts that art is the expression of life in all forms and on all levels, and that its sole aim is to reproduce nature by bringing it to its maximum strength and intensity: it is truth in equilibrium with science.

Such are the directions, such are the results.

The classical school, with its elevated ideal, its fastidious choice of models, its constant striving for noble drawing, has kept the dignity of French art pure. But, by having imposed stilted poses and traditional forms on the groups and combinations of groups presented by the external world; by having neglected color, which, of all the elements of painting, is the one that gives the most immediate sensation of life [the classical school] has suppressed the spontaneity of the artist, petrified the imagination, blighted naïveté and grace, those two wings of genius, achieved immobility and coldness in all its productions, and finally ended up with the very negation of its principle and its aim.

The romantic school, with its unreflecting individualism, its exclu-

sive preoccupation with color, its ophthalmic disorders; its multiple in-cursions into the literary domain, has thrown art off its course and led it to chaos, to anarchy. With its adoration of the accessory—furniture, weapons, costumes, old knickknacks, and bric-à-brac—with its subjugation of the figure to the picturesque effect [the romantic school] has created a class of superficial and hot-headed art lovers whose fatal influence has not yet been exhausted, and has opened the door to the most shameless com-mercialism; and it is to this [school] that the chief causes for the debase-ment of painting during the last twenty years must be laid.

The naturalist school reestablished the broken connections between man and nature. In a double effort—on country life, which it already in-terprets with such rustic power, and on city life, which still holds in re-serve this [school's] greatest triumphs—it strives to celebrate all the forms of the visible world. Already [the naturalists] have brought line and color, for this school no longer separable, back to their true roles. By putting the artist back into the midst of his era, with the mission of re-flecting it [the naturalists] determine the true utility, and in consequence, the morality of art. These few words suffice to give us confidence in its destiny. That which neither the artistic eccentricity of the Valois, nor the refined taste of the Medicis, nor the ostentatious aspirations of Louis XIV, nor the burdensome protection of centralized powers was capable of giv-ing us up to the present day, the development of liberty and the awaken-ing of decentralizing instincts alone will produce among us.

For the first time in three centuries, French society is on its way to producing a French painting that may be made in its own image, and no longer in that of long dead peoples; that describes its own appearances and customs and no longer those of vanished civilizations; that, finally, in all its aspects, bears the imprint of its own luminous grace, and lucid, penetrating, clear spirit.

May [French painting] in several hundred years become equal, in the eyes of posterity, to Spanish painting, so energetic and ferocious, to Dutch painting, so intimate and everyday, to Italian painting, the purest, the most harmonious, the most influential that ever flourished beneath a beautiful sky! . . .[38]

1868: Naturalism Further Defined

The word *naturalism*, which I use to define the tendencies of today, is not new in the history of art, and it is one of the reasons that makes it preferable to the word *realism*. Each time we encounter a nation, or, with-in a nation, a group of men taking the interpretation of surrounding life as the immediate object of painting, and striving to make a visual repro-

[38] [Jules Antoine] Castagnary, "Salon de 1863," originally published in *Le Nord* of Brussels, 1863, then reprinted in *Salons (1857–1870)* (Paris: Bibliothèque-Charpentier, 1892), I, 102–106.

duction of society in its natural setting, that art has been, that art is—called naturalist. Naturalism is, actually, characteristic of art during the major part of modern times. It was through naturalism that confidence arose: in Florence, when Cimabue, leaving behind the traditional cartoons of his predecessors, took it into his head to have a living person pose before his easel and chose a young girl from his neighborhood as model for his madonnas; in Venice, when the glorious republic commissioned the reproduction of its battles and victories on the walls of the Ducal Palace,[39] thus consecrating the most national of its monuments to the national glory; in Bruges, when the two Van Eycks, under the pretext of a religious legend, painted the people of their times and surrounded them with rural vistas borrowed from the soil of Flanders; [40] in our French communities, when, before those shipments from Italy which were to bring us Primaticcio and the fatal school of Fontainebleau,[41] unknown initiators strove to represent the people, the costumes, and the customs they had before them. I do not mention Spain, where, so to speak, art never had a youth, and entered immediately into its majority with the great naturalists: Velasquez, Zurbaran, Ribera. And not only is naturalism found at the point of departure, but it is met with all during the course of the journey. It accompanies painting and follows in the entire unfolding of its ascending period. It is naturalism that inspires painting, supports it or fertilizes it everywhere. It is like painting's vital force, conserving and at the same time developing it. From [naturalism] painting derives its major and best developments. In the countries where [naturalism] dies out [painting] dies, as in Italy, where, after Titian and Veronese, no one remains; or else [painting] abdicates, as in France, where for two hundred years, from François Clouet to Louis David, French painting was forgotten in favor of Italian painting. In the countries where [naturalism] persists [painting] produces an uninterrupted harvest of flowers, as in the Low Countries, where it manages to give such a faithful picture of the inhabitants, costumes, and customs, that Mr. Alfred Michiels, their historian, has been able to write: "If this race perished tomorrow, we should rediscover it in its totality in the products of its brush." And this is what made me say at the beginning of this *Salon* that, for us, to enter into naturalism is to return to the true tradition of our national art and of the art among all peoples.

39 Castagnary is probably referring to the series of murals created for the Sala del Gran Consiglio of the Ducal Palace by such artists as Jacopo Tintoretto, il Fiammingo, Domenico Tintoretto, Paolo Veronese, Francesco Bassano, Palma il Giovane, and others.

40 A reference to the famous *Ghent Altarpiece* (1432) by Jan and Hubert Van Eyck.

41 The Italian artist, Primaticcio (1504–1570), a painter with an extremely elegant, overrefined, artificial mannerist style, was summoned to France in 1531 by François I to decorate the palace of Fontainebleau, and exerted a powerful anti-naturalist influence upon French art.

I was wrong, then, submitting to customary phraseology, to apply the title of a school to naturalism. A school is a body of dicta, a private system of expression, a convenient and arbitrary manner of seeing, feeling, or executing. Classicism, which lives on mythology and allegory, manipulating both the countryside and the human form, correcting the one with Poussin and the other with Raphael, is a school. Romanticism, which illustrates poets, exhumes the Middle Ages, restores bric-à-brac, does up the old armor, and concocts artificial stews of color, is a school. Naturalism, which accepts all the realities of the visible world and, at the same time, all the ways of understanding these realities, is exactly the opposite of a school. Far from tracing a limit, it suppresses the barriers. It does not offer violence to the temperament of painters, it frees it. It does not chain up the personality of the painter, it gives it wings. [Naturalism] says to the artist: Be free! Nature and life, which are the eternal raw materials of all poetry, stretch out about you. Go, and come back to show other men what you have found there. You all live on the same clod of earth, at the same moment of time, and you are all the same thing. But *yours* is a deeper and clearer mirror, which perceives objects better; your art is a condenser that seizes and renders palpable the most fleeting sensations. It is for you to write the poem of the eyes and put into relief the beauties which, busy or indifferent, they would have passed over without seeing. Go, and let the truth which is their [the eyes'] sole requirement be your only law as well. If the fields, if humanity, in the infinite variety of their combinations, do not offer a theme vast enough for your genius, and you feel the need to invent, to imagine, to compose, then compose—I am willing—but compose with such accents of reality and life that each person is fooled by it and, taking your work for a copy of nature, cries: What sincerity!

Casting off schools, fleeing systems and preconceived notions, striving to make from immediate things simple, clear art, intelligible even to the most humble, naturalism spurns all that is obscurity, remoteness, enigma—that is to say, everything which addresses itself to the few.[42]

EDOUARD MANET: 1832–1883

Théophile Thoré: An Appreciation of Manet in the 1868 Salon

Théophile Thoré, who had previously defended Millet and Courbet, now turns to the defense of still another painter whose work, although appreciated by a small group of art lovers and critics, was being subjected to critical virulence and public mockery: Edouard Manet (1832–1883). Thoré's critical acumen is revealed not only in his generally positive re-

[42] [Jules Antoine] Castagnary, "Salon de 1868," originally published in *Le Siècle* and reprinted in *Salons*, I, 289–292.

action to the Olympia *(c. 1863) and the* Portrait of Zola *(1868), but even in his reservations about Manet's style: Manet's painterly "pantheism," as Thoré terms it, in which all elements of the painting are established as equal in visual value, is the artist's major failing, according to this humanitarian advocate of "art for man." Yet even in raising this objection and specifying what it involves, Thoré has brought out one of the most important innovations of Manet, and later of the Impressionist movement in general.*

I venture to say that M. Edouard Manet sees very well. It is the most important quality in a painter. To tell the truth, one must have still other qualities in addition to that one. Manet sees color and light, after which he no longer worries about the rest. When he has made the "spot of color" on his canvas that a person or an object makes on the surrounding environment, he feels that this is sufficient. Don't ask anything else of him—for the moment. He will doubtless work this out for himself later, when he thinks of giving the essential parts of beings their relative values. His present vice is a sort of pantheism in which a head is esteemed no more than a slipper; in which sometimes more importance is given to a bouquet of flowers than to the physiognomy of a woman, for example in his famous painting of the *Black Cat;* [43] in which everything is painted almost uniformly: the furniture, the rugs, the books, the costumes, the flesh, the accents of the face; as, for example, in his portrait of M. Emile Zola, exhibited in the present Salon.

This portrait of our colleague Zola, who writes on art and literature with a lively independence, has nevertheless triumphed over the animosity of "delicate souls." It has been found neither too unseemly nor too eccentric. It has been conceded that the books—above all, a wide-open book of engravings—and other objects covering the table or hung on the wainscoting were of an astonishing reality. Certainly the execution is frank and generous. But the principal merit of the portrait of M. Zola, like that of the other works of Edouard Manet, is the light that circulates within that interior and distributes three-dimensionality and depth everywhere.

This impalpable air, as we remarked a little while ago, is also present in the portrait of a young woman in a pink dress, standing next to a beautiful grey parrot, roosting on its perch.[44] The soft pink dress harmonizes delightfully with a delicate pearl-colored background. Pink and grey and a little touch of lemon at the base of the perch: that is all. One scarcely pays attention to the head, although it is full face and in the same light as the pink material. It is lost in the modulation of coloring.[45]

43 A reference to Manet's *Olympia*.

44 *The Woman with the Parrot* (1866) was in the Salon of 1868 and is now in the Metropolitan Museum in New York.

45 Théophile Thoré (W. Bürger, pseudonym), "Salon de 1868," *Salons de W. Bürger, 1861 à 1868*, pref. by T. Thoré (Paris: Librairie de Ve Jules Renouard, 1870), II, 531-533.

Emile Zola: A New Style in Painting

The famous naturalist writer Emile Zola (1840–1902) had been interested in art since his boyhood in Aix, where he had not only been a close friend of the young Paul Cézanne, but had also been one of a group of young art lovers; his interest in painting lasted throughout his whole life. It was Cézanne who first introduced his friend to the young painters of the "Batignolles group," as they were called in the early 1860s before they began to attract notice as the "Impressionists." Pissarro, Monet, Degas, Renoir, Fantin-Latour and, of course, Manet, to whom Zola was to devote most of his critical studies, made up this group; the model for the artist-hero of Zola's novel Claude Lantier was probably based chiefly on Manet.

In 1866 Zola's Salon, which had appeared serially under the name of "Claude" in the Evénement, unleashed a storm. Starting out with a scathing denunciation of the jury, he had gone on to devote an entire laudatory article to the work of the young Edouard Manet, whose two entries for the Salon, The Fifer and the Portrait of Rouvière (The Tragic Actor), had both been rejected by the jury, and whose Olympia had raised such a scandal in 1865. By 1867 Zola had established a close relationship with Manet, and in the spring of that year he began negotiations with Lacroix for a new edition of the Contes à Ninon to be illustrated by Manet—a project that failed to materialize. In 1868 the painter completed the famous Portrait of Zola, now in the Louvre, depicting the writer at his desk surrounded by his books, papers, Japanese prints, and, prominently displayed on the wall, a reproduction of the Olympia.

It was in 1867 that Zola developed his little article on Manet from his Salon of 1866 into a longer, more detailed appreciation. In the beginning of the year he prevailed upon Arsène Houssaye, director of the Revue du XIXᵉ Siècle, to accept about twenty pages devoted exclusively to Manet, which were published several months afterward by Dentu as a sort of publicity brochure for the private exhibition that Manet had opened in May on the Place de l'Alma, as Courbet had done in 1855. Edouard Manet, a Biographical and Critical Study, as the brochure was entitled, was received with customary sarcasm by the press, and with encouraging response only from Champfleury and Sainte-Beuve.[46]

While, in a sense, Zola goes too far in equating Manet's style with his own efforts as a novelist, he nevertheless was unique among contemporary critics in his extraordinary open-mindedness and sensitivity to and acceptance of the purely pictorial values of Manet's paintings. His choice of words and descriptive phrases often matches, in its delicately nuanced precision and eloquent restraint, the pictorial style of Manet. Zola cor-

[46] This essay was reprinted with certain minor variations and omissions in the collection of Zola's criticisms, Mes Haines (1879).

*rectly saw Manet as "a child of our times," although perhaps his equation
of the artist's striking contemporaneity with similar directions in science
is exaggerated, the result of the writer's own theory of "scientific method"
which he had found in Claude Bernard's* Introduction to the Study of
Experimental Medicine *(1865) and which made such a profound impres-
sion on his own work. All in all, Zola's is the most significant contempo-
rary criticism of Manet. With truly prophetic insight and the same brash
courage in the face of antagonism that motivated his defense of Dreyfus
at the end of the century, Zola proclaimed in 1866, when Manet was still
virtually a laughing-stock: "The place of M. Manet is marked out at the
Louvre, like that of M. Courbet. . . ."*

A Description of Manet

Edouard Manet is of middle height, short rather than tall. His hair
and beard are of a pale chestnut color; his eyes, narrow and deep, have a
youthful liveliness and fire; his mouth is characteristic: thin, mobile, a
bit mocking at the corners. His whole face, in its delicate and intelligent
irregularity, indicates flexibility and daring, a disdain for silliness and
banality. And if we descend from the face to the person himself, we find
in Edouard Manet a man of exquisite civility and politeness, distinguished
in bearing and sympathetic in appearance. . . .

. . . Edouard Manet is a man of the world, in the best sense of this
term. Three years ago he married a young Dutch woman, a musician of
great talent, and thus he lives the life of a family man, at the heart of a
happy desert, where the cries of the crowd can never reach him. There he
finds relaxation in affection and in the little pleasures of existence, for
heaven has been generous and has not wished to deprive this pariah of the
comforts of wealth: the artist is rich enough to accept his role of leper and
work according to his convictions, without heeding the advice of art
dealers.

He has admitted to me that he adores the world and that he finds
secret delights in the fragrant, glowing refinements of evening parties. He
is doubtless attracted to them by his love for bold, lively colors; but there
is also deep within him an innate need for distinction and elegance that
I undertake to rediscover in his works. . . .

Characteristics of Manet's Style

I accept all works of art in the same way—as manifestations of human
genius. And they interest me almost equally; they all possess true beauty:
that of life, life in its thousand expressions, ever changing, ever new. The
ridiculous general standard no longer exists; the critic studies a work for
itself and declares it great when he finds within it a powerful and original
translation of nature; he then affirms that another page has been added

to the Genesis of human creation, that an artist has been born who gives nature a new soul and new horizons. And our creation stretches from the past into the infinite future; each society will contribute its artists who, in turn, will contribute their personalities. No system, no theory can confine life in its ceaseless fecundity, and our role, as judges of art works, is limited to ascertaining the language of temperaments, studying these languages, and stating what they contain of flexible, energetic novelty. Philosophers may have the responsibility of establishing formulas, if this be necessary. I only want to analyze the facts, and works of art are simple facts.

Thus, I have put aside the past; I have neither ruler nor standard in my hands, and I stand before the paintings of Edouard Manet as though before new facts that I wish to explain and comment upon.

What strikes me first in these pictures is an extremely delicate exactitude in the relation of the tones to one another. Let me explain: some fruits are placed on a table and stand out against a grey background. There exist among the fruits, depending upon the degree to which they come forward, values of coloration forming a whole scale of hues. If you start with a note that is lighter than the real note, you must follow a scale which is consistently lighter; and the contrary must take place if you start off with a darker note. This, I think, is what is called the law of values. In the modern school, I scarcely know anyone, except Corot, Courbet, and Edouard Manet, who has constantly obeyed this law in figure painting. The works thereby gain a singular clarity and a great honesty and charm of appearance.

Edouard Manet generally starts off from a note which is lighter than its counterpart in nature. His paintings are blond and bright with a solid, firm paleness. The light falls, white and full, illuminating the objects gently. There is not the slightest forced effort; figures and landscapes bathe in a sort of delicate, gay brightness that fills the whole canvas.

What strikes me next follows as a necessary consequence of the exact observation of the law of values. The artist, before no matter what subject, lets himself be guided by his eyes, which perceive this subject in large areas of interdependent hues. A head placed against a wall is nothing but a more or less white spot against a more or less grey background, and the clothing juxtaposed to the face becomes merely a more or less blue spot placed next to the more or less white spot. From this results an extraordinary simplicity—almost no details at all—an ensemble of precise and delicate spots, which, from several feet away, gives the painting a striking sense of depth. I stress this characteristic of the works of Edouard Manet, for it is the dominant one and makes them what they are. The whole personality of the artist consists in the way his vision is organized: he sees blond; he sees in masses.

What strikes me in the third place is a slightly dry but delightful

charm. But don't misunderstand. I am not talking about that pink and white charm of china-dolls' heads; I am talking about an incisive and truly human charm. Edouard Manet is a man of the world, and there are in his paintings certain exquisite lines, certain frail and attractive postures which bear witness to his love for the elegance of the salon. This is the unconscious element, the very nature of the painter. And I will use this opportunity to protest against the relationship that has been asserted between the paintings of Edouard Manet and the poems of Charles Baudelaire. I know that a lively sympathy has brought the poet and the painter together, but I think that I can affirm the latter has never made the blunder, committed by so many others, of wanting to put ideas in his painting. The brief analysis which I have just given of his talent proves with what naïveté he places himself before nature; if he brings together several objects or several figures, he is guided in his choice only by the desire to obtain beautiful color areas, beautiful oppositions. It is silly to try to make a mystical dreamer out of an artist obedient to such a temperament.

After the analysis comes the synthesis. Let us take any canvas of the artist and look in it only for that which it contains: lighted objects, real creatures. The general appearance, as I have said, is of a luminous blondness. In the diffused light, the faces are carved in broad areas of flesh, the lips become simple strokes; everything is simplified and stands out from the background in powerful masses. The accuracy of the tones establishes the layers of depth, fills the canvas with air, gives strength to each element. It has been said, in derision, that the canvases of Edouard Manet are reminiscent of the woodcuts of Epinal,[47] and there is a great deal of truth in this scornful remark, which is really a eulogy. In both cases the procedures are the same—the colors are applied in patches, with this difference: the workmen of Epinal use pure tones while Edouard Manet multiplies the tones and establishes the proper relationships among them. It would be much more interesting to compare this simplified painting with Japanese prints, which resemble it in their bizarre elegance and their magnificent color patches.

The first impression that a canvas by Edouard Manet produces is a bit harsh and dry. We are not used to seeing such simple and sincere translations of nature. Then, as I said, there is a certain amount of elegant awkwardness which is surprising. At first the eye perceives nothing but broadly applied color areas. Soon, objects take form and fall into place; in a little while, the vigorous, firm totality appears, and one tastes real pleasure in contemplating this bright, serious painting, which yields up nature with a sweet brutality, if I may use the expression. In coming closer to the painting, one sees that the technique is delicate rather than crude.

47 Crude, popular images.

The artist uses nothing but the brush, and uses it with great reserve. There are no areas of thickly applied color, but rather a single, unified layer. This daring creature, so often ridiculed, has an extraordinarily well behaved technique, and if his works have an individual appearance, it is only because of the extremely personal way in which the painter sees and translates objects.

In conclusion, if I were being questioned and were asked what new language Edouard Manet spoke, I would reply: he speaks a language of simplicity and exactitude. The new note that he contributes is one of blondness, filling the canvas with light. The translation that he gives us is a precise and simplified one, achieving its effect through large units and broad masses.

We must, and I cannot say it too often, forget a thousand things, in order to understand and enjoy this talent. It is no longer a question of searching for absolute beauty; the artist paints neither a story nor a soul; what is generally called composition does not exist for him, and the task he imposes upon himself is far from that of representing such-and-such an idea or historical event. And for this reason we must judge him neither as a moralist nor as a man of letters; we must judge him as a painter. He treats figure painting in the same way that traditional artists are allowed to treat still life painting: I mean to say, he arranges the figures before him, more or less at random, and then is only interested in getting them down on the canvas as he sees them, with all the vivid contrasts that they make with one another. Ask nothing else from him than an exactly literal translation. He does not know how to sing or to philosophize. He knows how to paint and that is all; he has the gift (and this is exactly his unique temperament) of seizing the dominant tones in all their delicacy and thereby being able to model the things and beings that he paints in broad areas.

He is a child of our times. I see him as an analytic painter. All the problems have once more been called into question: science wanted a firm basis and therefore returned to a precise observation of facts. And this movement has been taking place not only in the realm of science; all the disciplines, all human efforts are directed toward the search for sure and definitive principles in nature. Our modern landscapists have gone far beyond our painters of history and genre because they have studied our countryside, content to translate the first spot of forest they come upon. Edouard Manet applies the same method to each of his works. While others rack their brains to invent a new *Death of Caesar* or a new *Socrates Drinking the Hemlock,* he calmly places a few objects and people in a corner of his studio and begins to paint the whole thing, carefully analyzing nature all the while. I repeat, he is a simple analyst; his labor is much more interesting than the plagiarisms of his colleagues; art itself thus leads toward certitude. The artist is an interpreter of that which is,

and his works have for me the enormous charm of a precise description made in a human and original language.

He has been reproached for imitating the Spanish masters. I will agree that there may be some resemblance between his early works and those of these masters; one is always someone's son. But since his *Déjeuner sur l'herbe* [48] he seems to me to have confirmed clearly that personality which I have tried to explain and briefly comment upon. Perhaps the truth is that the public, seeing him paint Spanish scenes and costumes, decided that he took his models from across the Pyrenees. From this it is not far to go on to an accusation of plagiarism. But it is good to know that if Edouard Manet painted *espadas* or *majos*,[49] it was because in his studio he had Spanish costumes which he thought beautiful in color. He visited Spain only in 1865, and his canvases have too individual an accent for anyone to find him nothing but a bastard of Velasquez and Goya. . . .[50]

The "Déjeuner sur l'herbe"

The *Déjeuner sur l'herbe* is Manet's greatest painting, the one in which he has realized the dream of every painter: to paint life-sized figures in a landscape. The ability with which he has overcome this difficulty is well known. . . . The public was scandalized by this nude, which was all it saw in the painting. "Good heavens! How indecent! A woman without a stitch on alongside two clothed men." Such a thing had never been seen before! But that was a gross mistake, for in the Louvre there are more than fifty canvases in which both clothed and nude figures occur. But no one goes to the Louvre to be shocked, and besides, the public took good care not to judge the *Déjeuner sur l'herbe* as a real work of art should be judged. It saw there only some people who were lunching out of doors after a swim, and it believed that the artist had been intentionally obscene and vulgar in composing such a subject, when he had simply tried to obtain vivid contrasts and free disposition of masses. Painters, especially Manet who is an analytical painter, do not share this preoccupation with subject matter which frets the public above everything else; for them the subject is only a pretext for painting, but for the public it is all there is. So, undoubtedly, the nude woman in the *Déjeuner sur l'herbe* is only there to provide the artist with an opportunity to paint a bit of flesh.

48 Painted c. 1863 and exhibited at the *Salon des Refusés* of that year.

49 *Espada:* bullfighter; *majo:* young man of lower class origin, rather gaudily dressed.

50 Emile Zola, "Une Nouvelle Manière en peinture: Edouard Manet," originally published in *La Revue du XIXe Siècle,* January 1, 1867; reprinted in Emile Zola, *Salons,* ed. F. W. J. Hemmings and Robert J. Neiss (Geneva: Librairie E. Droz, 1959), pp. 85–86, 90–93. The Zola article was originally preceded by the following note: "The *Revue du XIXe Siècle* has its beliefs, but it also has its open forum, to which it invites the expression of all opinions about art. This is why it has printed this daring study."

What should be noticed in this painting is not the picnic but the landscape as a whole, its strength and delicacy, the broad, solid foreground and the light, delicate distance, the firm flesh modeled in large areas of light, the supple and strong materials, and especially the delightful silhouette of the woman in her chemise in the background, a charming white spot in the midst of the green leaves. Finally the whole effect, full of atmosphere, this fragment of nature treated with a simplicity so exactly right, is all an admirable page upon which an artist has put the elements unique and peculiar to him.

In 1864 Manet exhibited the *Dead Christ* and a *Bullfight*. Of the latter painting he has preserved only the toreador in the foreground—the *Dead Man* which is very close in style to the *Boy with a Sword*. The technique is minute and tight, very fine and solid. Even now I know that it will be a success at the artist's exhibition, for the public loves to examine every inch without being scandalized by the too brutal harshness of real originality. I confess that I much prefer the *Dead Christ*. There I recognize Manet completely, his obstinate eye and audacious hand. It has been said that this Christ was not really *the* Christ, and I admit that this could be so. For me it is a cadaver freely and vigorously painted in a strong light, and I even like the angels in the background, those children with great blue wings who are so strangely elegant and gentle.

The "Olympia"

In 1865 Manet was again accepted at the Salon; he exhibited a *Christ Mocked by the Soldiers* and his masterpiece, his *Olympia*. I said masterpiece, and I will not retract the word. I maintain that this canvas is truly the painter's flesh and blood. It is all his and his alone. It will endure as the characteristic expression of his talent, as the highest mark of his power. In it I read the personality of Manet and when I analyzed the artist's temperament I had before me only this canvas which sums up all the others. Here we have, as the popular jokers say, an Epinal print. Olympia, reclining on the white sheets, is a large pale spot on the black background. In this black background are the head of a Negress carrying a bouquet and the famous cat which has entertained the public so much. Thus at the first glance you distinguish only two tones in the painting, two strong tones played off against each other. Moreover, details have disappeared. Look at the head of the young girl. The lips are two narrow pink lines, the eyes are reduced to a few black strokes. Now look closely at the bouquet. Some patches of pink, blue, and green. Everything is simplified and if you wish to reconstruct reality you must step back a bit. Then a curious thing happens. Each object falls into its proper plane. Olympia's head projects from the background in astonishing relief, the bouquet becomes marvelously fresh and brilliant. An accurate eye and a direct hand performed this miracle. The painter worked as nature works,

in simple masses and large areas of light, and his work has the somewhat rude and austere appearance of nature itself. In addition there is a personal quality; art lives only by prejudice. And this bias is found in just that elegant austerity, that violence of transitions which I have pointed out. This is the personal accent, the particular savor of his work. Nothing is more exquisitely refined than the pale tones of the white linen on which Olympia reclines. In the juxtaposition of these various whites an immense difficulty has been overcome. The child's body itself is charmingly pallid. She is a girl of sixteen, doubtless some model whom Edouard Manet has quietly copied just as she was. And everyone exclaimed that this nude body was indecent. That's as it should be since here in the flesh is a girl whom the artist has put on canvas in her youthful, slightly tarnished nakedness. When other artists correct nature by painting Venus, they lie. Manet asked himself why he should lie. Why not tell the truth? He has introduced us to Olympia, a girl of our own times, whom we have met in the streets pulling a thin shawl of faded wool over her narrow shoulders. As usual the public took good care not to understand what the painter wanted. There are even people who have looked for a philosophical meaning in the painting. Others, less restrained, would not have been displeased to find an indecent intention.[51]

Manet's Statements About Art

Edouard Manet had first attracted widescale public attention when his Déjeuner sur l'herbe *appeared in the* Salon des Refusés *in 1863. The work aroused the ire of public and critics, despite the fact that it drew on traditional sources as respectable as Giorgione's* Concert Champêtre *in the Louvre, and an engraving after Raphael's* Judgment of Paris. *Yet the scandal raised by the* Déjeuner *was nothing compared to that elicited by the painter's* Olympia, *which appeared in the Salon of 1865, perhaps Manet's greatest masterpiece and a work also based on a perfectly good traditional prototype, Titian's* Venus of Urbino. *With these two works one can say that the era of modern art has begun. In them Manet is detached both from direct contact with things and people and from direct emotional reaction to the values embodied in them. Almost from the beginning, he conceives of art as a monologue, which his subjects seem to interrupt, a peeled lemon as much as a human figure. The* Déjeuner sur l'herbe *in its ambiguous iconography, half-traditional, half-contemporary, its lack of nuanced modeling, the starkness of the separate color areas and the schematic reduction of the nude, already poses most of the problems*

51 This portion of Zola's essay on Manet (the version which later appeared in *Mes Haines* in 1879 and then in Zola's *Oeuvres complètes,* ed. Maurice Le Blond [Paris: F. Bernouard, 1938], XLI, 243–279), is taken from George Heard Hamilton, *Manet and his Critics* (New Haven: Yale University Press, 1954), pp. 97–99. It was translated by Professor Hamilton and reprinted by permission of the publisher.

that were to challenge artists for the next fifty years or longer; here, as in
the Olympia, *the shadows have begun to assume an independent formal*
identity, the spaces between the figures to play a role of their own, the
faces to assume that iconic remoteness so characteristic of modern art.

As one might expect, from Zola's brief description of his character,
Manet was not given to lengthy theoretical discussions about art, although
his remarks and observations were often brilliant and incisive in the lively
group discussions of the young painters centering around him, first at the
Café Guerbois and later, when they were already known as "Impression-
ists," at the Nouvelle-Athènes.

On Color

Color—that's a matter of taste and sensitivity. For example, you have
to have something to say; without that, goodnight! You aren't a painter
unless you love painting more than anything else. And then, it's not
enough just to know your trade; you have to be moved. Science is all
very well, but for us, don't you see, imagination is more important. . . .[52]

On Conciseness

Conciseness in art is a necessity and an elegance. The concise man
makes you think; the verbose man bores you. Always move in the direc-
tion of conciseness. . . . In a figure, always look for the greatest light
and the greatest shadow; the rest will follow naturally; it is often nothing
much. Then, cultivate your memory, for nature never gives you any-
thing but information. It's like a guardrail that keeps you from falling
into banality. . . .[53]

A Letter About Velasquez and Goya from Manet
to Fantin-Latour from Madrid in 1865

Henri Fantin-Latour (1836–1904), like Manet, had exhibited in the
Salon des Refusés *in 1863; he was especially known for flower-pieces and*
portraits, above all, those group portraits of artists and writers dedicated
to some famous personage, such as his Homage to Delacroix *of 1863, in*
which he had depicted Baudelaire, Champfleury, Duranty, Manet, and
himself with the artist, and A Studio in the Batignolles Quarter *of 1870,*
representing the young Impressionists and their friends—Zola, Bazille,
Renoir, Manet, Astruc, and others—gathered about Manet seated at his
easel.

Manet's letter to his friend conveys a strong sense of his excitement

[52] Edouard Manet in *Manet raconté par lui-même et par ses amis,* ed. Pierre
Courthion (Geneva: Pierre Cailler, 1945), p. 37. Reprinted by permission of the pub-
lisher.

[53] Edouard Manet in Paul Jamot and Georges Wildenstein, *Manet* (Paris: Les
Beaux-Arts, 1932), I, 71. Reprinted by permission of the publisher.

*at confronting the masterpieces of Spanish art; he obviously finds Velas-
quez's paintings vastly superior to those of Goya.*

How I miss you here, and what a joy it would have been for you
to see Velasquez, who alone is worth the trip. All the painters of the
school, who surround him in the Madrid Museum and who are very well
represented there, seem mere scribblers. He is the painters' painter. He
didn't surprise me but delighted me. The full length portrait that we
have in the Louvre is not by him; [54] the infanta alone cannot be ques-
tioned.[55] There is an enormous painting here filled with little figures
like those in the Louvre painting entitled *The Cavaliers,* but figures of
men and women, perhaps superior, and above all, perfectly free from
restoration. The background, the landscape, is by a pupil of Velasquez.[56]

The most astonishing example of this splendid oeuvre, and perhaps
the most astonishing piece of painting ever created is the picture indi-
cated in the catalogue as *Portrait of a Famous Actor of the Time of Philip
IV.*[57] The background disappears; it is air that surrounds the fellow, all
dressed in black, alive. And the *Spinners,* the beautiful portrait of Alonzo
Cano, *Las Meninas* (the dwarfs), also an extraordinary picture! The
philosophers, what exciting works! [58] All the dwarfs; one above all,
seated full face, his fists on his hips: a choice painting for a real connois-
seur.[59] His magnificent portraits should all be mentioned; there are
nothing but masterpieces. A portrait of Charles V by Titian, which has
a great reputation that must be merited and which certainly would have
seemed fine to me elsewhere, seems made out of wood here.[60]

And Goya! the most singular after the master he imitated too much,
in the most servile manner of imitation; very spirited, however. In the

[54] Probably a reference to the much disputed *Portrait of Philip IV in Hunting
Dress,* formerly in the Louvre, now in the Musée Goya at Castres, thought by many to
be a studio copy of the authentic version in the Prado. According to recent opinions,
however, "the quality of the execution revealed by cleaning, the position of the hair,
and its provenance, are proofs that permit one to assert that, with the exception of the
head, almost the entire painting is attributable to Velasquez's brush." Catalogue:
Trésors de la peinture espagnole: Eglises et musées de France (Palais du Louvre:
Musée des Arts Décoratifs, Paris, January–April, 1963), no. 85, pp. 215–217.

[55] The *Portrait of the Infanta Margarita,* an authentic work by Velasquez in the
Louvre.

[56] A reference to the *View of Saragossa* of 1647 in the Prado, now thought to be
entirely by Mazo. The Louvre *Petits Cavaliers,* evidently related to the Mazo painting
but at that time ascribed to Velasquez, had been copied by Manet in the middle of the
1850s, and in about 1860 he made two free variations of the supposed Velasquez work.

[57] Actually the *Portrait of the Court Jester, Pablo de Valladolid.*

[58] A series including Aesop, Archimedes, Democritus, Heraclitus, and Menippus,
of which only the first and the last are in the Prado.

[59] *Portrait of Sebastián de Morra.*

[60] Probably a reference to Titian's *Portrait of Charles V with a Dog* (1533) in the
Prado. It hardly seems possible that Manet could have described Titian's other Prado
portrait of Charles V, the lively equestrian *Emperor Charles V at the Battle of Mühl-
berg* (1548) in such terms!

museum there are two beautiful equestrian portraits by him, in the manner of Velasquez, although very inferior.[61] What I've seen by him until now hasn't pleased me enormously. I must, one of these days, go to see a magnificent collection of his works at the Duke of Ossuna's.

I am broken-hearted: the weather is bad this morning and I'm afraid that the bullfight I was looking forward to attending this evening will be postponed. Until when? Tomorrow I'm going to Toledo. There I will see Greco and Goya very well represented, I've been told.[62]

Reasons for a Private Exhibition

In 1867, Manet, angered at the exclusion of his name from the official list of artists invited to exhibit at the International Exposition, decided, as had Courbet in 1855, to hold a private showing of his own works. His exhibition opened in a temporary building on the Place de l'Alma on May 24, and contained fifty selections. In the preface to the catalogue for this one-man show, probably written jointly by Manet and Zola, the artist set forth his intentions with great force, directness, and clarity.

Since 1861 Manet has been exhibiting, or trying to exhibit.

This year he has decided to show the sum total of his works directly to the public.

Manet received an honorable mention when he first exhibited at the Salon. But since then he has seen himself rejected by the jury too often not to think that, if an artist's beginning is a struggle, at least one must fight with equal weapons. That is to say one must be able also to exhibit what one has done.

Without that the artist would be all too easily shut up in a circle from which there is no exit. He would be forced either to stack his canvases or roll them up in a hayloft.

It is said that official recognition, encouragement, and rewards are actually a guarantee of talent in the eyes of a certain part of the public; they are thereby forewarned in behalf of or against the accepted or rejected works. But, on the other hand, the painter is assured that it is the spontaneous impression of this same public which motivates the chilly welcome the various juries give his canvas.

In these circumstances the artist has been advised to wait.

To wait for what? Until there is no longer a jury?

He has preferred to settle the question with the public.

61 Possibly a reference to *King Charles IV, in the Uniform of a Colonel of the Life Guards on Horseback* of 1799, and its companion portrait, *Maria Luisa of Parma, Consort of Charles IV, in the Uniform of a Colonel of the Life Guards, on Horseback*, of the same year, also in the Prado.

62 Edouard Manet, Letter to Henri Fantin-Latour, dated Madrid, 1865, in *Manet raconté par lui-même*, ed. Pierre Courthion, pp. 42–44.

The artist does not say today, "Come and see faultless work," but, "Come and see sincere work."

This sincerity gives the work a character of protest, albeit the painter merely thought of rendering his impression.

Manet has never wished to protest. It is rather against him who did not expect it that people have protested, because there is a traditional system of teaching form, technique, and appearances in painting, and because those who have been brought up according to such principles do not acknowledge any other. From that they derive their naïve intolerance. Outside of their formulas nothing is valid, and they become not only critics but adversaries, and active adversaries.

To exhibit is for the artist the vital concern, the sine qua non; for it happens that after looking at something you become used to what was surprising or, if you wish, shocking. Little by little you understand and accept it.

Time itself imperceptibly works on paintings and softens the original harshness.

To exhibit is to find friends and allies for the struggle.

Manet has always recognized talent wherever he found it and has presumed neither to overthrow earlier painting nor to make it new. He has merely tried to be himself and not someone else. Besides, Manet has found important encouragement and has been able to see how much the judgment of men of real talent is daily becoming more favorable toward him.

Therefore it is now only a question for the painter of gaining the good will of the public which has been turned into a would-be enemy.[63]

Adverse Criticisms of Manet

"Manet has never wished to protest. It is rather against him who did not expect it that people have protested. . . ." So spoke Manet in the preface to the catalogue of his private exhibition in 1867. And the critics had protested, almost to a man, with a few notable exceptions, ever since the Salon des Refusés *of 1863. True, the* Spanish Guitar Player *in the Salon of 1861 had received favorable notices and even an honorable mention from the jury, but after the appearance of the shocking* Olympia, *even critics who had shown a mild interest in the young painter's work saw him as a dangerous radical, or worse.*

The samples of critical virulence below are simply two among many of the same kind. The first, from the Constitutionnel *of May 16, 1865, is by Ernest Chesneau (1833–1890) who had actually bought a small work by Manet the previous March. The second, by the novelist, historian,*

63 Preface to Catalogue of Manet's Private Exposition at the Place de l'Alma, May 24, 1867 in Hamilton, *Manet and his Critics*, pp. 105–107.

*dramatist, politician, and critic Jules Clarétie (1840–1913), which ap-
peared in* L'Artiste *of May 15, 1865, is even more specific in its charges,
and still more damning. In neither case has the critic made the slightest
effort to understand what the painter was aiming for; instead, each resorts
to facile mockery and that cynicism which is the bulwark of petty spirits
against the frightening encroachment of the authentically new.*

Ernest Chesneau

I must say that the grotesque aspect of his contributions has two
causes: first, an almost childish ignorance of the fundamentals of drawing,
and then, a prejudice in favor of inconceivable vulgarity. . . . He suc-
ceeds in provoking almost scandalous laughter, which causes the Salon
visitors to crowd around this ludicrous creature called *Olympia*. . . . In
this case, the comedy is caused by the loudly advertised intention of pro-
ducing a noble work, a pretension thwarted by the absolute impotence
of the execution.[64]

Jules Clarétie

I like audacity and I believe, like Danton, that a good deal is neces-
sary, but yet not too much. Once upon a time there was a young man
called Manet who, one fine day, bravely exhibited among the rejected
paintings a nude woman lunching with some young men dressed in sack
suits and capped with Spanish sombreros. Many cried shame, some smiled,
others applauded, all noted the name of the audacious fellow who al-
ready had something and who promised much more. We find him again
this year with two dreadful canvases, challenges hurled at the public,
mockeries or parodies, how can one tell? Yes, mockeries. What is this
Odalisque with a yellow stomach, a base model picked up I know not
where, who represents Olympia? Olympia? What Olympia? A courtesan
no doubt. Manet cannot be accused of idealizing the foolish virgins, he
who makes them vulgar virgins. I had promised myself not to speak of
it any more.[65]

EUGÈNE BOUDIN: 1824–1898

One Must Paint the Subjects of One's Time

*Eugène Boudin is better known as the teacher of Monet than as a
painter in his own right. Like Monet, a native of Le Havre, he too sought
inspiration in the seashore and its perpetually changing appearances.*

[64] Ernest Chesneau in Hamilton, *Manet and his Critics*, p. 72.
[65] Jules Clarétie in Hamilton, *Manet and his Critics*, p. 73.

Sensitive, modest, devoted to the honest portrayal of nature, yet often overwhelmed by the difficulties involved in capturing his prey on canvas, Boudin reveals in his writing the pathos of this attempt to capture the fleeting perfection of his vision and his heartbreaking awareness of the gap between his sensitive perception of his subjects and his inability to execute them. Starting out as the owner of an art supply and framing shop in Le Havre in 1844, acquainted with many artists like Couture, Troyon, and Millet, Boudin decided to follow their footsteps and in 1851 he obtained a fellowship from the city to study in Paris. But, after three years, when he brought back open-air studies and scenes of contemporary life instead of more conventional subjects, he lost favor with his benefactors. It was Boudin who encouraged the young Monet to confront nature without preconception, and in later life Monet acknowledged the full extent of his debt to his first master.

In this letter to Boudin's friend and fellow-resident of Le Havre, M. Martin, who was a member of the Art Commission of his native city, Boudin pleads for the admission of ordinary, observed reality as a proper subject for art—not necessarily picturesque peasants, but middle-class people in their everyday dress—a demand echoing that of Baudelaire who had suggested the same thing in the section entitled "On the Heroism of Modern Life" in his Salon of 1846. *Baudelaire, incidentally, was so enchanted with Boudin's work in the Salon of 1859—he had recently met Boudin at Honfleur—that he made a last-minute insertion about it in his account of the art of that year: "Cover the inscription with your hand, and you could guess the season, the time and the wind. I am not exaggerating. I have seen it."* [66]

SEPTEMBER 3, 1868

Your letter arrived just at the moment when I was showing Ribot, Bureau,[67] and another person my little studies of fashionable beach resorts. These gentlemen congratulated me precisely for having dared to put into paint the things and people of our time, and for having found a way of getting the gentleman in an overcoat and his lady in a raincoat accepted—thanks to the sauce and the seasoning.

This attempt is not new, however, since the Italians and Flemish simply painted the people of their own period, either in interiors or in vast architectural ensembles; it is now making its way, and a number of young painters, chief among whom I would put Monet, find that it is a subject that until now has been too much neglected. The peasants have

66 Charles Baudelaire, "The Salon of 1859," *The Mirror of Art,* trans. and ed. Jonathan Mayne (London: Phaidon Publishers, 1955), p. 281.

67 Théodule Ribot (1823–1891), painter of history, genre, portraits, and still life, specializing in kitchen interiors, also active as an etcher. Pierre-Isidore Bureau (1827– ?), painter and graphic artist, devoting himself mainly to landscape.

their painters of predilection: Millet, Jacque, Breton,[68] and this is good; these men carry on sincere and serious work, they partake of the work of the Creator and help Him to make Himself manifest in a manner fruitful for man. This is good; but between ourselves these middle-class men and women, walking on the pier toward the setting sun, have they no right to be fixed on canvas, *to be brought to light?* Between ourselves, these people coming from their businesses and their offices are often resting after hard work. If there are some parasites among them, aren't there also those who fulfill their tasks? This is a serious, irrefutable argument.

I should not like, under whatever pretext, to condemn myself to paint clothes, but isn't it pitiful to see serious men like Isabey, Meissonier,[69] and so many others, collecting carnival costumes and, under pretext of picturesqueness, dressing up models who most of the time don't know what to do under all their borrowed finery?

The Poitevin [Meissonier] has made his fortune with an old felt hat with a feather and a pair of musketeer's boots that he has painted under all possible pretexts. I should very much like to have one of these gentlemen explain to me the interest such subjects will have in the future, and whether the picturesque character of these canvases will make any impression on our grandchildren. We must not disguise the fact that a painting often owes its title to preservation to its technical perfection. Why else would one hang a Chardin pitcher in a museum? If your commission [of Le Havre] sees things in this light, let it lose no time in buying a Monet, a Ribot, or a Courbet: but it must give up one or the other. For the Lord knows there is no comparison.

I have permitted myself this little digression, my friend, because your good friendship leads you astray: you are worried about me, and you think that I should retrace my steps and make some concessions to the taste of a certain public. I have been unhappy long enough, and consequently uncertain enough to have explored, and sought, and reflected; I have sounded out others enough to know in what their stock consists, and to know what my own is worth. Well, my good friend, I still persist in following my own little road, however untrod it may be, wishing only to walk with a surer and a firmer step, smoothing it a bit if need be. One can find art in anything if one is gifted. And everyone who uses a brush or a pen of necessity thinks himself gifted. It is up to the public to judge, and

[68] Charles-Emile Jacque (1813–1894), member of the Barbizon School, well known as an etcher as well as a painter, specializing in the realistic rendition of peasant subjects, farmyard scenes with domestic animals, chiefly pigs. Jules Breton (1827–1905), extremely successful painter of minutely detailed, idealized, overgraceful peasant themes.

[69] Eugène Isabey (1803–1886), son of a famous painter and himself known for charming, delicately painted seascapes, genre scenes, and costume pieces. Jean Meissonier (1815–1891), one of the most popular and successful artists of his day, famed for tiny, minutely described genre paintings, military scenes, and costume pieces.

up to the artist to go forward, and to embrace nature, whether by painting cabbages and cheeses or supernatural and divine beings such as our friend Lemarcais paints so badly.

So I cannot accept your opinion on my bad choice of subjects: on the contrary, I am acquiring more and more taste for it, hoping to broaden this still too narrow genre.[70]

Excerpts from Boudin's Notebooks

Although generally undated, these statements were probably written for the most part in the middle or late fifties with a few dating from the sixties, when the artist would set down his disappointments each night upon coming back to Le Havre from Saint-Vigor or Saint-Siméon, where he had worked out of doors during the day. While he was not a great artist, many of Boudin's canvases—beach scenes with little figures, seascapes, small in scale and modest in pretentions—exhibit a sensitivity, liveliness, and freshness of perception that mark him as one of the pioneers of nascent Impressionism.

Perfection that flees, always flees. . . . I turn it over and over again in my mind; here the earth is crowded, the sky too close, there the equilibrium is no longer there . . . what energy must be expended! How many setbacks must be endured! How impoverished is that internal life going on within myself! I look at nature ceaselessly, without seeing it. Can one have peace only at this price? Sometimes, as I walk sunken in melancholy, I look at that light inundating the earth, trembling on the water, playing on clothing, and I become faint when I realize how much genius is needed to grasp so many difficulties, how limited man's mind is since he cannot put all these things together in his head; and then besides, I feel that poetry is there, and how can I seize it? Sometimes I catch a glimpse of what must be expressed. . . .

Sunday, December 12: This morning, I went back to my painting: it goes badly, like everything I undertake. I feel that fullness, that delicacy, the dazzling light that transforms everything into enchanting foliage before my eyes, and I can't make this come through from my mud-puddle of colors. I am stupefied to see that my mind, or rather my hand, is unwilling to take a wild leap and realize my ideal, be it ever so little. I still have a feeling I will get there, but it is slow and I am thirty years old; besides, I am in dull company.

70 Eugène Boudin, Letter to M. Martin of September 3, 1868, in Robert Goldwater and Marco Treves, eds., *Artists on Art*, trans. Robert Goldwater, 3rd ed. (New York: Pantheon Books, 1964), pp. 300–302. Reprinted by permission of Bernheim-Jeune, Paris, editors.

I went out this afternoon, the sun shone brightly; it was a joy. I was right to enjoy this lovely day a bit; it led me to all sorts of observations about painting. How starved for light it always is, how gloomy! I started all over again twenty times in order to get at that delicacy, that magic of light playing everywhere. Since the weather was cool, everything was soft, faded, a little pink. Objects are drowned; there are nothing but values everywhere.

The sea was superb; the sky mellow, velvety. Then it changed to yellow; it became warm, the setting sun put lovely purple nuances on all of it: the land, the dikes as well took on this nuance.

Only the paintings of Lorrain [71] have been able to capture in their freshness that delicacy of nuances. Corot manages it sometimes in the light, soft gamuts of his color; it is rough work. Still, new attempts must be made. How beautiful that pool of the Eure was, with its soft touches of violet; it is unpolished and transparent. We always paint too coarsely.

Sunday, October 29: All my energy leaves me. I am penniless, destitute. It's true that I have a little painting to work on, but I foresee that it will take such a long time that disgust overcomes me; I can accomplish nothing. I had started working on a big landscape, and here I am disgusted with it. You can't see a thing in this damned studio before noon, but it doesn't cost anything and it's heated. I am disgusted with everything I do; I am charmed when the subject comes to me in vagueness; but as soon as it starts getting clear I no longer see anything that I dreamed of in it, and then I get discouraged. I no longer take any recreation; my leisure is a burden.

May 28, 1869: Nature is so beautiful, so splendid that it always torments me, when misery loosens its hold a bit. Certainly it would be a great joy for us to see, to admire ceaselessly all these splendors of the sky and the earth, if only there were nothing to do but admire them. But isn't there always the torment of having to reproduce them mixed with it, the impossibility of recreating in painting, with such restricted means. But after all, is even the feeble reflection of these marvelous worlds a mere nothing? When I think that there are so many miserable creatures whose lives are occupied with such trivial things and who nevertheless derive a considerable profit from them! Yes, let there be a constant effort among us, aspirations toward these sublime things, and we will end up by being recognized and appreciated in our efforts and in our lofty inclinations.[72]

[71] Claude Lorrain (1600–1682), French landscape painter known for the subtlety of his light effects.

[72] Eugène Boudin, Pages from his Notebook, cited by Marthe de Fels in *La Vie de Claude Monet* (Paris: Gallimard, 1929), pp. 21–25. Reprinted by permission of Editions Gallimard.

FRÉDÉRIC BAZILLE: 1841–1870

Letters to His Parents

Frédéric Bazille came from a wealthy bourgeois family of Montpellier. He must have become familiar quite early with the art collection of the eccentric Alfred Bruyas, patron of Delacroix and Courbet, who lived in his native city. Bazille went to Paris to divide his time between the study of medicine and that of art, and entered Gleyre's studio, where he quickly made friends with Sisley, Renoir, and Monet, to whose financial assistance he often came; he was the godfather of Monet's son Jean, and frequented the Café Guerbois with other members of the group. An extremely talented, direct, forceful painter, Bazille might well have developed into a great, if somewhat naïve, artist, if he had not been killed in the Franco-Prussian war. As it is, he left behind several masterpieces, including the monumental Artist's Family on a Terrace near Montpellier *(1868–1869), and a truly distinguished, natural, and informal memorial of the group of young painters and their friends,* The Artist's Studio, Rue de la Condamine *(1870) where, within Bazille's large, airy studio, his friend, Maître, plays the piano, Zola stands on the staircase looking down at Renoir, Manet observes a picture on the easel while Monet, smoking, looks over his shoulder, and the tall figure of Bazille himself stands to the right; canvases by Bazille hang from or are ranged against the wall.*

The following selection is an excerpt from a letter written to his parents early in 1866. The painting Bazille refers to is the large Young Girl at the Piano, *which was refused by the jury of the 1866 Salon and later lost. The other painting he mentions,* The Fish, *was later accepted for the new Salon. The second excerpt is from a letter written a few days later. The "refusés," of course, refers to the artists rejected by the jury; there had been just such an exhibition of rejected artists in 1863. The third excerpt is from one of Bazille's letters to his family, written early in 1867.*

I have finished my painting. It was time. It will be sent over to the Palace of Industry the day after tomorrow. I am terribly afraid of being rejected, so I will send a still life of fish at the same time which will probably be accepted. The opinions about my picture are diametrically opposed, which gives me great pleasure. Some people find it very bad, others very good; this latter judgment is generally that of the painters. I would be content if the jury found my work simply mediocre. At any rate, if I am accepted, I will certainly be much discussed and noticed; I believe this because nobody has judged me with moderation. As for myself, I admit I

am quite pleased with my picture. Since I couldn't throw myself into a great composition, I tried to paint as best I could a subject which was as simple as possible. Furthermore, in my opinion, the subject is of little importance, as long as what I have done is interesting from the point of view of painting. I have chosen the modern era because it is the one I understand best, that I find most alive for living people—and that is what will get me rejected. If I had painted Greeks and Romans, I would have nothing to worry about; they would certainly appreciate the qualities my painting could have in a peplum or a trepidarium [sic], but they will reject, I'm afraid, my satin dress in a living room. . . .

I still know nothing about my paintings, but I am terribly afraid of being rejected, given the number of people who are. They will decide about me tomorrow. If I am rejected, I am going to sign with both hands a petition asking for an exhibition for the *refusés;* that idiotic public will perhaps make fun of me, but at least I will see my painting in the midst of others, which is the best way of seeing what is good or bad in it and of correcting myself another time. . . .

I have bad news to tell you: my paintings were refused for the exhibition. Don't be too upset about this; there is nothing discouraging about it; on the contrary, my works share this fate with everything that was good in the Salon this year. A petition is being signed at this moment demanding an exhibition of the *refusés.* This petition is being supported by all the painters of Paris who are of any value. However, it won't get anywhere. In any case, the annoyance I experienced this year won't happen again, for I will no longer send anything to the jury. It's much too ridiculous, when one knows one isn't a fool, to be exposed to these administrative whims, above all, when one doesn't care at all about medals and distributions of prizes. As for what I am telling you, a dozen talented young people think the same way as I do about it. We have therefore resolved to rent a big studio each year where we will show as many of our works as we want. We will invite the painters whom we like to send paintings. Courbet, Corot, Diaz, Daubigny, and many others with whom perhaps you aren't familiar have promised to send up paintings and highly approve of our idea. With the latter, and Monet who is stronger than all of us, we are sure to succeed. If, by chance, the exhibition of the *refusés* should be granted, we won't do anything this year, and our group will not start until the following year. I shall be very pleased with this, for my part. I shall have time to do two or three major paintings at Montpellier. Don't be frightened; I assure you I am extremely reasonable, that we are certainly right. It is nothing at all like a revolt of schoolboys. I am now working on a painting of two women, life size, who are arranging flowers;

I will finish it during the peony season. I am extremely anxious that it be finished, if our private exhibition should begin this year. I will also send a portrait that I am going to do of Monet.[73]

[73] Frédéric Bazille, Letters to his Family, 1866 and 1867, in Gaston Poulain, *Bazille et ses amis* (Paris: La Renaissance du Livre, 1932), pp. 62–64, 78–79. Reprinted by permission of the publisher.

3

England:
The Pre-Raphaelites
and Their Friends

FORD MADOX BROWN: 1821–1893

"The Pretty Baa-Lambs" ("Summer's Heat")

While not an "official" member of the Pre-Raphaelite Brotherhood (the P.R.B., as it was called for convenience), Ford Madox Brown was certainly a completely Pre-Raphaelite painter from 1849 to the middle '60s. It was to Brown, in fact, that the young Dante Gabriel Rossetti came in 1848, for instruction in painting; the former already had revealed in his exhibited work the purifying influence of the earlier German Nazarene Group, whose surviving members, Cornelius and Overbeck, he had encountered in Rome.

Pre-Raphaelitism was a movement of youthful intensity, sweepingly rejecting both the softened generalization of form and the equally lax moral fiber of English academic art of the mid-19th century. The Pre-Raphaelites aspired to create a form of art crystalline, medievalizing, brilliant, linear, hypnotic in the richness of its detail and its transparent truth to the minutiae of nature—an art, in short, of extraordinary visual and emotional intensity. Yet at the same time, they were the children of their age and place: Victorian England. Their art, like their writing, which is voluminous, is often diluted by exactly that simpering sentimentality, that sugary hypocrisy and archness, or even, at times, an outright middle-class vulgarity of phrasing and attitude, which they so condemned in their contemporaries.

In this statement from the Catalogue of his 1865 Exhibition, Ford Madox Brown comes out firmly for an antiliterary, purely visual interpretation of his painting. It is interesting to note that the Pre-Raphaelites anticipated the Impressionist's practice of plein-air *painting.*

This picture [*The Pretty Baa-Lambs*] was painted in 1851, and exhibited the following year, at a time when discussion was very rife on certain ideas and principles in art, very much in harmony with my own views, but more sedulously promulgated by friends of mine. Hung in a false light, and viewed through the medium of false ideas, the painting was, I think, much misunderstood. I was told that it was impossible to make out what *meaning* I had in the picture. At the present moment, few people, I trust, will seek for any meaning beyond the obvious one, that is—a lady, a baby, two lambs, a servant maid, and some grass. In all cases, pictures must be judged first as pictures—a deep philosophical intention will not make a fine picture, such being rather given in excess of the bargain; and though all epic works of art have this excess, yet I should be much inclined to doubt the genuineness of that artist's ideas who never painted from love of the mere look of things, whose mind was always on

the stretch for a moral. This picture was painted out in the sunlight; the only intention being to render that effect as well as my power in a first attempt of that kind would allow.[1]

The "Last of England" (1855)

Brown's strictures against overinterpretation of the work of art would seem to be completely contradicted by still another statement in the same Exhibition Catalogue. Little is left to the spectator's imagination or even to his visual acumen; in fact, one feels that one is actually supposed to "read" the picture, detail by detail, following the written text.

This picture is, in the strictest sense, historical. It treats of the great emigration movement, which attained its culminating point in 1852. The educated are bound to their country by closer ties than the illiterate, whose chief consideration is food and physical comfort. I have, therefore, in order to present the parting scene in its fullest tragic development, singled out a couple from the middle classes, high enough, through education and refinement, to appreciate all they are now giving up, and yet dignified enough in means to have to put up with the discomforts and humiliations incident to a vessel "all one class." The husband broods bitterly over blighted hopes, and severance from all he has been striving for. The young wife's grief is of a less cantankerous sort, probably confined to the sorrow of parting with a few friends of early years. The circle of her love moves with her.

The husband is shielding his wife from the sea spray with an umbrella. Next them, in the background, an honest family of the greengrocer kind, father (mother lost), eldest daughter and younger children, make the best of things with tobacco-pipe and apples, &c., &c. Still further back, a reprobate shakes his fist with curses at the land of his birth, as though that were answerable for *his* want of success; his old mother reproves him for his foul-mouthed profanity, while a boon companion, with flushed countenance, and got up in nautical togs for the voyage, signifies drunken approbation. The cabbages slung round the stern of the vessel indicate, to the practiced eye, a lengthy voyage; but for this their introduction would be objectless. A cabin-boy, too used to "laving his native land" to see occasion for much sentiment in it, is selecting vegetables for the dinner out of a boatful.

This picture, begun in 1852, was finished more than nine years ago (1855). To insure the peculiar look of *light all round* which objects have on a dull day at sea, it was painted for the most part in the open air on dull days, and, when the flesh was being painted, on cold days. Absolutely

[1] Ford Madox Brown, Exhibition Catalogue, 1865, reprinted in Robin Ironside, *Pre-Raphaelite Painters*, with a descriptive catalogue by John Gere (London: The Phaidon Press, 1948), p. 23. Reprinted by permission of the publisher.

without regard to the art of any period or country, I have tried to render this scene as it would appear. The minuteness of detail which would be visible under such conditions of broad daylight I have thought necessary to imitate as bringing the pathos of the subject more home to the beholder.[2]

A Description of "Work"

The highly literary, overtly moralizing aspect of Pre-Raphaelitism is nowhere better exhibited than in Ford Madox Brown's lengthy description of his major masterpiece, Work, *painted from 1852 to 1865. (Only Diderot, spellbound before the latest Greuze, in the 18th century, would seem capable of such an endless and involved disquisition!) The obvious debt owed by the painter to the ideas of Thomas Carlyle (1795–1881), social philosopher and historian, especially those in the latter's* Past and Present *(1843), a shattering exposure of the evils of present-day society, is frankly acknowledged by Brown: he has included Carlyle's portrait as one of the two "brain-workers" in the right foreground, and the name of a character from Carlyle's satire, Bobus Higgins, a sausage-maker and typical Philistine, is carried on sign-boards by the procession in the background. While there is no overt relation to Courbet or French Realism in general, one almost feels that similar social currents contemporaneous in France and England—humanitarian, labor-loving, popular—may at times give rise to a similar confrontation of reality. Though infinitely more complex and literary than Courbet's* Artist's Studio, *Brown's* Work *is, like it, an* Allégorie reélle, *a real allegory, or, more accurately, an allegory based on reality—the reality of the social climate of the times and the personal life of the artist himself.*

This picture was begun in 1852 at Hampstead. The background, which represents the main street of that suburb not far from the Heath, was painted on the spot.

At that time extensive excavations were going on in the neighbourhood, and, seeing and studying daily as I did the British excavator, or *navvy*, as he designates himself, in the full swing of his activity (with his manly and picturesque costume, and with the rich glow of colour which exercise under a hot sun will impart), it appeared to me that he was at least as worthy of the powers of an English painter as the fisherman of the Adriatic, the peasant of the Campagna, or the Neapolitan lazzarone. Gradually this idea developed itself into that of *Work* as it now exists, with the British excavator for a central group, as the outward and visible type of *Work*. Here are presented the young navvy in the pride of manly

2 Ford Madox Brown, Exhibition Catalogue, 1865, reprinted in Ford M. Hueffer [Ford Madox Ford], *Ford Madox Brown: A Record of his Life and Work* (London, New York, Bombay: Longmans, Green, and Co., 1896), pp. 100–101.

health and beauty; the strong fully-developed navvy who does his work and loves his beer; the selfish old bachelor navvy, stout of limb, and perhaps a trifle tough in those regions where compassion is said to reside; the navvy of strong animal nature, who, but that he was when young *taught* to work at useful work, might even now be working at the *useless crank*. Then Paddy with his larry and his pipe in his mouth. The young navvy who occupies the place of hero in this group, and in the picture, stands on what is termed a landing-stage, a platform placed half-way down the trench; two men from beneath shovel the earth up to him as he shovels it on to the pile outside. Next in value of significance to these is the ragged wretch who has never been *taught* to *work;* with his restless, gleaming eyes he doubts and despairs of every one. But for a certain effeminate gentleness of disposition and a love of nature he might have been a burglar! He lives in Flower and Dean Street, where the policemen walk two and two, and the worst cut-throats surround him, but he is harmless; and before the dawn you may see him miles out in the country, collecting his wild weeds and singular plants to awaken interest, and perhaps find a purchaser in some sprouting botanist. When exhausted he will return to his den, his creel of flowers then rests in an open court-yard, the thoroughfare for the crowded inmates of this haunt of vice, and played in by mischievous boys, yet the basket rarely gets interfered with, unless through the unconscious lurch of some drunkard. The bread-winning implements are sacred with the very poor. In the very opposite scale from the man who can't work, at the further corner of the picture, are two men who appear as having nothing to do. These are the brain-workers, who, seeming to be idle, work, and are the cause of well-ordained work and happiness in others—sages, such as in ancient Greece published their opinions in the market square. Perhaps one of these may already, before he or others know it, have moulded a nation to his pattern, converted a hitherto combative race to obstinate passivity; with a word may have centupled the tide of emigration, with another, have quenched the political passions of both factions—may have reversed men's notions upon criminals, upon slavery, upon many things, and still be walking about little known to some. The other, in friendly communion with the philosopher, smiling perhaps at some of his wild sallies and cynical thrusts (for Socrates at times strangely disturbs the seriousness of his auditory by the mercilessness of his jokes—against vice and foolishness), is intended for a kindred and yet very dissimilar spirit. A clergyman, such as the Church of England offers examples of—a priest without guile—a gentleman without pride, much in communion with the working classes, "honouring all men," "never weary in well-doing." Scholar, author, philosopher, and teacher, too, in his way, but not above practical efforts, if even for a small resulting good. Deeply penetrated as he is with the axiom that each unit of humanity feels as much as all the rest combined, and impulsive and hopeful in

nature, so that the remedy suggests itself to him concurrently with the evil.

Next to these, on the shaded bank, are different characters out of work: haymakers in quest of employment; a Stoic from the Emerald Island, with hay stuffed in his hat to keep the draught out, and need for Stoicism just at present, being short of baccy; a young shoeless Irishman, with his wife, feeding their first-born with cold pap; an old sailor turned haymaker; and two young peasants in search of harvest work, reduced in strength, perhaps by fever—possibly by famine. Behind the Pariah, who never has learned to work, appears a group of a very different class, who, from an opposite cause, have not been sufficiently used to work either. These are the *rich,* who "have no need to work"—not at least for bread— the *"bread of life"* is neither here nor there. The pastrycook's tray, the symbol of superfluity, accompanies these. It is peculiarly English; I never saw it abroad that I remember, though something of the kind must be used. For some years after returning to England, I could never quite get over a certain socialistic twinge on seeing it pass, unreasonable as the feeling may have been. Past the pastrycook's tray come two married ladies. The elder and more serious of the two devotes her energies to tract distributing, and has just flung one entitled, "The Hodman's Haven; or, Drink for Thirsty Souls," to the somewhat uncompromising specimen of navvy humanity descending the ladder; he scorns it, but with good-nature. This well-intentioned lady has, perhaps, never reflected that excavators may have notions to the effect that ladies might be benefited by receiving tracts containing navvies' ideas! nor yet that excavators are skilled workmen, shrewd thinkers chiefly, and, in general, men of great experience in life, as life presents itself to them.

In front of her is the lady whose only business in life as yet is to dress and look beautiful for our benefit. She probably possesses everything that can give enjoyment to life; how then can she but enjoy the passing moment, and, like a flower, feed on the light of the sun? Would anyone wish it otherwise? Certainly not I, dear lady. Only in your own interest, seeing that certain blessings cannot be insured for ever—as, for instance, health may fail, beauty fade, pleasures through repetition pall—I will not hint at the greater calamities to which flesh is heir—seeing all this, were you less engaged watching that exceedingly beautiful tiny greyhound in a red jacket that *will* run through that lime, I would beg to call your attention to my group of small, exceedingly ragged, dirty children in the foreground of my picture, where you are about to pass. I would, if permitted, observe that, though at first they may appear just such a group of ragged dirty brats as anywhere get in the way and make a noise, yet, being considered attentively, they, like insects, molluscs, miniature plants, &c., develop qualities to form a most interesting study, and occupy the mind at times when all else might fail to attract. That they are motherless, the baby's black ribbons and their extreme dilapidation indicate, making

them all the more worthy of consideration; a mother, however destitute, would scarcely leave the eldest one in such a plight. As to the father, I have no doubt he drinks, and will be sentenced in the police-court for neglecting them. The eldest girl, not more than ten, poor child! is very worn-looking and thin; her frock, evidently the compassionate gift of some grown-up person, she has neither the art nor the means to adapt to her own diminutive proportions—she is fearfully untidy, therefore, and her way of wrenching her brother's hair looks vixenish and against her. But then a germ or rudiment of good housewifery seems to pierce through her disordered envelope, for the younger ones are taken care of, and nestle to her as to a mother; the sun-burnt baby, which looks wonderfully solemn and intellectual, as all babies do, as I have no doubt your own little cherub looks at this moment asleep in its charming bassinet, is fat and well-to-do, it has even been put into poor mourning for its mother. The other little one, though it sucks a piece of carrot in lieu of a sugar-plum, and is shoeless, seems healthy and happy, watching the workmen. The care of the two little ones is an anxious charge for the elder girl, and she has become a premature scold all through having to manage that *boy*—that boy, though a merry, good-natured-looking young Bohemian, is evidently the plague of her life, as boys always are. Even now he *will* not leave that workman's barrow alone, and gets his hair well pulled, as is natural. The dog which accompanies them is evidently of the same outcast sort as themselves. The having to do battle for his existence in a hard world has soured his temper, and he frequently fights, as by his torn ear you may know; but the poor children may do as they like with him; rugged democrat as he is, he is gentle to them, only he hates minions of aristocracy in red jackets. The old bachelor navvy's small valuable bull-pup also instinctively distrusts outlandish-looking dogs in jackets.

The couple on horseback in the middle distance consists of a gentleman, still young, and his daughter. (The rich and the poor both marry early, only those of moderate income procrastinate.) This gentleman is evidently very rich, probably a colonel in the army, with a seat in Parliament, and fifteen thousand a year and a pack of hounds. He is not an over-dressed man of the tailor's dummy sort—he does not put his fortune on his back, he is too rich for that; moreover, he looks to me an honest, true hearted gentleman (he was painted from one I know), and could he only be got to hear what the two sages in the corner have to say, I have no doubt he would be easily won over. But the road is blocked, and the daughter says we must go back, papa, round the other way.

The man with the beer-tray, calling "Beer ho!" so lustily, is a specimen of town pluck and energy contrasted with country thews and sinews. He is hump-backed, stunted in his growth, and in all matters of taste vulgar as Birmingham can make him look in the 19th century. As a child he was probably starved, stunted with gin, and suffered to get run over.

But energy has brought him through to be a prosperous beer-man, and "very much respected," and in his way he also is a sort of hero; that black eye was got probably doing the police of his master's establishment, and in an encounter with some huge ruffian whom he has conquered in fight, and hurled out through the swing-doors of the palace of gin prone on to the pavement. On the wall are posters and bills, one of the "Boys' Home, 41 Euston Road," which the lady who is giving tracts will no doubt subscribe to presently, and place the urchin playing with the barrow in; one of "The Working Men's College, Great Ormond Street," or if you object to these, then a police bill offering £ 50 reward in a matter of highway robbery. Back in the distance we see the Assembly-room of the "Flamstead Institute of Arts," where Professor Snoöx is about to repeat his interesting lecture on the habits of the domestic cat. Indignant pussies up on the roof are denying his theory *in toto*.

The less important characters in the background require little comment. Bobus, our old friend, "the sausage-maker of Houndsditch," from "Past and Present," having secured a colossal fortune (he boasts of it *now*) by anticipating the French Hippophage Society in the introduction of horseflesh as a *cheap* article of human food, is at present going in for the county of Middlesex, and, true to his tactics, has hired all the idlers in the neighbourhood to carry his boards. These being one too many for the bearers, an old woman has volunteered to carry the one in excess.

The episode of the policeman who has caught an orange-girl in the heinous offence of resting her basket on a post, and who himself administers justice in the shape of a push that sends her fruit all over the road, is one of common occurrence, or used to be—perhaps the police now "never do such things."

I am sorry to say that most of my friends, on examining this part of my picture, have laughed over it as a good joke. Only two men saw the circumstance in a different light; one of them was the young Irishman who feeds his infant with pap. Pointing to it with his thumb, his mouth quivering at the reminiscence, he said, "That, Sir, *I* know to be true." The other was a clergyman; his testimony would perhaps have more weight. I dedicate this portion of the work to the Commissioners of Police.

Through this picture I have gained some experience of the navvy class, and I have usually found, that if you can break through the upper crust of *mauvaise honte* which surrounds them in common with most Englishmen, and which, in the case of the navvies, I believe to be the cause of much of their bad language, you will find them serious, intelligent men, and with much to interest in their conversation, which, moreover, contains about the same amount of morality and sentiment that is commonly found among men in the active and hazardous walks of life, for that their career is one of hazard and danger none should doubt. Many stories might be told of navvies' daring and endurance, were this the place for them.

One incident peculiarly connected with this picture is the melancholy fact that one of the very men who sat for it lost his life by a scaffold accident before I had yet quite done with him. I remember the poor fellow telling me, among other things, how he never but once felt nervous with his work, and this was having to trundle barrows of earth over a plank-line crossing a rapid river at a height of *eighty feet* above the water. But it was not the height he complained of, it was the *gliding motion of the water underneath*.

I have only to observe, in conclusion, that the effect of hot July sunlight, attempted in this picture, has been introduced because it seems peculiarly fitted to display *work* in all its severity, and not from any predilection for this kind of light over any other.

N.B.—In several cases I have had the advantage of sittings from personages of note, who, at a loss of time to themselves, have kindly contributed towards the greater truthfulness of some of the characters. As my object, however, in all cases, is to delineate types and not individuals, and as, moreover, I never contemplated employing their renown to benefit my own reputation, I refrain from publishing their names.[3]

Description of a Landscape

As an antidote to the lengthy literary description above, here is a page, dated July 21, 1855, from Brown's diary, revealing a fresh and direct approach to nature.

July 21st, 1855—Looked out for landscapes this evening; but, although all around one is lovely, how little of it will work up into a picture! that is, without great additions and alterations, which is a work of too much time to suit my purpose just now. I want little subjects that will paint off at once. How despairing it is to view the loveliness of nature towards sunset, and know the impossibility of imitating it!—at least in a satisfactory manner, as one could do, would it only remain so long enough. Then one feels the want of a life's study, such as Turner devoted to landscape; and even then what a botch is any attempt to render it! What wonderful effects I have seen this evening in the hayfields! the warmth of the uncut grass, the greeny greyness of the unmade hay in furrows or tufts with lovely violet shadows, and long shades of the trees thrown athwart all, and melting away one tint into another imperceptibly; and one moment more a cloud passes and all the magic is gone. Begin tomorrow morning, all is changed; the hay and the reapers are gone most likely, the sun too, or if not it is in quite the opposite quarter, and all that *was* loveliest is all that is tamest now, alas! It is better to be a poet; still better a mere lover of Nature, one who never dreams of possession. . . .[4]

[3] Ford Madox Brown in Hueffer, *Ford Madox Brown*, pp. 189–195.

[4] Ford Madox Brown in William Michael Rossetti, ed., *Praeraphaelite Diaries and Letters* (London: Hurst and Blackett Limited, 1900), pp. 188–189.

WILLIAM HOLMAN HUNT: 1827–1910

Raphael and Pre-Raphaelitism

In 1848 William Holman Hunt, John Everett Millais, and Dante Gabriel Rossetti founded the Pre-Raphaelite Brotherhood (P.R.B.), whose inception and aims Hunt recalls in later years. Hunt's rather humorless moral earnestness, his quest for absolute accuracy of detail, which, for example, led him several times to Palestine in order to paint Biblical scenes with complete visual and archaeological correctness, remained constant elements in his art throughout his lifetime.

Not alone was the work that we were bent on producing to be more persistently derived from Nature than any having a dramatic significance yet done in the world; not simply were our productions to establish a more frank study of creation as their initial intention, but the name adopted by us negatived the suspicion of any servile antiquarianism. Pre-Raphaelitism is not Pre-Raphaelism. Raphael in his prime was an artist of the most independent and daring course as to conventions. He had adopted his principle, it is true, from the store of wisdom gained by long years of toil, experiment, renunciation of used-up thought, and repeated efforts of artists, his immediate predecessors and contemporaries. What had cost Perugino, Fra Bartolomeo, Leonardo da Vinci, and Michael Angelo more years to develop than Raphael lived, he seized in a day—nay, in one single inspection of his precursors' achievements. His rapacity was atoned for by his never-stinted acknowledgements of his indebtedness, and by the reverent and philosophical use in his work of the conquests he had made. He inherited the booty like a prince, and, like Prince Hal, he retained his prize against all disputants; his plagiarism was the wielding of power in order to be royally free. Secrets and tricks were not what he stole; he accepted the lessons it had been the pride of his masters to teach, and they suffered no hardship at his hands. What he gained beyond enfranchisement was his master's use of enfranchisement, the power to prove that the human figure was of nobler proportion, that it had grander capabilities of action than seen by the casual eye, and that for large work, expression must mainly depend upon movement of the body. Further also, he tacitly demonstrated that there was no fast rule of composition to trammel the arrangement dictated to the artist's will by the theme. Yet, indeed, it may be questioned whether, before the twelve glorious years had come to an end after his sight of the Sixtine chapel ceiling, he did not stumble and fall like a high-mettled steed tethered in a fat pasture who knows not that his freedom is measured. The musing reader of history, however ordinarily sceptical of divine over-rule, may, on the revelation of a catastrophe altogether masqued till the fulness of time, invol-

untarily proclaim the finger of God pointing behind to some forgotten trespass committed in haste to gain the coveted end. There is no need here to trace any failure in Raphael's career; but the prodigality of his productiveness, and his training of many assistants, compelled him to lay down rules and manners of work; and his followers, even before they were left alone, accentuated his poses into postures. They caricatured the turns of his heads and the lines of his limbs, so that figures were drawn in patterns; they twisted companies of men into pyramids, and placed them like pieces on the chess-board of the foreground. The master himself, at the last, was not exempt from furnishing examples of such conventionalities. Whoever were the transgressors, the artists who thus servilely travestied this prince of painters at his prime were Raphaelites. And although certain rare geniuses since then have dared to burst the fetters forged in Raphael's decline, I here venture to repeat, what we said in the days of our youth, that the traditions that went on through the Bolognese Academy, which were introduced at the foundation of all later schools and enforced by Le Brun, Du Fresnoy, Raphael Mengs, and Sir Joshua Reynolds, to our own time were lethal in their influence, tending to stifle the breath of design. The name Pre-Raphaelite excludes the influence of such corrupters of perfection, even though Raphael, by reason of some of his works, be in the list, while it accepts that of his more sincere forerunners. . . .

To those who look upon art as a pretty toy, the earnestness of the notes which were passing through the minds of some of us at this critical time, and which I recall, may seem out of place even as sacred music at a ball. Such objections reveal the idle regard for art which is the natural outcome of fitful and unnational ambition of our disunited forerunners. Our impetuous hope was to replace this mere egotistical whim for art by a patriotic enthusiasm. . . .

In my studio soon after the initiation of the Brotherhood, when I was talking with Rossetti about our ideal intention, I noticed that he still retained the habit he had contracted with Ford Madox Brown of speaking of the new principles of art as "Early Christian." I objected to the term as attached to a school as far from vitality as was modern classicalism, and I insisted upon the designation "Pre-Raphaelite" as more radically exact, and as expressing what we had already agreed should be our principle. The second question, what our corporation itself should be called, was raised by the increase of our company. Gabriel improved upon the previous suggestion with the word Brotherhood, overruling the objection that it savoured of clericalism. When we agreed to use the letters P.R.B. as our insignia, we made each member solemnly promise to keep its meaning strictly secret, foreseeing the danger of offending the reigning powers of

the time. It is strange that with this precaution from dangers from outside our Body, we took such small care to guard ourselves against those that might assail us from within. The name of our Body was meant to keep in our minds our determination ever to do battle against the frivolous art of the day, which had for its ambition "Monkeyana" ideas, "Books of Beauty," Chorister Boys, whose forms were those of melted wax with drapery of no tangible texture. The illustrations to Holy Writ were feeble enough to incline a sensible public to revulsion of sentiment. Equally shallow were the approved imitations of the Greeks, and paintings that would ape Michael Angelo and Titian, with, as the latest innovation, through the Germans, designs that affected without sincerity the naïveté of Perugino and the early Flemings.[5]

A Trip to Paris and Belgium

In 1849 Hunt and Rossetti took a trip to see the art collections of Paris and Belgium. Perhaps most interesting of all, in light of the Pre-Raphaelite's own ideals for art, is Hunt's rather qualified appreciation of the Van Eycks and his unqualified one of Van Dyck! It should be noted, however, that Jan Van Eyck's Arnolfini Wedding Portrait *had entered the National Gallery in London in 1842, and that when Hunt painted his* Awakening Conscience *ten years later (see below, page 109), the example of the Flemish master—the couple within a precisely painted interior filled with meaningful objects, expanded by a mirror-reflection—was not forgotten. (For Rossetti's reactions to the same trip, see below, pp. 111 to 113.)*

The collection in the Louvre gave us much enlightening enjoyment. Fra Angelico's "Coronation of the Virgin" was of peerless grace and sweetness in the eyes of us both. We had hitherto seen nothing of this painter's original work. Titian's "Entombment" showed the artist with a sympathy for sublime sentiment which he rarely reached. Leonardo's "Mona Lisa" appeared as the first example to us of his supreme power to express dreamy beauty. The large composition by Tintoretto gave an idea of his dignity, but the arrangement of figures sitting in a half-circle and seen from below was so common to all painters of his century that to us it fell short of the exalted excellence appraised by Ruskin as the due of the San Rocco pictures. A "Virgin and Child" by Vandyck made me regard the author as a poetic painter of the rarest discrimination for beauty. . . .

Our estimate of Rubens at Antwerp was not so much heightened as we had hoped it would be. The magnificent "Descent from the Cross" was

5 William Holman Hunt, *Pre-Raphaelitism and the Pre-Raphaelite Brotherhood* (London: Macmillan and Co., Limited, 1905), 135–138, 140–42.

away at the restorers, we made some efforts to get an opportunity of examining it, but in vain, and we had to judge of the painter from works which appeared to me, although masterly, far from enchanting. "The Nativity," with one of the Magi in a vermilion blanket, and "The Pieta," representing the dead Christ in the arms of the Father, with bleeding wounds also vermilion, were to our eyes so coarse, that the wonderful facility of drawing and painting scarcely added merit to the productions. In all the collections abroad, except in the case of rare portraits by Rubens, and the painting over his tomb, we saw nothing of his of equal merit to four or five of our paintings in the National Gallery.

We studied attentively the works of John and Hubert Van Eyck; the exquisite delicacy of the workmanship and the unpretending character of the invention made us feel we could not overestimate the perfection of the painting, at least that of John van Eyck. "The Adoration of the Spotless Lamb" did not satisfy my expectations, although there was much suggestion derived from "The Apocalypse" which affected Rossetti to write of it. The same applies notably to Memling; he was led to love these paintings beyond their real claim by reason of the mystery of the subjects. The one real master whose glory was extended in my appreciation was Vandyck, for I found him in ideal work as well as in portraiture an artist peerless in nerve of line and in colour.[6]

A Harsh Review of the Pre-Raphaelites in The Times

In 1851 the Pre-Raphaelites' paintings were not hung together at the annual Exhibition of the Royal Academy (the equivalent of the annual Salons in France), and as a result of this dispersion, the individual works suffered. According to Hunt's own account: "No sooner had the Exhibition opened, than we found that the storm of abuse of last year was now turned into a hurricane." The artist chose the following review from The Times *to illustrate the general tenor of hostile criticism. It is reminiscent of the same sort of judgment directed against the Realists, and later, against the Impressionists, on the other side of the Channel. This review, incidentally, is the very one that goaded John Ruskin into his heated letter of rebuttal (see below, pp. 117 to 120), thus beginning the latter's role as public defender of the Pre-Raphaelite movement.*

We cannot censure at present as amply or as strongly as we desire to do, that strange disorder of the mind or the eyes which continues to rage with unabated absurdity among a class of juvenile artists who style themselves P.R.B., which, being interpreted, means *Pre-Raphael-brethren.* Their faith seems to consist in an absolute contempt for perspective and the known laws of light and shade, an aversion to beauty in every shape,

6 *Ibid.,* pp. 190–193.

and a singular devotion to the minute accidents of their subjects, including, or rather seeking out, every excess of sharpness and deformity. Mr. Millais, Mr. Hunt, Mr. Collins [7]—and in some degree—Mr. Brown, the author of a huge picture of Chaucer, have undertaken to reform the art on these principles. The Council of the Academy, acting in a spirit of toleration and indulgence to young artists, have now allowed these extravagances to disgrace their walls for the last three years, and though we cannot prevent men who are capable of better things from wasting their talents on ugliness and conceit, the public may fairly require that such offensive jests should not continue to be exposed as specimens of the waywardness of these artists who have relapsed into the infancy of their profession.

In the North Room will be found, too, Mr. Millais' picture of "The Woodman's Daughter," from some verses by Mr. Coventry Patmore,[8] and as the same remarks will apply to the other pictures of the same artist, "The Return of the Dove to the Ark" (651), and Tennyson's "Mariana" (561), as well as to similar works by Mr. Collins, as "Convent Thoughts" (493), and to Mr. Hunt's "Valentine receiving Proteus" [sic] (59), we shall venture to express our opinion on them all in this place. These young artists have unfortunately become notorious by addicting themselves to an antiquated style and an affected simplicity in Painting, which is to genuine art what the mediaeval ballads and designs in *Punch* are to Chaucer and Giotto. With the utmost readiness to humour even the caprices of Art when they bear the stamp of originality and genius, we can extend no toleration to a mere servile imitation of the cramped style, false perspective, and crude colour of remote antiquity. We do not want to see what Fuseli [9] termed drapery "snapped instead of folded," faces bloated into apoplexy or extenuated to skeletons, colour borrowed from the jars in a druggist's shop, and expression forced into caricature. It is said that the gentlemen have the power to do better things, and we are referred in proof of their handicraft to the mistaken skill with which they have transferred to canvas the hay which lined the lofts in Noah's Ark, the brown leaves of the coppice where Sylvia strayed, and the prim vegetables of a monastic garden. But we must doubt a capacity of which we have seen so little proof, and if any such capacity did ever exist in them, we fear that it has already been overlaid by mannerism and conceit. To

[7] Charles Allston Collins (1828–1873), publicist and painter, who exhibited at the Royal Academy and the British Institution between the years 1847 and 1872. He was the brother of Wilkie Collins, the writer.

[8] Coventry Patmore (1823–1896), English poet and critic, friend of Rossetti and Hunt, associated with the Pre-Raphaelite movement, and a contributor to their publication, the *Germ*.

[9] John Henry Fuseli (1741–1825), Swiss neo-classical artist who established himself in England, where he drew and painted classical, romantic, Shakespearean, and Miltonic subjects in a linear, often fantastically exaggerated style. He was a member of and teacher at the Royal Academy.

become great in art, it has been said that a painter must become as a little child, though not childish, but the authors of these offensive and absurd productions have continued to combine the puerility or infancy of their art with the uppishness and self-sufficiency of a different period of life. That morbid infatuation which sacrifices truth, beauty, and genuine feeling to mere eccentricity deserves no quarter at the hands of the public, and though the patronage of art is sometimes lavished on oddity as profusely as on higher qualities, these monkish follies have no more real claim to figure in any decent collection of English paintings than the aberrations of intellect which are exhibited under the name of Mr. Ward
—*Times*, 7th May, 1851.[10]

A Consideration of Technical Procedures

The system of painting on a white ground, described below, recalls that of the Flemish primitives, as does the careful outlining of the composition and the use of layers of transparent or translucent color. Hunt's discussion of technique, with its overtones of medieval craftsmanship, also reveals the attention paid to the "cookery" of the work of art by the Pre-Raphaelites.

While Millais and I had been conferring about systems of painting, we had dwelt much upon the great value of a plan we had both independently adopted of painting over a ground of wet white, which gave special delicacy of coloration and tone. Millais in earlier works had relied upon the system to produce the effect of sunlight on flesh and brilliantly lit drapery. The head of the boy in "The Woodman's Daughter" may be taken as example of what my friend had done before. I, quite independently, had relied on this novel system, extending it from small to larger parts of my work. The heads of Valentine and of Proteus, the hands of these figures, and the brighter costumes in the same painting had been executed in this way. In earlier pictures the method had been adopted by me to less extent. In the country we had used it, so far, mainly for blossoms of flowers, for which it was singularly valuable.

The process may be described thus. Select a prepared ground originally for its brightness, and renovate it, if necessary, with fresh white when first it comes into the studio, white to be mixed with a very little amber or copal varnish. Let this last coat become of a thoroughly stone-like hardness. Upon this surface, complete with exactness the outline of the part in hand. On the morning for the painting, with fresh white (from which all superfluous oil has been extracted by means of absorbent paper, and to which again a small drop of varnish has been added) spread a further coat very evenly with a palette knife over the part for the day's work,

[10] Hunt, *Pre-Raphaelitism*, pp. 249–251.

of such consistency that the drawing should faintly show through. In some cases the thickened white may be applied to the forms needing brilliancy with a brush, by the aid of rectified spirits. Over this wet ground, the colour (transparent and semi-transparent) should be laid with light sable brushes, and the touches must be made so tenderly that the ground below shall not be worked up, yet so far enticed to blend with the superimposed tints as to correct the qualities of thinness and staininess, which over a dry ground transparent colours used would inevitably exhibit. Painting of this kind cannot be retouched except with an entire loss of luminosity. Millais proposed that we should keep this as a precious secret to ourselves.[11]

"The Light of the World"

Hunt began work on an outspokenly religious and primitivizing work, The Light of the World, *in 1851. It was to become one of the most popular paintings of its age. A full length figure of the crowned Christ, carrying a lantern, knocking on a vine-covered door (reminiscent of the antique Diogenes with his light, searching for an honest man), the figure was meant to suggest Christ's search for a wide-awake soul in a sleeping world. The varieties of foliage, the brocade of Christ's dalmatic, and the lantern itself, even the dewdrops on the tips of the blades of grass illuminated by the lantern light—all, as the French novelist and critic, Théophile Gautier, observed admiringly, are painted with an incredible degree of finish. Gautier's only regret, expressed in his review of the English painters at the Paris Universal Exposition of 1855, was that Hunt, in his anxiety to capture every particle of the visible world with absolute precision, was unable to give a sense of scale to his canvas. As a result, "the details take on that exaggerated importance that the microscope gives to objects and a blade of grass attracts the eye as much as a tree." (For a quite different opinion of the English critic, John Ruskin, about this painting, see below, pp. 123 to 125.)*

It was late in the autumn, but I had matured my preparations for "The Light of the World" enough to work in the old orchard before the leaves and fruit had altogether disappeared. To paint the picture life size, as I should have desired, would then have forbidden any hope of sale. For my protection from the cold, as far as it could be found, I had a little sentry-box built of hurdles, and I sat with my feet in a sack of straw. A lamp, which I at first tried, proved to be too strong and blinding to allow me to distinguish the subtleties of hue of the moonlit scene, and I had to be satisfied with the illumination from a common candle. I went out to my work about 9 P.M., and remained till 5 A.M. the next morning, when I

[11] *Ibid.,* pp. 275–277.

retired into the house to bed till about ten, and then rose to go back to my hut and devote myself for an hour or two to the rectifying of any errors of colour, and to drawing out the work for the ensuing night. . . .

. . . One of my first duties now was to design the lantern which was to be carried by the Saviour; the windows and opening had to be carefully studied in relation to the rays of light they would emit from the central light. It had to be made in metal; it seemed to me that tin might serve the purpose, which could be lacquered to represent gold. A metal worker agreed to make it for a small sum, but afterwards represented that the cost would not be much extra if made in brass, and as this seemed too trifling to be considered, I assented, but was not a little dismayed eventually at having to pay over seven pounds. Had I gone to a brass ornamentalist in the first instance it is probable that his price would have been less, and the work much better.

On moonlight nights at Chelsea I was able by some dried clinging tendrils of ivy, which I had brought from the door in Surrey and fastened to an old board, to advance what I had done on the spot itself. Until the place of the figure and drapery could be decided I had been unable to paint this part of the background. . . .

I may say that any occult meaning in the details of my design was not based upon ecclesiastical or archaic symbolism, but derived from obvious reflectiveness. My types were of natural figures such as language had originally employed to express transcendental ideas, and they were used by me with no confidence that they would interest any other mind than my own. The closed door was the obstinately shut mind, the weeds the cumber of daily neglect, the accumulated hindrances of sloth; the orchard the garden of delectable fruit for the dainty feast of the soul. The music of the still small voice was the summons to the sluggard to awaken and become a zealous labourer under the Divine Master; the bat flitting about only in darkness was a natural symbol of ignorance; the kingly and priestly dress of Christ, the sign of His reign over the body and the soul, to them who could give their allegiance to Him and acknowledge God's overrule. In making it a night scene, lit mainly by the lantern carried by Christ, I had followed metaphorical explanation in the Psalms, "Thy word is a lamp unto my feet, and a light unto my path," with also the accordant allusions by St. Paul to the sleeping soul, "The night is far spent, the day is at hand." The symbolism was designed to elucidate, not to mystify, truth; and as I never gave any explanation of my underlying meaning, and the purpose has in the main been interpreted truly, the strictures upon my typical presentment of the subject are surely not founded on reason.[12]

12 *Ibid.,* pp. 299, 308–309, 350–351.

"The Awakening Conscience"

Painted from 1852 to 1854, this work attempts to convey the dawning spiritual realization of a fallen woman, who slowly rises from the knees of her lover, within a cluttered and minutely painted interior rich in symbolic implication. Hunt's moralistic self-righteousness verges on the absurd in this work. Here is the description of its genesis. (See below, pp. 125 to 127, for Ruskin's encomium of the painting.)

. . . When "The Light of the World" was on my easel at Chelsea in 1851, it occurred to me that my spiritual subject called for a material counterpart in a picture representing in actual life the manner in which the appeal of the spirit of heavenly love calls a soul to abandon a lower life. In reading *David Copperfield* I had been deeply touched by the pathos of the search by old Peggotty after little Emily, when she had become an outcast, and I went about to different haunts of fallen girls to find a locality suitable for the scene of the old mariner's pursuing love. My object was not to illustrate any special incident in the book, but to take the suggestion of the loving seeker of the fallen girl coming upon the object of his search. I spoke freely of this intended subject, but, while cogitating upon the broad intention, I reflected that the instinctive eluding of pursuit by the erring one would not coincide with the willing conversion and instantaneous resolve for a higher life which it was necessary to emphasise.

While recognising this, I fell upon the text in Proverbs, "As he that taketh away a garment in cold weather, so is he that singeth songs to a heavy heart." These words, expressing the unintended stirring up of the deeps of pure affection by the idle sing-song of any empty mind, led me to see how the companion of the girl's fall might himself be the unconscious utterer of a divine message. In scribbles I arranged the two figures to present the woman recalling the memory of her childish home, and breaking away from her gilded cage with a startled holy resolve, while her shallow companion still sings on, ignorantly intensifying her repentant purpose.[13]

DANTE GABRIEL ROSSETTI: 1828–1882

The Pre-Raphaelite Immortals

Dante Gabriel Rossetti, with his febrile enthusiasm and intense imagination, was the guiding spirit of the P.R.B., which he founded in 1848, at the age of twenty, with the young Hunt and Millais. It was mainly due

[13] Hunt, *Pre-Raphaelitism*, II, 429–430.

to Rossetti that the Pre-Raphaelite movement made its decisive turn away from contemporary subjects like Brown's Work *or Hunt's the* Last of England, *and toward mystical, medieval, and literary ones, choosing themes, for example, derived from Dante or Arthurian legend. (Rossetti himself painted only one subject drawn from contemporary life in a realistic manner:* Found, *begun in 1853 and left unfinished at his death.) In a sense, some of the moral tension of the best works confronting, or at least suggesting, the outrages committed by an industrial society was lost by this withdrawal into a purified, symbolic, and richly polychromed, decorative past. Yet two of Rossetti's best works (and his earliest),* The Girlhood of Mary Virgin *(1848–1851) and* Ecce Ancilla Domini *(The Annunciation, 1848–1853), were produced under the impulsion of a retreat into a more symbolic world of spiritual grace and physical attrition.*

The following list of "Immortals," the Pre-Raphaelite manifesto, written by Rossetti, gives an idea of the taste of the P.R.B., certainly rather catholic—even eclectic—in its range. It is amusing to note that George Washington outranked Fra Angelico!

. . . Hunt and I have prepared a list of Immortals, forming our creed, and to be pasted up in our study for the affixing of all decent fellows' signatures. It has already caused considerable horror among our acquaintance. I suppose we shall have to keep a hair-brush. The list contains four distinct classes of Immortality; in the first of which three stars are attached to each name, in the second two, in the third one, and in the fourth none. The first class consists only of Jesus Christ and Shakespear. We are also about to transcribe various passages from our poets, together with forcible and correct sentiments, to be stuck up about the walls. . . .[14]

We, the undersigned, declare that the following list of Immortals constitutes the whole of our Creed, and that there exists no other Immortality than what is centred in their names and in the names of their contemporaries, in whom this list is reflected:—

Jesus Christ****	Rienzi
The Author of Job***	Ghiberti
Isaiah	Chaucer**
Homer**	Fra Angelico*
Pheidias	Leonardo da Vinci**
Early Gothic Architects	Spenser
Cavalier Pugliesi	Hogarth
Dante**	Flaxman
Boccaccio*	Hilton

[14] Dante Gabriel Rossetti, Excerpt from a letter to his brother, William Michael, dated August 30, 1848, in *His Family Letters,* with a memoir by William Michael Rossetti (Boston: Roberts Brothers, 1895), II, 42.

Goethe** Shakespeare***
Kosciusko Milton
Byron Cromwell
Wordsworth Hampden
Keats** Bacon
Shelley** Newton
Haydon Landor**
Cervantes Thackeray**
Joan of Arc Poe
Mrs. Browning* Hood
Patmore* Longfellow*
Raphael* Emerson
Michael Angelo Washington**
Early English Balladists Leigh Hunt
Giovanni Bellini Author of *Stories after Nature**
Georgioni Wilkie
Titian Columbus
Tintoretto Browning**
Poussin Tennyson* [15]
Alfred**

Van Eyck and Memling

In this letter to James Collinson, a fellow member of the Pre-Raphaelite Brotherhood, written from Bruges in the course of the art-tour of 1849 with Holman Hunt, Rossetti exhibits his enthusiasm for the works of Van Eyck and Memling. (For a description of the tour by Hunt, see above, pp. 103 to 104.) Rossetti's obvious preference for Memling is typical both of the period and of the unfortunate weakness of the artist's own taste: the rigors of the Flemish primitive style had to be mitigated by softness, sweetness, and a self-consciously spiritual content before they could be digested by even the most rebellious youth from Victorian England. For Rossetti, Van Eyck was simply "less poetical" than Memling. The term is revealing.

BRUGES: HÔTEL DU COMMERCE
25 OCTOBER 1849.

DEAR P.R.B.,

. . . I believe we have seen to-day almost everything very remarkable at Bruges; but I assure you we shall want to see much of it again. This is a most stunning place, immeasurably the best we have come to. There is a quantity of first-rate architecture, and very little or no Rubens.

But by far the best of all are the miraculous works of Memling and Van Eyck. The former is here in a strength that quite stunned us—and perhaps proves himself to have been a greater man even than the latter.

[15] Dante Gabriel Rossetti, in William Holman Hunt, *Pre-Raphaelitism and the Pre-Raphaelite Brotherhood* (London: Macmillan and Co., Limited, 1905), I, 159. A fourth star was finally added to the name of Jesus Christ.

In fact, he was certainly so intellectually, and quite equal in mechanical power. His greatest production is a large triptych in the Hospital of St. John, representing in its three compartments: firstly, the *Decollation of St. John Baptist;* secondly, *the Mystic Marriage of St. Catherine to the Infant Saviour;* and thirdly, *the Vision of St. John Evangelist in Patmos.* I shall not attempt any description; I assure you that the perfection of character and even drawing, the astounding finish, the glory of colour, and above all the pure religious sentiment and ecstatic poetry of these works, is not to be conceived or described. Even in seeing them, the mind is at first bewildered by such Godlike completeness; and only after some while has elapsed can at all analyse the causes of its awe and admiration; and then finds these feelings so much increased by analysis that the last impression left is mainly one of utter shame at its own inferiority. Van Eyck's picture at the Gallery [16] may give you some idea of the style adopted by Memling in these great pictures; but the effect of light and colour is much less poetical in Van Eyck's; partly owing to *his* being a more sober subject and an interior, but partly also, I believe, to the intrinsic superiority of Memling's intellect. In the background of the first compartment there is a landscape more perfect in the abstract lofty feeling of nature than anything I have ever seen. The visions of the third compartment are wonderfully mystic and poetical.

The Royal Academy here possesses also some most stupendous works of Memling—among them one of a Virgin and Child, quite astounding. In the same collection is a very wonderful Van Eyck, some of the heads of which, however, are dreadfully vulgar in character; [17] and two pictures by some unknown author, representing the capture and execution of Cambyses—equal to any one for colour and individuality, and most remarkably fine in drawing. They are powerfully dramatic—the second perhaps a trifle too much so, as it represents a man being flayed alive, and is revolting from its extreme truthfulness.[18]

We have seen here a great many other stunning pictures, in which this town is marvellously rich. There are several Memlings besides those named above, and some glorious portraits by one of the Porbus family —perhaps the finest specimens of portraiture we ever saw.

I forgot to mention that Memling's pictures in the Hospital of St. John were presented to the Institution by that stunner in return for the care bestowed upon him when he was received here, severely wounded and in great want, after the battle of Nancy. The interior of the hospital has undergone since his time but very little alteration. His pictures are

[16] A reference to Jan Van Eyck's *Arnolfini Wedding Portrait,* which had entered the National Gallery in 1842.

[17] No doubt a reference to Jan Van Eyck's *Virgin and Child with the Canon van der Paele, Sts. George and Donatian,* 1436.

[18] Rossetti here refers to Gerard David's diptych, *The Judgment of Cambyses,* 1498.

not painted with oil—he having preceded Van Eyck [19]—but with some vehicle of which brandy and white of egg are the principal components. They have cracked very slightly indeed; and one cannot conceive the colours to have been more brilliant on the day of their completion.

Another great treat we had to-day was in visiting the Chapelle du Sang de Dieu, a wonderful little place: also the Jerusalem, which is in all respects a facsimile of the Holy Sepulchre in Palestine.[20]

"Ecce Ancilla Domini" ("The Annunciation")

As Secretary of the Brotherhood, William Michael Rossetti, Dante Gabriel's brother, kept the **P.R.B.** Journal *from 1849 to 1853. In these excerpts from it, he describes the evolution of his brother's* Annunciation, *on which the latter worked from 1849 to 1853 (although it is signed and dated 1850). This painting, though one of Rossetti's most successful, nevertheless reveals his unfortunate weakness in such technical matters as drawing and perspective—here perhaps compensated for or hidden by the youthful intensity of Rossetti's religious emotion, the extreme simplicity, reminiscent of Fra Angelico, of the setting, and the earnest exactitude of detail. Rossetti's use of friends or relatives rather than professional models reflects another element of the Pre-Raphaelite canon. Yet even this early work is tinged with that sense of morbid fancifulness and withheld eroticism, which, perhaps, only finds its complete expression in the elegant refinement and linear sensuality of an artist like Beardsley at the end of the century.*

Saturday [December] 25th [1849]—Gabriel began making a sketch for *The Annunciation.* The Virgin is to be in bed, but without any bedclothes on, an arrangement which may be justified in consideration of the hot climate; and the angel Gabriel is to be presenting a lily to her. The picture, and its companion of the Virgin's Death, will be almost entirely white. . . .

Friday [March] 29th [1850]—Gabriel painted at the feet and arm of the angel from White. He had Miss Love to sit for the Virgin's hair, and is also repainting the head entirely. He has finished the embroidery-stand; and of the background done a curious lamp Brown has got, and a vase. The angel's head is being painted from a model, Lambert, of whom he has had two or three sittings. . . .

[19] This is, of course, completely untrue. Jan Van Eyck lived from c. 1390 to 1441 while Hans Memling was born in c. 1435 and died in 1494.

[20] Dante Gabriel Rossetti, Letter from Bruges, October 25, 1849 to James Collinson, in William Michael Rossetti, ed., *Praeraphaelite Diaries and Letters* (London: Hurst and Blackett, Limited, 1900), pp. 13–16.

Sunday [April] 7th [1850]—. . . I did not get home till too late to sit to Gabriel, who had wanted me for a final re-touching of the Angel's hand. He has got some spirits of wine and chloride of something, to make the flame for the Angel's feet. . . .

Friday [December] 6th [1850]—Gabriel painted a left hand to his angel Gabriel, thinking it objectionable that one hand only should be visible of each figure. . . .

Sunday [January] 23rd to Saturday [January] 29th [1853]—Gabriel finished and sent off *The Annunciation* picture. It has now lost its familiar name of "The Ancilla," the mottoes having been altered from Latin to English, to guard against the imputation of "popery." . . .[21]

Two Poems

Many of Rossetti's poems included in the Sonnets for Pictures *were inspired by paintings—either those of masters he admired or his own pictorial works. The first of these, "For a Marriage of St. Catherine by Memmelinck," was obviously inspired by the triptych he had so admired when he had first seen it in 1849; the second, "Mary's Girlhood," seems a fairly accurate description of Rossetti's own painting,* The Girlhood of Mary Virgin *(1848–1851).*

For
A MARRIAGE OF ST. CATHERINE
By *Hans Memmelinck.*

(In the Hospital of St. John at Bruges.)
Mystery: Catherine the bride of Christ.
 She kneels, and on her hand the holy Child
 Now sets the ring. Her life is hushed and mild,
Laid in God's knowledge—ever unenticed
From God, and in the end thus fitly priced.
 Awe, and the music that is near her, wrought
 Of angels, have possessed her eyes in thought:
Her utter joy is hers, and hath sufficed.

There is a pause while Mary Virgin turns
 The leaf, and reads. With eyes on the spread book,
 That damsel at her knees reads after her.
 John whom He loved and John His harbinger,
Listen and watch. Whereon soe'er thou look,
The light is starred in gems and the gold burns.

[21] William Michael Rossetti, "The P.R.B. Journal, 1849–1853," in *Praeraphaelite Diaries*, pp. 235, 270–272, 290, 309.

MARY'S GIRLHOOD
(For a Picture.)

I.

This is that blessed Mary, pre-elect
 God's Virgin. Gone is a great while, and she
 Dwelt young in Nazareth of Galilee.
Unto God's will she brought devout respect,
Profound simplicity of intellect,
 And supreme patience. From her mother's knee
 Faithful and hopeful; wise in charity;
Strong in grave peace; in pity circumspect.

So held she through her girlhood; as it were
 An angel-watered lily, that near God
 Grows and is quiet. Till, one dawn at home
She woke in her white bed, and had no fear
 At all,—yet wept till sunshine, and felt awed:
 Because the fulness of the time was come.

II.

These are the symbols. On that cloth of red
 I' the centre is the Tripoint: perfect each,
 Except the second of its points, to teach
That Christ is not yet born. The books—whose head
Is golden Charity, as Paul hath said—
 Those virtues are wherein the soul is rich:
 Therefore on them the lily standeth, which
Is Innocence, being interpreted.

The seven-thorn'd briar and the palm seven-leaved
 Are her great sorrow and her great reward.
 Until the end be full, the Holy One
Abides without. She soon shall have achieved
 Her perfect purity: yea, God the Lord
 Shall soon vouchsafe His Son to be her Son.[22]

JOHN EVERETT MILLAIS: 1829–1896

Letter About "Before the Flood"

John Everett Millais, one of the founding members of the Pre-Raphaelite Brotherhood, along with Rossetti and Hunt, was the most technically skillful of all the group. He was, in fact, a child prodigy who had been accepted by the Royal Academy schools at the early age of eleven. From the inception of the Brotherhood in 1848 until the waning

[22] Dante Gabriel Rossetti, *Collected Works*, ed. William Michael Rossetti (Boston: Roberts Brothers, 1887), I, 349, 353–354.

*of its creative powers in the late 1850s, Millais painted some of its finest
pictures, such as* Christ in the House of His Parents (The Carpenter's
Shop) *of 1850, for which, in the interests of verisimilitude, he had an
actual carpenter pose for the figure of St. Joseph, using his own father for
the head; and the beautiful* Blind Girl *of 1856, with its relatively unsenti-
mentalized figures and fresh, radiant landscape. In later years Millais'
work degenerated and he turned to sentimental, facile genre pieces and
portraits which won him immense popularity. Elected to the Royal Acad-
emy in 1853, he later became its president and received a baronetcy.*

*The painting he describes to Mrs. Combe (who, with her husband,
was one of Millais' closest friends), entitled "For as in the Days that were
Before the Flood . . . ," was never completed as a painting, although a
finished drawing of it exists. Millais' letter conveys a sense of the high
moral tone of the Pre-Raphaelite endeavor.*

83, GOWER STREET,
[MAY] 28th, 1851

MY DEAR MRS. COMBE,

I feel it a duty to render you my most heartfelt thanks for the noble
appreciation of my dear friend Collins' work and character. I include char-
acter, for I cannot help believing, from the evident good feeling evinced
in your letter, that you have thought more of the beneficial results the
purchase may occasion him than of your personal gratification at possess-
ing the picture.

You are not mistaken in thus believing him worthy of your kindest
interests, for there are few so devotedly directed to the one thought of
some day (through the medium of his art) turning the minds of men to
good reflections and so heightening the profession as one of unworldly
usefulness to mankind.

This is our great object in painting, for the thought of simply pleas-
ing the senses would drive us to other pursuits requiring less of that un-
ceasing attention so necessary to the completion of a perfect work.

I shall endeavour in the picture I have in contemplation—"For as in
the Days that were Before the Flood," etc., etc.—to affect those who may
look on it with the awful uncertainty of life and the necessity of always
being prepared for death. My intention is to lay the scene at the marriage
feast. The bride, elated by her happiness, will be playfully showing her
wedding-ring to a young girl, who will be in the act of plighting her troth
to a man wholly engrossed in his love, the parents of each uniting in con-
gratulation at the consummation of their own and their children's happi-
ness. A drunkard will be railing boisterously at another, less intoxicated,
for his cowardice in being somewhat appalled at the view the open win-
dow presents—flats of glistening water, revealing but the summits of

mountains and crests of poplars. The rain will be beating in the face of the terrified attendant who is holding out the shutter, wall-stained and running down with the wet, but slightly as yet inundating the floor. There will also be the glutton quietly indulging in his weakness, unheeding the sagacity of his grateful dog, who, thrusting his head under his hands to attract attention, instinctively feels the coming ruin. Then a woman (typical of worldy vanity) apparelled in sumptuous attire, withholding her robes from the contamination of his dripping hide. In short, all deaf to the prophecy of the Deluge which is swelling before their eyes—all but one figure in their midst, who, upright with closed eyes, prays for mercy for those around her, a patient example of belief standing with, but far from, them placidly awaiting God's will.

I hope, by this great contrast, to excite a reflection on the probable way in which sinners would meet the coming death—all on shore hurrying from height to height as the sea increases; the wretched self-congratulations of the bachelor who, having but himself to save, believes in the prospect of escape; the awful feelings of the husband who sees his wife and children looking in his face for support, and presently disappearing one by one in the pitiless flood as he miserably thinks of his folly in not having taught them to look to God for help in times of trouble; the rich man who, with his boat laden with wealth and provisions, sinks in sight of his fellow-creatures with their last curse on his head for his selfishness; the strong man's strength failing gradually as he clings to some fragment floating away on the waste of water; and other great sufferers miserably perishing in their sins.

I have enlarged on this subject and the feelings that I hope will arise from the picture, as I know you will be interested in it. One great encouragement to me is the certainty of its having this one advantage over a sermon, that it will be all at once put before the spectator without that trouble of realisation often lost in the effort of reading or listening. . . .[23]

JOHN RUSKIN: 1819–1900

A Defense of the Pre-Raphaelites

John Ruskin, author of The Seven Lamps of Architecture, The Stones of Venice, *and* Modern Painters, *became the apologist, patron, and friend of the Pre-Raphaelites. His first contact with them took place in 1851, when he defended them in a letter to* The Times. *Throughout the fifties his position as an established art critic and the author of* Mod-

23 John Everett Millais, Letter to Mrs. Combe of [May] 28th, 1851, in John Guille Millais, *The Life and Letters of Sir John Everett Millais* (London: Methuen and Co., 1899), I, 103–105.

ern Painters, *in which he had so skillfully established the importance of Turner and the values of truthfully observed and accurately rendered landscape painting in general, helped the Pre-Raphaelites to gain public acceptance.*

His closest friends in the Brotherhood were Rossetti and Millais, until Millais' love affair with the beautiful Mrs. Ruskin, ended in her divorce from Ruskin and marriage to Millais in 1854. The year before, Millais had painted Ruskin's portrait at Glenfilas, with an appropriate setting of precisely painted rocks and torrents: Ruskin was an ardent amateur geologist. Ruskin himself made innumerable landscape drawings— delicate, sensitive studies of details of trees, rock-formations, leaves, foliage, shells, and architecture. He is, of course, less known as an artist than as an art critic, theoretician, and proselytizer, notably as the spokesman for a socially rooted conception of architecture and art in general, for which he found authority in the creations of the past, especially those of the Gothic period. In his insistence upon the absolute connection of aesthetic value with social justice and moral probity, Ruskin's is the voice of a small but significant body of opinion in the art criticism of the 19th century, crying out in the wilderness against the industrial age.

The following letter is Ruskin's answer to an extremely harsh criticism, which had appeared in The Times *in May, 1851, of the works of Millais and Hunt at the Royal Academy Exhibition. For the critical article in question, see above pp. 104 to 106.*

. . . Let me state, in the first place, that I have no acquaintance with any of these artists [the Pre-Raphaelites], and very imperfect sympathy with them. No one who has met with any of my writings will suspect me of desiring to encourage them in their Romanist and Tractarian [24] tendencies. I am glad to see that Mr. Millais' lady in blue [25] is heartily tired of her painted window and idolatrous toilet-table; and I have no particular respect for Mr. Collins' lady in white, because her sympathies are limited by a dead wall, or divided between some gold fish and a tadpole—(the latter Mr. Collins may, perhaps, permit me to suggest *en passant,* as he is already half a frog, is rather too small for his age). But I happen to have a special acquaintance with the water plant *Alisma Plantago,* among which the said gold fish are swimming; and as I never saw it so thoroughly or so well drawn, I must take leave to remon-

[24] Tractarianism (or the Oxford movement) was a High-Church reaction in the direction of a return to primitive Catholicism and against rationalism and formalism in the nineteenth-century Church of England. The movement received its name from ninety tracts published in Oxford from 1833 to 1841.

[25] The paintings discussed by Ruskin, shown by the Pre-Raphaelites at the Academy in 1851 were: Millais' *Mariana, The Return of the Dove to the Ark,* and *The Woodman's Daughter;* Holman Hunt's *Valentine Rescuing Sylvia from Proteus,* and Charles A. Collins' *Convent Thoughts.*

strate with you, when you say sweepingly that these men "sacrifice *truth* as well as feeling to eccentricity." For as a mere botanical study of the water-lily and *Alisma,* as well as of the common lily and several other garden flowers, this picture would be invaluable to me, and I heartily wish it were mine.

But, before entering into such particulars, let me correct an impression which your article is likely to induce in most minds, and which is altogether false. These Pre-Raphaelites (I cannot compliment them on common-sense in choice of a *nom de guerre*) do *not* desire nor pretend in any way to imitate antique painting as such. They know very little of ancient paintings who suppose the works of these young artists to resemble them. As far as I can judge of their aim—for, as I said, I do not know the men themselves—the Pre-Raphaelites intend to surrender no advantage which the knowledge or inventions of the present time can afford to their art. They intend to return to early days in this one point only—that, as far as in them lies, they will draw either what they see, or what they suppose might have been the actual facts of the scene they desire to represent, irrespective of any conventional rules of picture-making; and they have chosen their unfortunate though not inaccurate name because all artists did this before Raphael's time, and after Raphael's time did *not* this, but sought to paint fair pictures, rather than represent stern facts; of which the consequence has been that, from Raphael's time to this day, historical art has been in acknowledged decadence.

Now, sir, presupposing that the intention of these men was to return to archaic *art* instead of to archaic *honesty,* your critic borrows Fuseli's [26] expression respecting ancient draperies "snapped instead of folded," and asserts that in these pictures there is a *"servile* imitation of *false* perspective." To which I have just this to answer:

That there is not one single error in perspective in four out of the five pictures in question; and that in Millais' "Mariana" there is but this one—that the top of the green curtain in the distant window has too low a vanishing-point; and that I will undertake, if need be, to point out and prove a dozen worse errors in perspective in any twelve pictures, containing architecture, taken at random from among the works of the popular painters of the day.

Secondly: that, putting aside the small Mulready, and the works of Thorburn and Sir W. Ross,[27] and perhaps some others of those in the miniature room which I have not examined, there is not a single study of drapery in the whole Academy, be it in large works or small, which for perfect truth, power and finish could be compared for an instant with

[26] John Henry Fuseli (1741–1825). See note 9, this chapter.
[27] William Mulready (1786–1863), British genre, landscape, and portrait painter. Robert Thorburn (1818–1885), a Scottish-born miniature painter, specializing in ivory paintings. William Charles Ross (1794–1860), also a painter of ivory miniatures.

the black sleeve of the Julia, or with the velvet on the breast and the chain mail of the Valentine, of Mr. Hunt's picture; or with the white draperies on the table of Mr. Millais' "Mariana," and of the right-hand figure in the same painter's "Dove returning to the Ark."

And further: that as studies both of drapery and of every minor detail, there has been nothing in art so earnest or so complete as these pictures since the days of Albert Durer. This I assert generally and fearlessly. On the other hand, I am perfectly ready to admit that Mr. Hunt's "Sylvia" is not a person whom Proteus or any one else would have been likely to fall in love with at first sight; and that one cannot feel very sincere delight that Mr. Millais' "Wives of the Sons of Noah" should have escaped the Deluge; and many other faults besides, on which I will not enlarge at present, because I have already occupied too much of your valuable space, and I hope to enter into more special criticism in a future letter.

> I have the honor to be, Sir,
> Your obedient servant,
>
> THE AUTHOR OF "MODERN PAINTERS." [28]

A Second Letter to The Times *About the Pre-Raphaelites*

It will become obvious from the letter below, if it is not obvious already, that Ruskin was by no means completely approving of his new protégés. Throughout his association with the Brotherhood he continually offered its members advice, criticism, and instruction, despite the fact that they were not always anxious to have it. (See below for Rossetti's reaction; for instance, page 127.) Nevertheless, in this particular case, Ruskin's criticisms—i.e., commonness of features, defective coloring of flesh—are certainly minor ones.

To the Editor of *The Times*

SIR:

Your obliging insertion of my former letter encourages me to trouble you with one or two further notes respecting the Pre-Raphaelite pictures. I had intended, in continuation of my first letter, to institute as close an inquiry as I could into the character of the morbid tendencies which prevent these works from favorably arresting the attention of the public; but I believe there are so few pictures in the Academy whose reputation would not be grievously diminished by a deliberate inventory of their errors, that I am disinclined to undertake so ungracious a task with respect to this or that particular work. These points, however, may be

28 John Ruskin, Letter dated May 9, 1851, appearing in *The Times*, May 13, 1851, reprinted in *Arrows of the Chace* (Boston: Dana Estes, n.d.), I, 67–70.

noted, partly for the consideration of the painters themselves, partly that forgiveness of them may be asked from the public in consideration of high merits in other respects.

The most painful of these defects is unhappily also the most prominent—the commonness of feature in many of the principal figures. In Mr. Hunt's "Valentine defending Sylvia," this is, indeed, almost the only fault. Further examination of this picture has even raised the estimate I had previously formed of its marvellous truth in detail and splendor in color; nor is its general conception less deserving of praise; the action of Valentine, his arm thrown round Sylvia, and his hand clasping hers at the same instant as she falls at his feet, is most faithful and beautiful, nor less so the contending of doubt and distress with awakening hope in the half-shadowed, half-sunlit countenance of Julia. Nay, even the momentary struggle of Proteus with Sylvia just past, is indicated by the trodden grass and broken fungi of the foreground. But all this thoughtful conception, and absolutely inimitable execution, fail in making immediate appeal to the feelings, owing to the unfortunate type chosen for the face of Sylvia. Certainly this cannot be she whose lover was

> "As rich in having such a jewel,
> As twenty seas, if all their sands were pearl."

Nor is it, perhaps, less to be regretted that, while in Shakspeare's play there are nominally "Two Gentlemen," in Mr. Hunt's picture there should only be one—at least, the kneeling figure on the right has by no means the look of a gentleman. But this may be on purpose, for any one who remembers the conduct of Proteus throughout the previous scenes will, I think, be disposed to consider that the error lies more in Shakspeare's nomenclature than in Mr. Hunt's ideal.

No defence can, however, be offered for the choice of features in the left-hand figure of Mr. Millais' "Dove returning to the Ark." I cannot understand how a painter so sensible of the utmost refinement of beauty in other objects should deliberately choose for his model a type far inferior to that of average humanity, and unredeemed by any expression save that of dull self-complacency. Yet, let the spectator who desires to be just turn away from this head, and contemplate rather the tender and beautiful expression of the stooping figure, and the intense harmony of color in the exquisitely finished draperies; let him note also the ruffling of the plumage of the wearied dove, one of its feathers falling on the arm of the figure which holds it, and another to the ground, where, by the bye, the hay is painted not only elaborately, but with the most perfect ease of touch and mastery of effect, especially to be observed because this freedom of execution is a modern excellence, which it has been inaccurately stated that these painters despise, but which, in reality, is one of the remarkable distinctions between their painting and that of Van

Eyck or Hemling [sic], which caused me to say in my first letter that "those knew little of ancient painting who supposed the works of these men to resemble it."

Next to this false choice of feature, and in connection with it, is to be noted the defect in the coloring of the flesh. The hands, at least in the pictures in Millais, are almost always ill painted, and the flesh tint in general is wrought out of crude purples and dusky yellows. It appears just possible that much of this evil may arise from the attempt to obtain too much transparency—an attempt which has injured also not a few of the best works of Mulready. I believe it will be generally found that close study of minor details is unfavorable to flesh painting; it was noticed of the drawing by John Lewis, in the old water-color exhibition of 1850, (a work which, as regards its treatment of detail, may be ranged in the same class with the Pre-Raphaelite pictures), that the faces were the worst painted portions of the whole.[29]

The apparent want of shade is, however, perhaps the fault which most hurts the general eye. The fact is, nevertheless, that the fault is far more in the other pictures of the Academy than in the Pre-Raphaelite ones. It is the former that are false, not the latter, except so far as every picture must be false which endeavors to represent living sunlight with dead pigments. I think Mr. Hunt has a slight tendency to exaggerate reflected lights; and if Mr. Millais has ever been near a piece of good painted glass, he ought to have known that its tone is more dusky and sober than that of his Mariana's window. But for the most part these pictures are rashly condemned because the only light which we are accustomed to see represented is that which falls on the artist's model in his dim painting room, not that of sunshine in the fields.

I do not think I can go much further in fault-finding. I had, indeed, something to urge respecting what I supposed to be the Romanizing tendencies of the painters; but I have received a letter assuring me that I was wrong in attributing to them anything of the kind; whereupon, all that I can say is that, instead of the "pilgrimage" of Mr. Collins' maiden over a plank and round a fish-pond, that old pilgrimage of Christiana and her children towards the place where they should "look the Fountain of Mercy in the face," would have been more to the purpose in these times. And so I wish them all heartily good-speed, believing in sincerity that if they temper the courage and energy which they have shown in the adoption of their systems with patience and discretion in framing it, and if they do not suffer themselves to be driven by harsh or careless criticism into rejections of the ordinary means of obtaining influence over the minds of others, they may, as they gain experience, lay in our England

[29] John Frederick Lewis (1805–1876), English graphic artist and water colorist, noted for landscapes of foreign lands such as Spain, Constantinople, and the Balkans.

the foundations of a school or art nobler than the world has seen for three hundred years.

<div align="center">
I have the honor to be, Sir,

Your obedient servant,

THE AUTHOR OF "MODERN PAINTERS." [30]
</div>

Holman Hunt's "Light of the World"

It is interesting to compare Ruskin's interpretation of this painting, of May, 1854, with that of the artist himself (pp. 107 to 108.) It would seem more than coincidental that Ruskin links Christ's lantern in this work with the "awakening conscience," the very title of the painting which Hunt himself intended as a pendant to Light of the World. *While the French critic Théophile Gautier (see above, page 107) had found the minute treatment of detail in the* Light of the World *as destructive of a sense of scale as would be a view through a microscope, Ruskin, on the contrary, considers the details well adapted to their positions within the total context of the painting, and as such, visually convincing.*

<div align="center">

To the Editor of *The Times*
</div>

SIR:

I trust that, with your usual kindness and liberality, you will give me room in your columns for a few words respecting the principal prae-Raphaelite picture in the Exhibition of the Royal Academy this year. Its painter is travelling in the Holy Land, and can neither suffer nor benefit by criticism. But I am solicitous that justice should be done to his work, not for his sake, but for that of the large number of persons who, during the year, will have an opportunity of seeing it, and on whom, if rightly understood, it may make an impression for which they will ever afterwards be grateful.

I speak of the picture called "the Light of the World," by Mr. Holman Hunt. Standing by it yesterday for upwards of an hour, I watched the effect it produced upon the passersby. Few stopped to look at it, and those who did almost invariably with some contemptuous expression, founded on what appeared to them the absurdity of representing the Savior with a lantern in his hand. Now, it ought to be remembered that, whatever may be the faults of a prae-Raphaelite picture, it must at least have taken much time; and therefore it may not unwarrantably be presumed that conceptions which are to be laboriously realized are not adopted in the first instance without some reflection. So that the spectator may surely question with himself whether the objections which now

30 John Ruskin, Letter dated May 26, 1851, appearing in *The Times*, May 30, 1851, reprinted in *Arrows*, I, 70–73.

strike every one in a moment might not possibly have occurred to the painter himself, either during the time devoted to the design of the picture, or the months of labor required for its execution; and whether, therefore, there may not be some reason for his persistence in such an idea, not discoverable in the first glance.

Mr. Hunt has never explained his work to me. I give what appears to me its palpable interpretation.

The legend beneath it is the beautiful verse, "Behold, I stand at the door and knock. If any man hear my voice, and open the door, I will come in to him, and will sup with him, and he with me."—Rev. iii. 20. On the left-hand side of the picture is seen this door of the human soul. It is fast barred: its bars and nails are rusty; it is knitted and bound to its stanchions by creeping tendrils of ivy, showing that it has never been opened. A bat hovers about it; its threshold is overgrown with brambles, nettles, and fruitless corn—the wild grass "whereof the mower filleth not his hand, nor he that bindeth the sheaves his bosom." Christ approaches it in the night-time—Christ, in his everlasting offices of prophet, priest, and king. He wears the white robe, representing the power of the Spirit upon him; the jewelled robe and breast-plate, representing the sacerdotal investiture; the rayed crown of gold, inwoven with the crown of thorns; not dead thorns, but now bearing soft leaves, for the healing of the nations.

Now, when Christ enters any human heart, he bears with him a two-fold light: first, the light of conscience, which displays past sin, and afterwards the light of peace, the hope of salvation. The lantern, carried in Christ's left hand, is this light of conscience. Its fire is red and fierce; it falls only on the closed door, on the weeds which encumber it, and on an apple shaken from one of the trees of the orchard, thus marking that the entire awakening of the conscience is not merely to committed, but to hereditary guilt.

The light is suspended by a chain, wrapt about the wrist of the figure, showing that the light which reveals sin appears to the sinner also to chain the hand of Christ.

The light which proceeds from the head of the figure, on the contrary, is that of the hope of salvation; it springs from the crown of thorns, and, though itself sad, subdued, and full of softness, is yet so powerful that it entirely melts into the glow of it the forms of the leaves and boughs, which it crosses, showing that every earthly object must be hidden by this light, where its sphere extends.

I believe there are very few persons on whom the picture, thus justly understood, will not produce a deep impression. For my own part, I think it one of the very noblest works of sacred art ever produced in this or any other age.

It may, perhaps, be answered, that works of art ought not to stand

in need of interpretation of this kind. Indeed, we have been so long accustomed to see pictures painted without any purpose or intention whatsoever, that the unexpected existence of meaning in a work of art may very naturally at first appear to us an unkind demand on the spectator's understanding. But in a few years more I hope the English public may be convinced of the simple truth, that neither a great fact, nor a great man, nor a great poem, nor a great picture, nor any other great thing, can be fathomed to the very bottom in a moment of time; and that no high enjoyment, either in picture-seeing or any other occupation, is consistent with a total lethargy of the powers of the understanding.

As far as regards the technical qualities of Mr. Hunt's painting, I would only ask the spectator to observe this difference between true prae-Raphaelite work and its imitations. The true work represents all objects exactly as they would appear in nature in the position and at the distances which the arrangement of the picture supposes. The false work represents them with all their details, as if seen through a microscope. Examine closely the ivy on the door in Mr. Hunt's picture, and there will not be found in it a single clear outline. All is the most exquisite mystery of color; becoming reality at its due distance. In like manner examine the small gems on the robe of the figure. Not one will be made out in form, and yet there is not one of all those minute points of green color, but it has two or three distinctly varied shades of green in it, giving it mysterious value and lustre.

The spurious imitations of prae-Raphaelite work represent the most minute leaves and other objects with sharp outlines, but with none of the concealment, none of the infinity of nature. With this spurious work, the walls of the Academy are half covered; of the true school one very small example may be pointed out, being hung so low that it might otherwise escape attention. It is not by any means perfect, but still very lovely —the study of a calm pool in a mountain brook, by Mr. J. Dearle,[31] No. 191, "Evening, on the Marchno, North Wales."

I have the honor to be, Sir,
Your obedient servant,

THE AUTHOR OF "MODERN PAINTERS."[32]

Holman Hunt's "Awakening Conscience"

Ruskin's analysis of this work, despite its humorlessness, is nevertheless penetrating in its insight into the expressive function of the objects within the crowded room in which the scene of dawning moral realization

[31] John Dearle, English landscape painter, born on the Isle of Jersey, who exhibited in London from 1851 to 1900.
[32] John Ruskin, Letter dated May 4, 1854, appearing in *The Times*, May 5, 1854, reprinted in *Arrows*, I, 74–77.

takes place. One is reminded of the similar role played by description of objects—concrete, objectively detailed, yet anthropocentrically expressive —in the novels of such 19th-century realistic writers as Balzac, Dickens, and Zola. The very vulgarity of things, their opacity, their "fatal newness" as Ruskin terms it, can soon be seen as the paradigm of man's alienation from his environment—an attitude given its most anguishing expression in such works as Van Gogh's Night Café *or* Bedroom at Arles.

To the Editor of *The Times*

SIR:

Your kind insertion of my notes on Mr. Hunt's principal picture encourages me to hope that you may yet allow me room in your columns for a few words respecting his second work in the Royal Academy, the "Awakening Conscience." Not that his picture is obscure, or its story feebly told. I am at a loss to know how its meaning could be rendered more distinctly, but assuredly it is not understood. People gaze at it in a blank wonder, and leave it hopelessly; so that, though it is almost an insult to the painter to explain his thoughts in this instance, I cannot persuade myself to leave it thus misunderstood. The poor girl has been sitting singing with her seducer; some chance words of the song, "Oft in the stilly night," have struck upon the numbed places of her heart; she has started up in agony; he, not seeing her face, goes on singing, striking the keys carelessly with his gloved hand.

I suppose that no one possessing the slightest knowledge of expression could remain untouched by the countenance of the lost girl, rent from its beauty into sudden horror; the lips half open, indistinct in their purple quivering; the teeth set hard; the eyes filled with the fearful light of futurity, and with tears of ancient days. But I can easily understand that to many persons the careful rendering of the inferior details in this picture cannot but be at first offensive, as calling their attention away from the principle [sic] subject. It is true that detail of this kind has long been so carelessly rendered, that the perfect finishing of it becomes a matter of curiosity, and therefore an interruption to serious thought. But, without entering into the question of the general propriety of such treatment, I would only observe that, at least in this instance, it is based on a truer principle of the pathetic than any of the common artistical expedients of the schools. Nothing is more notable than the way in which even the most trivial objects force themselves upon the attention of a mind which has been fevered by violent and distressful excitement. They thrust themselves forward with a ghastly and unendurable distinctness, as if they would compel the sufferer to count, or measure, or learn them by heart. Even to the mere spectator a strange interest exalts the accessories of a

scene in which he bears witness to human sorrow. There is not a single object in all that room—common, modern, vulgar (in the vulgar sense, as it may be), but it becomes tragical, if rightly read. That furniture so carefully painted, even to the last vein of the rosewood—is there nothing to be learnt from that terrible lustre of it, from its fatal newness; nothing there that has the old thoughts of home upon it, or that is ever to become a part of home? Those embossed books, vain and useless,—they are also new,— marked with no happy wearing of beloved leaves; the torn and dying bird upon the floor, the gilded tapestry, with the fowls of the air feeding on the ripened corn; the picture above the fireplace, with its single drooping figure—the woman taken in adultery; nay, the very hem of the poor girl's dress, at which the painter has labored so closely, thread by thread, has story in it, if we think how soon its pure whiteness may be soiled with dust and rain, her outcast feet failing in the street; and the fair garden flowers, seen in that reflected sunshine of the mirror—these also have their language—

> "Hope not to find delight in us, they say,
> For we are spotless, Jessy—we are pure." [33]

I surely need not go on. Examine the whole range of the walls of the Academy,—nay, examine those of all our public and private galleries,— and while pictures will be met with by the thousand which literally tempt to evil, by the thousand which are directed to the meanest trivialities of incident or emotion, by the thousand to the delicate fancies of inactive religion, there will not be found one powerful as this to meet full in the front the moral evil of the age in which it is painted; to waken into mercy the cruel thoughtlessness of youth, and subdue the severities of judgment into the sanctity of compassion.

<div align="right">

I have the honor to be, Sir,
Your obedient servant,

THE AUTHOR OF "MODERN PAINTERS." [34]

</div>

Advice to Rossetti

Ruskin was extremely magnanimous toward Rossetti. From 1851 on, the critic bought the painter's works and recommended that others do the same. Yet, at the same time, he showered Rossetti and the other Pre-Raphaelites with gratuitous, often unwelcome advice. As early as 1855 Rossetti had complained to Madox Brown of "Ruskin . . . sticking pins into him . . . for a couple of hours every three days." The following

[33] Lines from an Elegy by William Shenstone (1714–1763), dealing with a very similar theme.

[34] John Ruskin, Letter appearing in *The Times*, May 25, 1854, reprinted in *Arrows*, I, 77–79.

hints in a letter of 1865—of a technical nature, to be sure—were probably not too well received by the artist, who might, however, have profited by them.

[1865]

MY DEAR ROSSETTI,

It is very good and pretty of you to answer so. I have little time this morning, but will answer at once so far as regards what you say you wish me to tell you.

There are two methods of laying oil-colour which can be proved right, each for its purposes—Van Eyck's (or Holbein's) and Titian's (or Correggio's): one of them involving no display of power of hand, the other involving it *essentially* and as an element of its beauty. Which of these styles you adopt I do not care. I supposed, in old times, you were going to try to paint like that Van Eyck in the National Gallery with the man and woman and mirror.[35] If you say, "No—I mean rather to paint like Correggio"—by all means, so much the better—but you are not on the way to Correggio. And you are, it seems, under the (for the present) *fatal* mistake of thinking that you will ever learn to paint well by painting badly, *i.e.,* coarsely.

At present you lay your colour ill, and you will only learn by doing so, to lay it worse. No great painter ever allowed himself, in the smallest touch, to paint ill, *i.e.,* to daub or smear his paint. What he could not paint easily he would not paint at all—and gained gradual power by never in the smallest thing doing wrong.

1. You may say you like coarse painting better than Correggio's, and that it is righter. To this I should make no answer—knowing answer to be vain.

2. If you say you do not see the difference, again I only answer—I am sorry. Nothing more is to be said.

3. If you say, "I see the difference and mean to do better, and am on the way to do better," I answer I know you are not on the way to do better, and I cannot bear the pain of seeing you at work as you are working now. But come back to me when you have found out your mistake—or (if you are right in your method) when you *can* do better.

All this refers only to laying of paint.

I have two distinct other counts against you: your method of study of chiaroscuro; and your permission of modification of minor truths for sensational purposes.

I will see what you say to this first count before I pass to the others.

[35] A reference to Jan Van Eyck's *Arnolfini Wedding Portrait.*

I am very glad, at all events, to understand *you* better than I did, in the grace and sweetness of your letters.

Ever affectionately yours,

J. Ruskin [36]

WILLIAM MORRIS: 1834–1896

The Aims of Art

This impassioned plea for the reintegration of art into a living and life-affirming social order clearly establishes William Morris as one of those who (like Ruskin, whose views had indeed inspired him) viewed industrialism, and its consequent reduction of human beings to mere auxiliaries of machines, as the chief evil of the 19th century. Yet it would be a mistake to view Morris as a mere nostalgic yearner after the vanished splendors of the Middle Ages, although indeed, from his earliest period of artistic activity (in 1856, when he had been engaged in creating one of the series of paintings illustrating Arthurian legend, designed by the Pre-Raphaelites and some of their friends for the Oxford Union) he had been attracted by that organic unity, linking heart and hand, feeling and making, which seemed to him characteristic of life in the Middle Ages, and which had endowed each of its artifacts, "from a cathedral to a porridge-pot," with significance and distinction.

Yet Morris would not have objected so strenuously to the destruction of the old beauty of cities like Oxford or Rouen, if only such destruction, instead of being merely wanton, for the profit of the few, had been for the benefit of the people. Active in the radical politics of his day, Morris had been one of the founders of the Socialist League in 1884 and editor of its organ, the Commonweal. *It is not the disappearance of the past per se that Morris professes to regret in this essay,* The Aims of Art *(first published in 1887), but rather that the values of that past were being "muddled away by the greed and incompetence of fools who do not know what life and pleasure mean." The result of this muddle is, on one side, the frivolous delectation of a few privileged "art-lovers"—art for art's sake at its emptiest—and, on the other, sheer, unmitigated ugliness and drudgery for the mass of humanity. Morris is thus one link in that chain of passionate Englishmen who have cried out against the devastating encroachment of the "dark, satanic mills," and have seen a return to a simpler, more direct way of life as a solution: Lawrence's wistful suggestion in* Lady

36 John Ruskin, Letter of 1865 to Dante Gabriel Rossetti in William Michael Rossetti, ed., *Rossetti Papers, 1862 to 1870* (London: Sands and Co., 1903), pp. 135–136.

Chatterley's Lover *that the miners wear little red jackets has the same implications as Morris' insistence on the pursuit of handicrafts as the antidote to the depersonalization and mechanization of modern society. The firm of Morris, Marshall, Faulkner and Co. at 8 Red Lion Square, in which Morris was associated with Rossetti, Madox Brown, Burne-Jones, and Philip Webb,[37] among others, engaged in producing mural decoration, architectural carving, stained glass, metal work, furniture, weaving, wallpaper, hangings, etc. In addition, Morris made two essays in typography: the Chiswick and Kelmscott presses. Both in theory and in practice, then, Morris exerted a lasting influence upon the history of taste, combatting the complicated hideousness of Victorian machine-made decoration and industrialism's disregard for human and aesthetic value with his own taste, integrity, industry, and conviction.*

In considering the Aims of Art, that is, why men toilsomely cherish and practice Art, I find myself compelled to generalize from the only specimen of humanity of which I know anything; to wit, myself. Now, when I think of what it is that I desire, I find that I can give it no other name than happiness. I want to be happy while I live; for as for death, I find that, never having experienced it, I have no conception of what it means, and so cannot even bring my mind to bear upon it. I know what it is to live; I cannot even guess what it is to be dead. Well, then, I want to be happy, and even sometimes, say generally, to be merry; and I find it difficult to believe that that is not the universal desire: so that, whatever tends towards that end I cherish with all my best endeavour. Now, when I consider my life further, I find out, or seem to, that it is under the influence of two dominating moods, which for lack of better words I must call the mood of energy and the mood of idleness: these two moods are now one, now the other, always crying out in me to be satisfied. When the mood of energy is upon me, I must be doing something, or I become mopish and unhappy; when the mood of idleness is on me, I find it hard indeed if I cannot rest and let my mind wander over the various pictures, pleasant or terrible, which my own experience or my communing with the thoughts of other men, dead or alive, have fashioned in it; and if circumstances will not allow me to cultivate this mood of idleness, I find I must at the best pass through a period of pain till I can manage to stimulate my mood of energy to take its place and make me happy again. And if I have no means wherewith to rouse up that mood of energy to do its duty in making me happy, and I have to toil while the idle mood is upon me,

[37] Edward Burne-Jones (1833–1898), a friend of Morris' at Oxford, was deeply impressed by Rossetti in the fifties, and became a latter-day Pre-Raphaelite painter, creating such well known works as *King Cophetua and the Beggar Maid* (1884) and *The Golden Stairs* (1880). Philip Speakman Webb (1831–1915), an architect associated with the Morris firm, designed the famous Red House for Morris at Upton in 1859.

then I am unhappy indeed, and almost wish myself dead, though I do not know what that means.

Furthermore, I find that while in the mood of idleness memory amuses me, in the mood of energy hope cheers me; which hope is sometimes big and serious, and sometimes trivial, but that without it there is no happy energy. Again, I find that while I can sometimes satisfy this mood by merely exercising it in work that has no result beyond the passing hour–in play, in short–yet that it presently wearies of that and gets languid, the hope therein being too trivial, and sometimes even scarcely real; and that on the whole, to satisfy my master the mood, I must either be making something or making believe to make it.

Well, I believe that all men's lives are compounded of these two moods in various proportions, and that this explains why they have always, with more or less of toil, cherished and practised art.

Why should they have touched it else, and so added to the labour which they could not choose but do in order to live? It must have been done for their pleasure, since it has only been in very elaborate civilizations that a man could get other men to keep him alive merely to produce works of art, whereas all men that have left any signs of their existence behind them have practised art.

I suppose, indeed, that nobody will be inclined to deny that the end proposed by a work of art is always to please the person whose senses are to be made conscious of it. It was done *for* some one who was to be made happier by it; his idle or restful mood was to be amused by it, so that the vacancy which is the besetting evil of that mood might give place to pleased contemplation, dreaming, or what you will; and by this means he would not so soon be driven into his workful or energetic mood: he would have more enjoyment, and better.

The restraining of restlessness, therefore, is clearly one of the essential aims of art, and few things could add to the pleasure of life more than this. There are, to my knowledge, gifted people now alive who have no other vice than this of restlessness, and seemingly no other curse in their lives to make them unhappy: but that is enough; it is "the little rift within the lute." Restlessness makes them hapless men and bad citizens.

But granting, as I suppose you all will do, that this is a most important function for art to fulfill, the question next comes, at what price do we obtain it? I have admitted that the practice of art has added to the labour of mankind, though I believe in the long run it will not do so; but in adding to the labour of man has it added, so far, to his pain? There always have been people who would at once say yes to that question; so that there have been and are two sets of people who dislike and contemn art as an embarrassing folly. Besides the pious ascetics, who look upon it as a worldly entanglement which prevents men from keeping their minds fixed on the chances of their individual happiness or misery in the next

world; who, in short, hate art, because they think that it adds to man's earthly happiness—besides these, there are also people who, looking on the struggle of life from the most reasonable point that they know of, contemn the arts because they think that they add to man's slavery by increasing the sum of his painful labour: if this were the case, it would still, to my mind, be a question whether it might not be worth the while to endure the extra pain of labour for the sake of the extra pleasure added to rest; assuming, for the present, equality of condition among men. But it seems to me that it is not the case that the practice of art adds to painful labour; nay more, I believe that, if it did, art would never have arisen at all, would certainly not be discernible, as it is, among peoples in whom only the germs of civilization exist. In other words, I believe that art cannot be the result of external compulsion; the labour which goes to produce it is voluntary, and partly undertaken for the sake of the labour itself, partly for the sake of the hope of producing something which, when done, shall give pleasure to the user of it. Or, again, this extra labour, when it *is* extra, is undertaken with the aim of satisfying that mood of energy by employing it to produce something worth doing, and which, therefore, will keep before the worker a lively hope while he is working; and also by giving it work to do in which there is absolute immediate pleasure. Perhaps it is difficult to explain to the non-artistic capacity that this definite sensuous pleasure is always present in the handiwork of the deft workman when he is working successfully, and that it increases in proportion to the freedom and individuality of the work. Also you must understand that this production of art, and consequent pleasure in work, is not confined to the production of matters which are works of art only, like pictures, statues, and so forth, but has been and should be a part of all labour in some form or other: so only will the claims of the mood of energy be satisfied.

Therefore the Aim of Art is to increase the happiness of men, by giving them beauty and interest of incident to amuse their leisure, and prevent them wearying even of rest, and by giving them hope and bodily pleasure in their work; or, shortly, to make man's work happy and his rest fruitful. Consequently, genuine art is an unmixed blessing of the race of man.

But as the word "genuine" is a large qualification, I must ask leave to attempt to draw some practical conclusions from this assertion of the Aims of Art, which will, I suppose, or indeed hope, lead us into some controversy on the subject; because it is futile indeed to expect any one to speak about art, except in the most superficial way, without encountering those social problems which all serious men are thinking of; since art is and must be, either in its abundance or its barrenness, in its sincerity or its hollowness, the expression of the society amongst which it exists.

First, then, it is clear to me that, at the present time, those who look widest at things and deepest into them are quite dissatisfied with the pres-

ent state of the arts, as they are also with the present condition of society. This I say in the teeth of the supposed revivification of art which has taken place of late years: in fact, that very excitement about the arts amongst a part of the cultivated people of to-day does but show on how firm a basis the dissatisfaction above mentioned rests. Forty years ago there was much less talk about art, much less practice of it, than there is now; and that is specially true of the architectural arts, which I shall mostly have to speak about now. People have consciously striven to raise the dead in art since that time, and with some superficial success. Nevertheless, in spite of this conscious effort, I must tell you that England, to a person who can feel and understand beauty, was a less grievous place to live in then than it is now; and we who feel what art means know well, though we do not often dare to say so, that forty years hence it will be a more grievous place to us than it is now if we still follow up the road we are on. Less than forty years ago—about thirty—I first saw the city of Rouen, then still in its outward aspect a piece of the Middle Ages: no words can tell you how its mingled beauty, history, and romance took hold on me; I can only say that, looking back on my past life, I find it was the greatest pleasure I have ever had: and now it is a pleasure which no one can ever have again: it is lost to the world for ever. At that time I was an undergraduate of Oxford. Though not so astounding, so romantic, or at first sight so mediaeval as the Norman city, Oxford in those days still kept a great deal of its earlier loveliness: and the memory of its grey streets as they then were has been an abiding influence and pleasure in my life, and would be greater still if I could only forget what they are now—a matter of far more importance than the so-called learning of the place could have been to me in any case, but which, as it was, no one tried to teach me, and I did not try to learn. Since then the guardians of this beauty and romance so fertile of education, though professedly engaged in the "higher education" (as the futile system of compromises which they follow is nick-named), have ignored it utterly, have made its preservation give way to the pressure of commercial exigencies, and are determined apparently to destroy it altogether. There is another pleasure for the world gone down the wind; here, again, the beauty and romance have been uselessly, causelessly, most foolishly thrown away.

These two cases are given simply because they have been fixed in my mind; they are but types of what is going on everywhere throughout civilization: the world is everywhere growing uglier and more commonplace, in spite of the conscious and very strenuous efforts of a small group of people towards the revival of art, which are so obviously out of joint with the tendency of the age that, while the uncultivated have not even heard of them, the mass of the cultivated look upon them as a joke, and even that they are now beginning to get tired of.

Now, if it be true, as I have asserted, that genuine art is an unmixed

blessing to the world, this is a serious matter; for at first sight it seems to show that there will soon be no art at all in the world, which will thus lose an unmixed blessing; it can ill afford to do that, I think.

For art, if it has to die, has worn itself out, and its aim will be a thing forgotten; and its aim was to make work happy and rest fruitful. Is all work to be unhappy, all rest unfruitful, then? Indeed, if art is to perish, that will be the case, unless something is to take its place—something at present unnamed, undreamed of.

I do not think that anything will take the place of art; not that I doubt the ingenuity of man, which seems to be boundless in the direction of making himself unhappy, but because I believe the springs of art in the human mind to be deathless, and also because it seems to me easy to see the causes of the present obliteration of the arts.

For we civilized people have not given them up consciously, or of our free will; we have been *forced* to give them up. Perhaps I can illustrate that by the detail of the application of machinery to the production of things in which artistic form of some sort is possible. Why does a reasonable man use a machine? Surely to save his labour. There are some things which a machine can do as well as a man's hand, *plus* a tool, can do them. He need not, for instance, grind his corn in a hand-quern; a little trickle of water, a wheel, and a few simple contrivances will do it all perfectly well, and leave him free to smoke his pipe and think, or to carve the handle of his knife. That, so far, is unmixed gain in the use of a machine—always, mind you, supposing equality of condition among men; no art is lost, leisure or time for more pleasurable work is gained. Perhaps a perfectly reasonable and free man would stop there in his dealings with machinery; but such reason and freedom are too much to expect, so let us follow our machine-inventor a step farther. He has to weave plain cloth, and finds doing so dullish on the one hand, and on the other that a power-loom will weave the cloth nearly as well as a hand-loom: so, in order to gain more leisure or time for more pleasurable work, he uses a power-loom, and foregoes the small advantage of the little extra art in the cloth. But so doing, as far as the art is concerned, he has not got a pure gain; he has made a bargain between art and labour, and got a makeshift as a consequence. I do not say that he may not be right in so doing, but that he has lost as well as gained. Now, this is as far as a man who values art and is reasonable would go in the matter of machinery *as long as he was free*—that is, was not *forced* to work for another man's profit; so long as he was living in a society *that had accepted equality of condition*. Carry the machine used for art a step farther, and he becomes an unreasonable man, if he values art and is free. To avoid misunderstanding, I must say that I am thinking of the modern machine, which is as it were alive, and to which the man is auxiliary, and not of the old machine, the improved tool, which is auxiliary to the man, and only works as long as his hand is

thinking; though I will remark, that even this elementary form of machine has to be dropped when we come to the higher and more intricate forms of art. Well, as to the machine proper used for art, when it gets to the stage above dealing with a necessary production that has accidentally some beauty about it, a reasonable man with a feeling for art will only use it when he is *forced* to. If he thinks he would like ornament, for instance, and knows that the machine cannot do it properly, and does not care to spend the time to do it properly, why should he do it at all? He will not diminish his leisure for the sake of making something he does not want unless some man or band of men force him to it; so he will either go without the ornament, or sacrifice some of his leisure to have it genuine. That will be a sign that he wants it very much, and that it will be worth his trouble: in which case, again, his labour on it will not be mere trouble, but will interest and please him by satisfying the needs of his mood of energy.

This, I say, is how a reasonable man would act if he were free from man's compulsion; not being free, he acts very differently. He has long passed the stage at which machines are only used for doing work repulsive to an average man, or for doing what could be as well done by a machine as a man, and he instinctively expects a machine to be invented whenever any product of industry becomes sought after. He is the slave to machinery; the new machine *must* be invented, and when invented he *must* —I will not say use it, but be used by it, whether he likes it or not.

But why is he the slave to machinery? Because he is the slave to the system for whose existence the invention of machinery was necessary.

And now I must drop, or rather have dropped, the assumption of the equality of condition, and remind you that, though in a sense we are all the slaves of machinery, yet that some men are so directly without any metaphor at all, and that these are just those on whom the great body of the arts depends—the workmen. It is necessary for the system which keeps them in their position as an inferior class that they should either be themselves machines or be the servants to machines, in no case having any interest in the work which they turn out. To their employers they are, so far as they are workmen, a part of the machinery of the workshop or the factory; to themselves they are proletarians, human beings working to live that they may live to work: their part of craftsmen, of makers of things by their own free will, is played out.

At the risk of being accused of sentimentality, I will say that since this is so, since the work which produces the things that should be matters of art is but a burden and a slavery, I exult in this at least, that it cannot produce art; that all it can do lies between stark utilitarianism and idiotic sham.

Or indeed is that merely sentimental? Rather, I think we who have learned to see the connection between industrial slavery and the degrada-

tion of the arts have learned also to hope for a future for those arts; since the day will certainly come when men will shake off the yoke, and refuse to accept the mere artificial compulsion of the gambling market to waste their lives in ceaseless and hopeless toil; and when it does come, their instincts for beauty and imagination set free along with them, will produce such art as they need; and who can say that it will not as far surpass the art of past ages as that does the poor relics of it left us by the age of commerce?

A word or two on an objection which has often been made to me when I have been talking on this subject. It may be said, and is often, You regret the art of the Middle Ages (as indeed I do), but those who produced it were not free; they were serfs, or gild-craftsmen surrounded by brazen walls of trade restrictions; they had no political rights, and were exploited by their masters, the noble caste, most grievously. Well, I quite admit that the oppression and violence of the Middle Ages had its effect on the art of those days, its shortcomings are traceable to them; they repressed art in certain directions, I do not doubt that; and for that reason I say, that when we shake off the present oppression as we shook off the old, we may expect the art of the days of real freedom to rise above that of those old violent days. But I do say that it was possible then to have social, organic, hopeful progressive art; whereas now such poor scraps of it as are left are the result of individual and wasteful struggle, are retrospective and pessimistic. And this hopeful art was possible amidst all the oppression of those days, because the instruments of that oppression were grossly obvious, and were external to the work of the craftsman. They were laws and customs obviously intended to rob him, and open violence of the highway-robbery kind. In short, industrial production was not the instrument used for robbing the "lower classes;" it is now the main instrument used in that honourable profession. The mediaeval craftsman was free in his work, therefore he made it as amusing to himself as he could; and it was his pleasure and not his pain that made all things beautiful that were made, and lavished treasures of human hope and thought on everything that man made, from a cathedral to a porridge-pot. Come, let us put it in the way least respectful to the mediaeval craftsman, most polite to the modern "hand:" the poor devil of the fourteenth century, his work was of so little value that he was allowed to waste it by the hour in pleasing himself—and others; but our highly-strung mechanic, his minutes are too rich with the burden of perpetual profit for him to be allowed to waste one of them on art; the present system will not allow him—cannot allow him—to produce works of art.

So that there has arisen this strange phenomenon, that there is now a class of ladies and gentlemen, very refined indeed, though not perhaps as well informed as is generally supposed, and of this refined class there

are many who do really love beauty and incident—*i.e.,* art, and would make sacrifices to get it; and these are led by artists of great manual skill and high intellect, forming altogether a large body of demand for the article. And yet the supply does not come. Yes, and moreover, this great body of enthusiastic demanders are no mere poor and helpless people, ignorant fisher-peasants, half-mad monks, scatter-brained sansculottes— none of those, in short, the expression of whose needs has shaken the world so often before, and will do yet again. No, they are of the ruling classes, the masters of men, who can live without labour, and have abundant leisure to scheme out the fulfillment of their desires; and yet I say they cannot have the art which they so much long for, though they hunt it about the world so hard, sentimentalizing the sordid lives of the miserable peasants of Italy and the starving proletarians of her towns, now that all the picturesqueness has departed from the poor devils of our own country-side, and of our own slums. Indeed, there is little of reality left them anywhere, and that little is fast fading away before the needs of the manufacturer and his ragged regiment of workers, and before the enthusiasm of the archaeological restorer of the dead past. Soon there will be nothing left except the lying dreams of history, the miserable wreckage of our museums and picture-galleries, and the carefully guarded interiors of our aesthetic drawing-rooms, unreal and foolish, fitting witnesses of the life of corruption that goes on there, so pinched and meagre and cowardly, with its concealment and ignoring, rather than restraint of, natural longings; which does not forbid the greedy indulgence in them if it can but be decently hidden.

The art then is gone, and can no more be "restored" on its old lines than a mediaeval building can be. The rich and refined cannot have it though they would, and though we will believe many of them would. And why? Because those who could give it to the rich are not allowed by the rich to do so. In one word, slavery lies between us and art.

I have said as much as that the aim of art was to destroy the curse of labour by making work the pleasurable satisfaction of our impulse towards energy, and giving to that energy hope of producing something worth its exercise.

Now, therefore, I say, that since we cannot have art by striving after its mere superficial manifestation, since we can have nothing but its sham by so doing, there yet remains for us to see how it would be if we let the shadow take care of itself and try, if we can, to lay hold of the substance. For my part I believe, that if we try to realize the aims of art without much troubling ourselves what the aspect of the art itself shall be, we shall find we shall have what we want at last: whether it is to be called art or not, it will at least be *life;* and, after all, that is what we want. It may lead us into new splendours and beauties of visible art; to architecture with manifold magnificence free from the curious incompleteness and

failings of that which the older times have produced—to painting, uniting to the beauty which mediaeval art attained the realism which modern art aims at; to sculpture, uniting the beauty of the Greek and the expression of the Renaissance with some third quality yet undiscovered, so as to give us the images of men and women splendidly alive, yet not disqualified from making, as all true sculpture should, architectural ornament. All this it may do; or, on the other hand, it may lead us into the desert, and art may seem to be dead amidst us; or feebly and uncertainly to be struggling in a world which has utterly forgotten its old glories.

For my part, with art as it is now, I cannot bring myself to think that it much matters which of these dooms awaits it, so long as each bears with it some hope of what is to come; since here, as in other matters, there is no hope save in Revolution. The old art is no longer fertile, no longer yields us anything save elegantly poetical regrets; being barren, it has but to die, and the matter of moment now is, as to how it shall die, whether *with* hope or *without* it.

What is it, for instance, that has destroyed the Rouen, the Oxford of *my* elegant poetic regret? Has it perished for the benefit of the people, either slowly yielding to the growth of intelligent change and new happiness? or has it been, as it were, thunderstricken by the tragedy which mostly accompanies some great new birth? Not so. Neither phalangstere nor dynamite has swept its beauty away, its destroyers have not been either the philanthropist or the Socialist, the co-operator or the anarchist. It has been sold, and at a cheap price indeed: muddled away by the greed and incompetence of fools who do not know what life and pleasure mean, who will neither take them themselves nor let others have them. That is why the death of that beauty wounds us so: no man of sense or feeling would dare to regret such losses if they had been paid for by new life and happiness for the people. But there is the people still as it was before, still facing for its part the monster who destroyed all that beauty, and whose name is Commercial Profit.

I repeat, that every scrap of genuine art will fall by the same hands if the matter only goes on long enough, although a sham art may be left in its place, which may very well be carried on by *dilettanti* fine gentlemen and ladies without any help from below; and, to speak plainly, I fear that this gibbering ghost of the real thing would satisfy a great many of those who now think themselves lovers of art; though it is not difficult to see a long vista of its degradation till it shall become at last a mere laughing-stock; that is to say, if the thing were to go on: I mean, if art were to be for ever the amusement of those whom we now call ladies and gentlemen.

But for my part I do not think it will go on long enough to reach such depths as that; and yet I should be hypocritical if I were to say that I thought that the change in the basis of society, which would enfranchise

labour and make men practically equal in condition, would lead us by a short road to the splendid new birth of art which I have mentioned, though I feel quite certain that it would not leave what we now call art untouched, since the aims of that revolution do include the aims of art —viz., abolishing the curse of labour.

I suppose that this is what is likely to happen; that machinery will go on developing, with the purpose of saving men labour, till the mass of the people attain real leisure enough to be able to appreciate the pleasure of life; till, in fact, they have attained such mastery over Nature that they no longer fear starvation as a penalty for not working more than enough. When they get to that point they will doubtless turn themselves and begin to find out what it is that they really want to do. They would soon find out that the less work they did (the less work unaccompanied by art, I mean), the more desirable a dwelling-place the earth would be; they would accordingly do less and less work, till the mood of energy, of which I began by speaking, urged them on afresh: but by that time Nature, relieved by the relaxation of man's work, would be recovering her ancient beauty, and be teaching men the old story of art. And as the Artificial Famine, caused by men working for the profit of a master, and which we now look upon as a matter of course, would have long disappeared, they would be free to do as they chose, and they would set aside their machines in all cases where the work seemed pleasant or desirable for handiwork; till in all crafts where production of beauty was required, the most direct communication between a man's hand and his brain would be sought for. And there would be many occupations also, as the processes of agriculture, in which the voluntary exercise of energy would be thought so delightful, that people would not dream of handing over its pleasure to the jaws of a machine.

In short, men will find out that the men of our days were wrong in first multiplying their needs, and then trying, each man of them, to evade all participation in the means and processes whereby those needs are satisfied; that this kind of division of labour is really only a new and wilful form of arrogant and slothful ignorance, far more injurious to the happiness and contentment of life than the ignorance of the processes of Nature, of what we sometimes call *science,* which men of the earlier days unwittingly lived in.

They will discover, or rediscover rather, that the true secret of happiness *lies in the taking a genuine interest in all the details of daily life,* in elevating them by art instead of handing the performance of them over to unregarded drudges, and ignoring them; and that in cases where it was impossible either so to elevate them and make them interesting, or to lighten them by the use of machinery, so as to make the labour of them trifling, that should be taken as a token that the supposed advantages gained by them were not worth the trouble and had better be given up.

All this to my mind would be the outcome of men throwing off the burden of Artificial Famine, supposing, as I cannot help supposing, that the impulses which have from the first glimmerings of history urged men on to the practice of Art were still at work in them.

Thus and thus only *can* come about the new birth of Art, and I think it *will* come about thus. You may say it is a long process, and so it is; but I can conceive of a longer. I have given you the Socialist or Optimist view of the matter. Now for the Pessimist view.

I can conceive that the revolt against the Artificial Famine of Capitalism, which is now on foot, may be vanquished. The result will be that the working class—the slaves of society—will become more and more degraded; that they will not strive against overwhelming force, but, stimulated by that love of life which Nature, always anxious about the perpetuation of the race, has implanted in us, will learn to bear everything—starvation, overwork, dirt, ignorance, brutality. All these things they will bear, as, alas! they bear them too well even now; all this rather than risk sweet life and bitter livelihood, and all sparks of hope and manliness will die out of them.

Nor will their masters be much better off: the earth's surface will be hideous everywhere, save in the uninhabitable desert; Art will utterly perish, as in the manual arts so in literature, which will become, as it is indeed speedily becoming, a mere string of orderly and calculated ineptitudes and passionless ingenuities; Science will grow more and more one-sided, more incomplete, more wordy and useless, till at last she will pile herself up into such a mass of superstition, that beside it the theologies of old time will seem mere reason and enlightenment. All will get lower and lower, till the heroic struggles of the past to realize hope from year to year, from century to century, will be utterly forgotten, and man will be an indescribable being—hopeless, desireless, lifeless.

And will there be deliverance from this even? Maybe: man may, after some terrible cataclysm, learn to strive towards a healthy animalism, may grow from a tolerable animal into a savage, from a savage into a barbarian, and so on; and some thousands of years hence he may be beginning once more those arts which we have now lost, and be carving interlacements like the New Zealanders, or scratching forms of animals on their cleaned blade-bones, like the pre-historic men of the drift.

But in any case, according to the pessimist view, which looks upon revolt against Artificial Famine as impossible to succeed, we shall wearily trudge the circle again, until some accident, some unforeseen consequence of arrangement, makes an end of us altogether.

That pessimism I do not believe in, nor, on the other hand, do I suppose that it is altogether a matter of our wills as to whether we shall further human progress or human degradation; yet, since there are those who are impelled towards the Socialist or Optimistic side of things, I must

conclude that there is some hope of its prevailing, that the strenuous efforts of many individuals imply a force which is thrusting them on. So that I believe that the "Aims of Art" will be realized, though I know that they cannot be, so long as we groan under the tyranny of Artificial Famine. Once again I warn you against supposing, you who may specially love art, that you will do any good by attempting to revivify art by dealing with its dead exterior. I say it is the *aims of art* that you must seek rather than the *art itself;* and in that search we may find ourselves in a world blank and bare, as the result of our caring at least this much for art, that we will not endure the shams of it.

Anyhow, I ask you to think with me that the worst which can happen to us is to endure tamely the evils that we see; that no trouble or turmoil is so bad as that; that the necessary destruction which reconstruction bears with it must be taken calmly; that everywhere—in State, in Church, in the household—we must be resolute to endure no tyranny, accept no lie, quail before no fear, although they may come before us disguised as piety, duty, or affection, as useful opportunity and good-nature, as prudence or kindness. The world's roughness, falseness, and injustice will bring about their natural consequences, and we and our lives are part of those consequences; but since we inherit also the consequences of old resistance to those curses, let each look to it to have our fair share of that inheritance also, which, if nothing else come of it, will at least bring to us courage and hope; that is, eager life while we live, which is above all things the Aim of Art.[38]

[38] William Morris, "The Aims of Art," originally published as a pamphlet (London, 1887), reprinted in *Signs of Change* (London: Longmans, Green, and Co., 1903), pp. 117–140.

4

Italy
and Germany

GIOVANNI FATTORI: 1825–1908

Letter to a Group of Pupils

The rebellion against academic painting in Italy in the middle of the 19th century centered around the group of young artists known as the "Macchiaioli"—"spot-painters"—a term roughly corresponding to the term "Impressionist," though by no means synonymous with it. Included in the group, which met at the Caffè Michelangiolo in Florence, were Giovanni Fattori, Serafino De Tivoli, Vito d'Ancona, Telemaco Signorini, Silvestro Lega, Raffaello Sernesi, Giuseppe Abbati, Odoardo Borrani, Adriano Cecioni, and other more peripherally connected painters. Their spokesman and defender was the critic Diego Martelli, who, although not an artist himself, understood the aims of both the Macchiaioli and the French Impressionists as well. "Ingenuousness, Truth, Individuality" —such was the program of this group of young painters, who actually predate the French Impressionist movement. The Italians were really closer in spirit to Courbet, Corot, and the Barbizon School. Like the latter, they felt the need to escape the studio and the prescribed subjects of the academy, to seek inspiration in the countryside, close to nature and the simple people who lived in contact with the soil.

Probably the greatest, most instinctive and simple painter in the group was the Livornese, Giovanni Fattori. Rarely leaving his beloved Tuscany—although he made a brief trip to Paris in 1875—he fled theoretical discussion in order to immerse himself in the bleak, solitary landscape of the Maremma. Notable for its rather broad, simplified color areas, Fattori's style is sometimes reminiscent of Corot's, sometimes of the earlier works of Pissarro. He was well known for his depiction of military scenes and figure pieces, as well as for landscapes.

In the following letter, written in his old age to a group of his pupils, the awkwardness of the phrasing serves to underline the sincerity of his advice: be yourselves; imitation of even the most daring innovations of others leads to mannerism and a new kind of academic convention.

[FLORENCE, JANUARY OR FEBRUARY, 1891]

MY DEAR FRIENDS,

I am answering immediately.

Your paintings have been exhibited. Those not accepted for the competition have been placed, following my suggestion, all together in one room, since the attempt to put them with the others didn't turn out well.[1]

1 The exhibition referred to was probably that of the Promotrice of Florence of 1891–1892. Taking part in the competition were Fattori's students: Pagni, Mueller, and Ghezzani.

You yourselves will see that placing one painting right next to the other destroys all individuality; it's a new, conventional academy, even worse than the one we have, because that one at least pays attention to form.

This is my criticism.

Do you want the sun? With what means? With yellow, with blue, and with white-lead; you want the movement of the air, abandoning the shape of things; you get all of the objects by mixing the colors with your fingers and by making war with the paintbrushes.

I love realism and I have made you love it—the manifestations of nature are immense, are great; it does not always appear alive with light nor does it always appear sad and dark—the animals, the men, the plants all have a form, a language, a feeling. They have sadness and joy to be expressed; I will write an *et cetera,* since writing a literary essay is not one of my strengths. Have you thought about all these things on this new path you think that you have taken?

You, Pagni,[2] whom I applauded at the Bandino;[3] I cannot praise you in Florence. I find Ghezzani[4] alone [praiseworthy], and we find him more careful about form.

I once said: *do something in art that shakes us old ones up!* But this present upheaval is not the result of that attempt to achieve light that you are searching for, but rather the result of an art without form or conception and complete forgetfulness of the relations of colors and of chiaroscuro; it is not Muller,[5] who returned from Paris, having seen Manet, Pissarro, and others, who, having behind him the feelings of those great men, was careful to make an art of his own. Please create that art in which you believe, and the criticism and the praise will fall to us. But to every one of you to whom I have always preached: *be yourself*—don't run after the first comer who paints blue shadows, and light the color of orange flowers.

Blue shadow is one of the characteristics of Signorini;[6] the deeper reds and orange color belonged to the Roman, Costa,[7] and he taught them to me; mixing the color with the palette knife was one of the little tricks Rembrandt used when making his self-portrait, and I did it too,

[2] Ferruccio Pagni (1866–1936), a student of Fattori who later emigrated to South America.

[3] The Bandino was a place outside the Porta S. Niccolò in Florence.

[4] Arturo Ghezzani (1865–1892), another Fattori pupil who exhibited landscapes.

[5] Alfredo Muller or Mueller (1869–1940), a Livornese painter, who studied in Paris with Carolus Duran and F. Flameng, returned to Florence from 1890 to 1895, and finally settled in Paris. His works show a clear Impressionist influence.

[6] Telemaco Signorini (1835–1901), Florentine painter, a member of the Macchiaioli group, noted for strong contrasts of light and shadow and for figure studies often reminiscent of Degas and Toulouse-Lautrec.

[7] Nino Costa (1826–1903), Roman-born painter of landscapes and portraits, who had contacts in England and France; especially friendly with Corot.

in 1858, when I tried making sketches with my palette knife. It's an old story, dear friends: nothing is new under the sun.

Yet perhaps these rash comments and all this criticism made by your old friend (not master) can serve to make you think, and with what you have attempted, can now serve as a guide to you in making a good impression upon me in the future.

I believe that you have had a clear conscience about not imitating *anyone*, but the fact indicates the contrary, and if you do not see that, it's all the worse for you.

If Muller had not been to Leghorn, you would have remained just as you were! Look at your past studies, look at your present ones: the facts are there and speak for themselves.

Martelli saw you and told me that he hasn't yet decided; if he applauded at Bandino, he cannot applaud at Florence.

The sentence "We are sure of what has been done" is a strong one, because you give me a kick—a kick to a poor old devil who has loved art, loved you; it is a phrase that shows your own great arrogance in accusing me and us of being reactionaries. . . . I will always remain the same

FATTORI [8]

Recollections of Youth

In this letter to a biographer, Carlo Raffaelli, the old artist recalls the struggles of his early days and reveals, in crudely turned phrases, the depth and durability of his artistic convictions. The odd punctuation is probably Fattori's own, or else that of Raffaelli, who recopied the letter.

[LEGHORN] AUGUST 16, 1907

DEAR RAFFAELLI,

How welcome your letter was! Now I will give you the notes on whatever I can remember: the first attempts were inspired by pure realism. A small painting of a nun at the bedside of a dying woman. Another: an attic, poverty—two abandoned children—rejected by the *Promotrice* for being too socially conscious. Then, already noted, the sons of Edward VI and the Mary Stuart which is in the gallery. The name of Ussi [9] rightly obsessed the minds of many young men. . . . I was set apart. I remember that Professor Pollastrini [10] said that I was a mad-

8 Giovanni Fattori, Letter to his Pupils, in Lamberto Vitali, ed., *Lettere dei macchiaioli* (Turin: Giulio Einaudi, 1953), pp. 64–65. Reprinted by permission of the publisher.

9 Stefano Ussi (1822–1901), Florentine painter of history, genre, portraits, and landscape.

10 Enrico Pollastrini (1817–1876), Livornese history painter, professor, and later director of the Academy of Beaux-Arts in Florence.

man and that I would never do anything—and the majority thought so, too. There came to Florence a certain Piedmontese painter, Castaldi; [11] he took me into the country to study landscape and encouraged me a great deal. After a year or two, he left and I never knew anything more about him. I was at the Beaux-Arts Academy of painting, but detesting academic instruction, I never did anything and was the despair of my companions, who enthusiastically worked and studied according to the established rules. When I was a student and my father took me to Florence and left me to board with another Livornese, I felt the need to study, but how? In my own way. I wanted, yearned to, reproduce everything I saw. I obtained a little album (of which I still have many), and since I was the friend of a household where there were young men and girls, I set down in this album all their quickly made movements (before impressionism); this system of observation and of recording has been useful to me. Lacking money and not being able to buy an animal [?], easels, or studio, I thought that I could study by observing on the streets as I pleased, and then I filled myself and all my little albums with sketches; for which reason, poverty is good for something, serves some purpose, [gives] strength to observe and to draw. All of this was at the beginning of my studies, from which I profited little, being greatly distracted by the conspiracies of '48, '49, '50—although I was little adapted to being a conspirator. The year 1859 you know about, and my savior, Nino Costa, also, who directed me to battle in art; and for as long as I have life and health and a strong mind, I will always fight; when it is exhausted, the young people who remain will think of us to free themselves from academic pedantries and they will understand that art is a feeling, not a trade—and the angles and triangles, the theory of shadows, is a lot of stuff for making slaves of the most promising geniuses of the future; I will cite one case as an example. For the scholarship competition, they have sent the theme from Rome, and I know that two youths of great talent have made a fiasco of it! I defy this, because they were obliged to do something which they neither felt nor loved. Banish (I have always said) the competition and tell the competitors to take the *theme* from you others; then one would see a fine exhibition of works worthy of being discussed and admired. This is what I have always thought—and I shall insist upon it. Other things relating to art I don't remember; if I remember something I shall make note of it. . . .[12]

11 Actually Andrea Gastaldi (1826–1889), a painter of historical and sacred scenes.

12 Giovanni Fattori, Letter of August 16, 1907, to Carlo Raffaelli, in Vitali, *Lettere,* pp. 100–101.

ADRIANO CECIONI: 1836–1886

The Style of the "Macchiaioli"

Adriano Cecioni was perhaps more important as a sculptor and as a chronicler of the art of his time (Scritti e ricordi, *1905*) *than as a painter, although he produced several unpretentious paintings of interiors of an undeniable and intimate charm. He studied both painting and sculpture at the Florentine Academy and became active as a polemicist and apologist for the Macchiaioli.*

In this excerpt from a letter of 1884, Cecioni attempts to explain the aims and stylistic characteristics of the paintings of the group.

AUGUST 3, 1884

All the *macchiaioli,* or *impressionists,* if you like to call them that, were in agreement with Signorini. Their art consisted not in a research for form but in a mode of rendering the impressions received from reality by using patches of color, or of light and dark; for instance, a single patch of color for the face, another for the hair, a third, say, for the neckerchief, another for the jacket or dress, another for the skirt, others for the hands and feet, and so with the ground and the sky.

The figures scarcely ever exceeded the dimension of fifteen centimeters [six inches], this being the dimension assumed by real persons when viewed at a certain distance—the distance at which the parts of the scene that gave us the impression are seen as masses and not in details. Hence the figure viewed against a white wall or against the sky at sunset or against a sunlit surface was considered as a dark patch on a light patch. In painting the dark patch, moreover, we took into account only its principal and more conspicuous features, such as the head—but without detailing the eyes, nose, and mouth; the hands—without the fingers; the dress—without the folds; first, because in those dimensions such details disappear, secondly because in the nature of the *macchia* such research had no place, for we cared only to lay down such principles as could serve as a solid base for an entirely new art. These principles were color, value, and relation [*rapporto*]. . . .

It would be impossible to give an idea of the attempts made, especially to render the effects of the sun. We laid pigment upon pigment, but sometimes failed to achieve the value of light. Then we said it depended not on the quantity but on the quality of the pigment and scraped the canvas to try new colors. Yet the desired result failed us. . . . You will understand that in that kind of research the study of form and

contour had only a very secondary part or none at all. Outline, properly so called, had not and could not have any part.[13]

Cecioni's Sculpture and Painting

These excerpts from the Memorial Essay, prepared by a friend immediately following the death of the artist in 1886, give an idea of the range of themes treated by Cecioni and of his realistic approach to the execution of the works themselves.

. . . Adriano conceived the thought that an artist had to complete himself with a family, and having taken a wife, he gave life to the first love-inspired creation of his imagination with a little statue of a pregnant woman, which, most exquisite in its modernity and sentiment, aroused wonder and admiration in all those who saw it. In frequent conversations about this subject with him, he told me that the first immediate sensation experienced in regard to the pregnant woman arose while examining the remains, cast in plaster, of a woman's corpse taken from the disaster of Pompeii. This human form revealed two things: the youthful age of the victim and her pregnant condition; and he, struck by this sight, understanding within the loftiest familial feeling, found in the subject of the pregnant wife the point upon which to concentrate all the forces of his artistic imagination, and he modeled the masterpiece of which we have spoken, now preserved in the Capodimonte museum.

Having executed this first work as a studio exercise, he created the statue of the *Suicide,* a semi-nude figure, barely covered by a cloth, belonging to any epoch of man's history. Young, not handsome, the suicide looks at a knife, meditating in his thoughts the planting of it in his heart; and while sometimes a man, seen with a knife in his hand, could just as well seem to be meditating upon revenge, yet the attitude of Cecioni's statue is such that there is no doubt that this individual will stab himself; it is a true suicide; and this undeniable quality is due entirely to the subtle probing into character that Cecioni was always searching for, and above all in his own works. . . .

. . . In this period Adriano made an appearance in the Sale della Promotrice with some little essays in painting in which the study of relationships was most precise, deepened by love and awareness in the setting of the domestic interior. The subject of one of these little pictures, however, representing the morning house cleaning, in which the

[13] Adriano Cecioni, "Macchia and Macchiaioli," in Robert Goldwater and Marco Treves, eds., *Artists on Art,* trans. Robert Goldwater, 3rd ed. (New York: Pantheon Books, 1964), p. 328. Reprinted by permission of the publisher.

protagonist, placed directly in the center of the observer's view, was a beautiful chamber-pot, made the purists shout so much that no one wanted to discuss the pictorial qualities of this canvas. . . .

At the august exhibition at Turin he presented two works, a very pretty baby boy surprised by the impudence of a dog while descending the stairs, and the statue of the *Mother* playing with her nursling. The natural and honest character of this group and the way in which the two figures of mother and son are animated leaves nothing to be desired; the fact that he made the woman ugly rather than not, yet full of expression, is a merit, not a defect. . . .[14]

ANSELM FEUERBACH: 1829–1880

Letters to His Mother

German painting of the second half of the 19th century lacked the organic cohesiveness and creative unity characteristic of French art of the period. Rather, it tended toward partial expression and extremism, with the two currents of romantic or intellectual idealism on the one hand and an often exaggerated naturalism on the other coexisting and developing at the same time. Like the Pre-Raphaelites in England and Puvis de Chavannes in France, the idealistic "German Romans" as they were called because of their predilection for Italy and classical themes, responded to the ugliness, materialism, and complexity of the modern age by withdrawing from it into some purer, more poetic, atemporal realm.

One of the leaders of this "intellectual" current was Anselm Feuerbach, a member of a highly cultivated family and nephew of the famous philosopher, Ludwig Feuerbach. Feuerbach studied at the Düsseldorf Academy and made two trips to Paris between 1851 and 1854, where he felt the influence of both Courbet and Couture, more especially the latter.

In 1855 he went to Italy, first to Venice, then to Florence and Rome. Italy and its art were an epiphany: from then on, he felt at home only on classical soil. It was in Italy that he produced his major works: the series of portraits of his classical-featured Italian model, Nanna, the Medea, *and the* Iphigenia. *With reference to his work, he speaks of striving for a "truly majestic, forbidding tranquility." And although, in some of his female portraits he does at times achieve this goal, they*

14 Memorial Essay prepared for the death of Cecioni in 1886, reprinted in the *Fieramosca* of May 20, 1889 as "The Work of A. Cecioni exhibited to the Public in the Royal Academy of the Beaux-Arts of Florence," in Vitali, *Lettere*, pp. 230–231, 234.

attain their melancholy distinction at the price of formal vitality and conceptual richness.

These letters of 1855 and 1861 to his mother from Venice and Rome give an insight into his spiritual qualities and artistic predilections.

VENICE, SEPTEMBER 1, 1855

MY DEAR MOTHER,

To begin with, as lonely as I may feel, I still praise loneliness. I have a charming, elegant little room; my view is over trees, the sea, the tower of St. Mark's and a *pezzo* [15] Doge's Palace—and the main thing: I am inwardly calm and content. . . .

I don't know whether I have explained myself clearly. The only thing I really am is a painter through and through; my restlessness has lessened more and more and I can say that I could sacrifice my life to art. You don't believe—because I can't say anything with words—how clear the road I have already covered has become and how definite and strongly marked and serious the future one is. The problem of the thirty steps distance of my pictures will soon be solved. But I must remain brief, otherwise this letter too will be an ell too long. The Virgin of the Assumption as well as the small Martyr will be good and ready at the beginning of next month.

My will is inflexible and my hand has what is called skill; and I also work with pleasure. Afterward, I should like to go to Parma for a month to study the first of all painters, Correggio. Once I have grasped him, my pictures will be no Veroneses, for Correggio has everything that could enchant a man's heart: warmth, grace, glowing color. Out of these three I shall develop my own ideas through nature painting and through the understanding of what is in me. My present painting shall bear witness to it. I bless the hour that allowed me to become master of technique so that I may now calmly follow the spirit. It is true that I said this two years ago, but it was misunderstood. . . .

One thing is clear to me now: our modern art is nothing but the poetry of a painted corpse. May God grant me the grace and the strength to find a path leading to Olympus, with the help of the dead and what nature has given me. . . .

. . . My suffering and struggling in Paris and at home were dreadful; now it is all over and it did not harm my character. . . .

It is indeed true, man must know pain, great pain, in order that he also know great joy. If we don't have both when we are young, then

[15] *Pezzo:* a piece of. In Italian in original.

we have nothing. Even calm must be an achievement of our own, not a gift of nature. . . .[16]

<div align="right">ROME, MAY 8, 1861</div>

There is already a big Iphigenia; [17] it has been done after long searching amidst sleet and storm: she shall travel all over Germany and win over all hearts to me. I have then traced out a second one, entirely different but with the same meaning. The first one, dressed all in white, comes out of the forest and halts at the sight of the seething sea. The second leans against a column and is completely absorbed by the sight of the sea and by the thought of her far-away home. That, my dear Mother, has also its justification, and my way of grappling, my way of hitting the nail on the head is a battle which can be waged only on classical soil.[18]

ARNOLD BÖCKLIN: 1827–1901

Letter to Colonel Merian-Iselin

Arnold Böcklin, who was born at Basel and studied at Düsseldorf, is perhaps the best known of the German "idealist" painters who adopted Italy as their residence. Although he was extremely successful during his own lifetime, especially among upper-middle-class art lovers, who found his realistically rendered allegories both "poetic" and easy to grasp at the same time, most of Böcklin's paintings tend to appear trite or even ludicrous to modern eyes. Böcklin specialized in several types of themes, most of them literary and vaguely symbolic in conception, often with classical or mythological overtones: classical landscapes peopled by nude and costumed personages with wistful expressions; paintings of sea creatures—mermaids, tritons, nereids, sea-monsters, and other beings related to Germanic folklore, in some ways comparable to Wagner's use at about the same time of similar legendary material in a poetic, mood-creating style. Unfortunately the detailed precision, at times reminiscent of that of the Pre-Raphaelites, with which he treated his invented fantastic or poetic themes often destroys their mood-creating propensities with a heavy-handed descriptive literalism.

[16] Anselm Feuerbach, Letter to his mother, Venice, September 1, 1855, in Else Cassirer, ed., *Künstlerbriefe aus dem neunzehnten Jahrhundert* (Berlin: Bruno Cassirer, 1923), pp. 287–288. Reprinted by permission of the publisher.

[17] Feuerbach executed at least three versions of this classical theme: the two, standing, that he describes in 1861; and a third, seated, in 1871, now in the Stuttgart Gallery.

[18] Anselm Feuerbach, Letter to his mother, Rome, May 8, 1861, in Cassirer, *Künstlerbriefe*, p. 293.

Yet at times, in such visionary landscapes as The Isle of the Dead *of 1880, Böcklin suppresses his tendency to creaking literary description and succeeds in creating a visual image—however theatrical—of a mysterious dream-world, both frightening and idyllic at the same time. Böcklin's magic realism has, moreover, exerted a considerable influence on at least one important 20th-century painter: Giorgio di Chirico, who, as a young student in Munich, fell completely under the German painter's spell and copied many of his works.*

In later years Böcklin was preoccupied mainly with plans for a flying-machine, concerning which there exists an extensive correspondence.

The following letter, while not terribly revealing, gives some insight into his views on art.

ROME, 26 SEPTEMBER 1865

DEAR SIR,

All this summer I have been prevented by various reasons from answering your kind letter. To begin with I had a fever for several weeks, which left me weak and with no courage to work—and recovered only when the great heat was beginning. All this had its effect on the picture too, and what with the heat and the doubts that combined to torment me, several months went by before I could again see a smooth road ahead. As everyone knows who is not made of stone, a situation like this does not make one communicative, and I therefore feel sure I can rely on your indulgence. Because I was dissatisfied with the work, I postponed taking the photographs too, wanting to spare you a depressing sight by waiting till the picture was more advanced.

Your remark that an easel picture should not be treated like a decoration, but carried out as the expression of a definite practical mood, precisely reflects my view concerning this picture. In others, detail may perhaps predominate, in yet others the decorative aspect; in each case this depends on the leading, basic ideas, which are conditioned by the outlook of the individual artist—it would take too long to discuss that here. My own view is that a picture should not weary the beholder—that while each particular feature should be in tune with the whole, and sometimes in quite a subordinate way, it should be beautiful in itself. The fine arts are not intended for man's torment, but for his enjoyment. To achieve this practical skill I have made all kinds of technical experiments in the last few years, but I have not ventured to make use of them in your picture, because I have reliable evidence of the lasting qualities of oil painting which, when suitably handled, is capable of a perfection and a beauty of color seldom credited to this medium. I now think I shall be finished by December or January, but I would like to

wait another few weeks so as to hear opinions and be able to make any necessary corrections. Up to now I have kept the work carefully hidden, in order not to be led astray by premature comments. At a later stage, however, an expert opinion becomes indispensable, because the eye can grow accustomed even to mistakes, and I will even venture to ask you yourself for your opinion. I can have no objection to a little extra work when it gives me the opportunity to complete the picture to your satisfaction and my own.

Meantime I shall most gratefully avail myself of your kind offer to send me a further advance, and should be much obliged if you would send it within the month.

<div style="text-align:right">

With great respect,
Your devoted
A. BÖCKLIN [19]

</div>

HANS VON MARÉES: 1837–1887

Two Letters to Conrad Fiedler

Of the German artists working in Italy during the second half of the 19th century, Hans von Marées is without doubt the most important, the least literary or self-consciously philosophical, and the one most able to convey his meaning through the visual image itself.

Devoting himself almost exclusively to the human figure within a landscape, in 1873 Marées painted what is no doubt his masterpiece in the series of frescoes for the Zoological Institute at Naples. Both contemporary—the work contains portraits of some of the naturalists sitting with artist friends at a tavern table and depictions of the activities of fishermen—and timeless—the program includes monumental nude figures in a paradisiacal setting—the fresco cycle produces an effect of mysterious and evocative simplicity not unlike that produced, though by more abstract pictorial means, in Gauguin's Where Do We Come From? What Are We? Where Are We Going? *of more than twenty years later. Marées' four great triptychs painted in the late seventies and eighties, now in Munich, are equally grand in scale and conception: one feels that they must have had an effect on the German 20th-century painter Max Beckmann, who also turned to the triptych form.*

Yet while Marées' painting is classical in its monumentality and evocation, his use of color and the importance of its role in creating the simplified, stereometric forms of his figures is decidedly contemporary;

19 Arnold Böcklin, Letter of September 26, 1865 from Rome to Colonel Merian-Isclin, in Richard Friedenthal, ed., *Letters of the Great Artists: From Blake to Pollock*, trans. Daphne Woodward (New York: Random House, 1963), pp. 85–86.

the richness of his handling of pigment is often reminiscent of the style of Courbet, and some of his portraits recall those of Manet. At times, in his feeling for the reciprocal relationships between visual reality and the colored plane on the surface, Marées actually approaches the figure-style of Cézanne, although, it is true, his figures generally exist within a more overtly Arcadian setting.

In these letters to his friend Conrad Fiedler (see below, pp. 168 to 176), who, although a lawyer by profession, was greately interested in certain theoretical problems which had been raised by Kant in the realm of the plastic arts, Marées sets forth his views and aspirations in art. These problems were concerned with the relationship of the three dimensional world of reality to the flat, invented one of pictorial representation. Marées had previously summarized these views touchingly in a letter to the same friend in 1871: "I long for nothing more than the moment in which conception and representation will flow together and form a unity."

<div align="right">ROME, JANUARY 29, 1882</div>

I would call a born artist that man whose soul has been endowed with an ideal by nature, right from the start, and for whom this ideal takes the place of truth; he believes in this [ideal] unreservedly, and his life's work will consist in bringing it forth for the contemplation of others and in the absolute realization of it for himself. This word "ideal" is one that can very easily be misunderstood. I think that for the plastic artist it consists above all in the fact that for him everything that falls beneath his eyes displays its total richness, an inexhaustible value. Thus, his spirit turns in this direction early, and the qualities necessary to it, like reflection, the effort to copy, skillfulness, etc., also develop young.

I still remember quite clearly how the world appeared to me at the age of five, and how I tried immediately to grasp this impression in painterly terms. It was also at this point that the difficulties began, for no sooner does one become observant of things than influence sets in, and influence, even when it is well intentioned, in most cases becomes a wall between the individual and revelation. (Naturally, he alone is an artist to whom the *essentials* of appearance are revealed. All attempts to sum this up in words and rules have remained vain until now; Nature herself always had to intervene with assistance when such a revelation was to take place again. In the apparently extremely varied works of art from Phidias to Velasquez, I can still understand only that which strikes and enlightens me. When one realizes this, it becomes evident that time and the tendencies within that time can have only a very minor influence on an artist; just as the most fashionable garments still can disguise a man of old-fashioned sterling worth.) (In these parentheses I should like to insert another: that is, that art is not really old; it is as old or as new as the unchanged and unchanging passions of man;

only art is not a passion and that is why it was called divine by the Ancients.) If I have just spoken about my own childhood, I did so because I wanted to say that I, from the beginning, felt within myself a standard by means of which I could form my own judgment. And the forming of the latter has, strictly speaking, become the chief task of my life, for even the most gifted can do nothing without ripe judgment. "And he saw that it was good": this is what the artist must be able to say in the end, even if—since he is merely human—in only a partial fashion. The fact that he is human is what makes it so difficult for him to be an artist, and yet, the one is not possible without the other. Nor can he avoid the problem of becoming as completely pure a human being as possible. I know of no other way to obtain for oneself that direct, naïve attitude toward nature which we consider one of the loveliest gifts of childhood, nor any other way to learn how to discover a type of expression comprehensible to everyone. (Easy accessibility still remains one of the most admirable qualities of an art work.) No sooner does one become observant in life, than one quickly notices that this can be nothing but an advantage in art as well. If one does not know one's own weaknesses, one cannot change accordingly.

The balance between warm susceptibility and cool judgment, between which the artist incessantly swings to and fro, can only be found in self-conquest and resultant self-control. The luckiest and noblest artist will be the one who achieves renunciation most easily. I mean renunciation in the highest sense of the word—that which consists not in showing off one's talent and knowledge, but in using them only insofar as they are relevant. For it will prove to be the case that a mere overdose of power will not make the solution of even the simplest artistic task simple; for a perfect solution even the most extraordinary strength will scarcely be sufficient. Even if it is not given to man to achieve perfection, he still must strive toward it. If he thus becomes modest, he will learn to set limits and a goal to his will. Whoever wants what is impossible for him to accomplish does not give dazzling witness to his intelligence. If the artist accomplishes everything he actually can, he has really achieved the highest that is obtainable. I think that this is extremely rare, and find that the chief cause always lies in purely human, moral motives. There is no question but that the external circumstances also have a great deal to do with it. But for this reason I say that the artist must struggle to raise himself above all external circumstances, even above himself. For, last but not least, he must achieve in his works a bold and unhampered resolution that negates all toil and trouble, or at least hides them from the eyes of the world. . . .[20]

20 Hans von Marées, Letter to Conrad Fiedler, Rome, January 29, 1882, in Julius Meier-Graefe, *Hans von Marées: sein Leben und sein Werk* (Munich and Leipzig: R. Piper & Co. Verlag, 1910), III (*Briefe*), 232–233. Reprinted by permission of the publisher.

ROME, FEBRUARY 5, 1882

DEAR FIEDLER,

The meaning of what I recently said is that whoever devotes himself to the practice of the arts must attempt to achieve and maintain an unprejudiced relationship to nature. This is possible only if the artist remains as much as possible untouched by incidental social conditions, by bourgeois narrow-mindedness; the external mark of such a state would be the indestructible freshness of youth.

If one succeeded in penetrating into the nature of appearance and grasping the essential, it would become relatively easy to understand the nature of one's art. Both the understanding of nature and of art are entirely necessary in order to form a judgment of what one should and can accomplish. (As an encouragement and incitement, we can at this point recall what an extraordinarily beneficial influence was exerted on our German literature by Lessing's *Laokoön.*[21] It is true that there is no question here of the plastic arts; Lessing uses it only as a contrast.) In connection with what I was saying before, the question arises as to whether our problem concerns the expression of one's feeling about nature through talent and skillfulness. I personally would answer it with a decided "no," and I would add that even the higher and nobler feelings about nature ought to be no more than one of the necessary means for making a definite and forceful impression on the spectator. (The painter should not speak about himself but about what is outside him.) . . .

High excellence cannot be achieved if the basic conditions are not fulfilled. All the efforts of the Greeks were directed toward excellence; to attain it they had to have a clear, natural basis. Great variety of knowledge, great talent, and outstanding skillfulness are in the final analysis useless if they are not guided by a healthy, pure, natural spirit. That is why I always have to repeat that the artist must pay the greatest attention to his human qualities, as well as to his relationship to other people. . . .[22]

WILHELM LEIBL: 1844–1900

Letter to Baurat U. Wingen [23]

Wilhelm Leibl is the most important representative of realism or naturalism in Germany during the second half of the 19th century. He

[21] In his *Laokoön,* written in 1766, the German writer, Gotthold Ephraim Lessing (1729–1781), draws a clear distinction between the plastic arts, which deal with spatial entities, and the art of poetry, which concerns itself with temporal ones.

[22] Hans von Marées, Letter to Conrad Fiedler, Rome, February 5, 1882, in Meier-Graefe, *Hans von Marées,* III, 234–235.

[23] "Baurat" is a title given a distinguished architect in Germany, or it may simply refer to a government architect or member of a Board of Works.

*studied first in Munich, then went to Paris, where he remained until
1870, and where he fell under the influence of Courbet, who had ap-
proved of Leibl's work in the Munich Exhibition of 1869. In Paris he
produced two of his most accomplished works,* Old Parisian Woman *and*
The Cocotte. *Like Courbet, whose conscious roughness of manner and
countrified simplicity he seems to echo, he wished to restrict the domain
of painting exclusively to the representation of real, visible, and con-
crete things.*

*Leibl skillfully combined color and chiaroscuro, working in a style
sometimes open and painterly, sometimes precise and enamel-like. While
he may be considered Courbet's German counterpart, his range is far
more restricted, and, despite certain minor masterpieces such as the*
Three Women in a Church *(1881), is flawed by a certain cramped pro-
vincialism of conception and pettiness of execution.*

*This letter probably refers to a request from Wilhelm von Kaul-
bach (1805–1874), head of the Munich Academy, for assistance in the
completion of a cycle of subjects taken from the works of Schiller: such
literary-historical subjects were, naturally enough, not to Leibl's taste.*

MUNICH, OCTOBER 14, 1867

Kaulbach wants me to paint one of his cartoons (the encounter of
Maria Stuart and Elizabeth) and to sign a contract with me for this pur-
pose. But I feel no desire for that. I would rather express my own ideas
and I don't believe I could work according to the ways and manners of
someone else—I believe this would hamper my progress to an essential
degree, or even destroy it. At the moment, I should like to paint a monk
sitting at the window of his cell and playing the violin. I should like
to represent this single figure on a considerably large scale and try to
see whether my strength is equal to the expressiveness with which I
should like to endow it. How welcome the stipend would be now! I could
do what I wanted and not what others wished. I wouldn't like to offend
Kaulbach, but in no case would I like to comply with his wish. I don't
want to be used. And so I turn to you for advice. Not only I, but every-
one else wishes that you were again among us; I often think of you
even if I anger you a little with my slow answers: you well know this
fatal habit of mine.[24]

Letters to His Parents

*In 1877 Leibl received a commission to paint the portrait of the
Countess Treuberg at Holzen. He stayed at the castle as the guest of the
noble family from approximately July to October of that year. His con-
sciousness of, and pride in, his own humble origins are touchingly remi-
niscent of similar qualities in his French counterpart, Gustave Courbet.*

24 Wilhelm Leibl, Letter to Baurat U. Wingen in Cologne, Munich, March 7,
1867, in Cassirer, *Künstlerbriefe*, p. 356.

HOLZEN, JULY 12, 1877

The life I am leading here is not bad at all. It is filled with eating, drinking, painting, hunting, and so on. I am served with the greatest thoughtfulness and people here try to fulfill all my wishes. In exchange, I make efforts to adapt my behavior gradually to such a society. In this, however, I shall never be entirely successful. Certain people who think they know me would no doubt be much astonished if they could see me now in most respectable clothes, with fine wrist-frills, bowing and making obliging, amiable grimaces, if they could hear me use the courtly form of address: "Your Lordship," "Your Ladyship." Those would especially be surprised who come from the country and are used to seeing me walk around in slippers or even barefoot, dressed in old pants and a smock brought along from Paris. Really, sometimes when I wake up in the morning and the servant brings the breakfast or takes my clothes to be cleaned and says respectfully: his Lordship wishes to inform you that the horses are harnessed or her Ladyship will sit at 9 o'clock if it suits you —well this sometimes seems to be a dream.

The Count is a passionate hunter and since I own an eminent pointer and I am tireless at the chase, I seem to suit him well.

HOLZEN, 1877

To return once more to my present work, I painted the portrait of the Countess with tempera colors and with great zeal, and I am sure that it will please art lovers. The Count has an old saddle horse of the noblest race whom he has been riding for a long time and whose age will soon make him unfit. I painted him upon the Count's wish. In the beginning he doubted whether I could do it. You know, however, that I am used to painting according to nature, and that it is a matter of indifference to me whether I paint a landscape, people, or animals, and so I cheerfully consented to paint it on a sizable canvas. I stood in the stable amidst the horses while the Count was behind me most of the time, frankly expressing his satisfaction, indeed his astonishment, that I could so well seize the character and specific color. When I had finished, he summed up his judgment by saying that he did not think anyone else could have done it, for the horse is a speaking likeness and I had captured all the characteristics of a noble race, which he then explained to me.[25]

Letters to His Mother
About "Three Peasant Women in a Village Church"

Leibl had been unimpressed by the shopworn grandiloquence of Kaulbach and the other luminaries of the Munich Academy. Instead, he

[25] Wilhelm Leibl, Two letters to his parents from Holzen in 1877, the first dated July 12, in Cassirer, *Künstlerbriefe*, pp. 359–360.

turned to a humble subject from the life of the common people for a major work, and, abandoning his former broad, painterly style, set about to capture his subject with minute, meticulous realism; the effort took him almost four years and the painting, now in Hamburg, was finally completed in 1881. In this work, an objective description of peasant piety, Leibl has tried to maintain a balance between color and drawing, descriptive materialism and spiritual value. He recounts the various difficulties encountered in the course of completing the work in a series of letters to his mother.

BERBLING, 18 MARCH 1879

Here, in the open country and among those who live close to nature, one can paint naturally. My stay in Munich served to confirm my belief that painting in that town is simply a habit, carried on with a shrewd eye to expediency, but quite without original feeling or any independent outlook. Whether it be called historical painting, genre, or landscape, that kind of thing is not art; it is merely a superficial copying of things familiar to the point of satiety.

BERBLING, 20 MAY 1879

It really takes great staying-power to bring such a difficult, detailed picture to completion in the circumstances. Most of the time I have literally taken my life in my hands in order to paint it. For up to now the church has been as cold as the grave, so that one's fingers get completely stiff. Sometimes, too, it is so dark that I have the greatest difficulty in getting a clear enough view of the part on which I am working. I need hardly say that work like this can be completely upset by even the faintest idea of finishing it by a particular date. So you must begin to accustom yourself to the thought that you will not find me represented at the Munich exhibition. But do not feel uneasy. Even if the picture is not exhibited, it will have its effect. Several peasants came to look at it just lately, and they instinctively folded their hands in front of it. One man said, "That is the work of a master." I have always set greater store by the opinion of simple peasants than by that of so-called painters, so I take that peasant's remark as a good omen.

NOVEMBER 1879

You are mistaken in assuming that the picture is nearly finished by now. If you could only see it, you would cease once and for all to imagine that such a thing could be painted in the time you suppose. I always have to pay dearly when I try to go quickly, because the sight of the hurriedly painted portions annoys me so much that I cannot leave them as they are. I have to clean them off completely and begin all over again.

26 June 1880

I am still working in the sweat of my brow, simply so as to inch forward a little every day. It is really enough to drive one out of one's mind, and requires cast-iron patience.

15 November 1880

I cannot complain of my health; on the contrary I feel perfectly well, though I am still working in the church every day. But I have been having very bad luck with the picture. For instance, I could not finish the hands of the last figure, because when I had already got a long way with them the model developed a boil—and an inflammation of the eye, so that I could not finish the head either. My patience is being sorely tried.[26]

HANS THOMA: 1839–1924

A Letter to Emil Lugo

Hans Thoma studied at the art schools of Karlsruhe and Düsseldorf, then went on to Munich after a visit to Paris in 1868, where he had been impressed by Courbet. Despite the professedly straightforward naturalism of his aims, Thoma tended more and more, after the late seventies, to alternate between a realistic rendering of familiar landscape scenes, and a more poetical, allegorical or literary kind of approach to painting. In 1880, for example, the year in which he wrote the letter from Frankfurt printed below, Thoma produced both a clear, objectively described, meticulously realistic canvas of a herd of goats in the Campagna and a fuzzy, hazy "poetical scene" of a Faun Family in an imaginary forest—the latter accompanied by two perfectly realistic goats which seem to have wandered in from the other painting! While his portrait style remains quite distinguished and sometimes even reminiscent of the early Holbein in its meticulous intensity (i.e., the Double-Portrait of Himself and his Wife in a Painted Frame, *1887), he often lapsed into meretricious and sentimental "folksiness"—scenes of wrinkled old peasant women with children and animals or pious grandmothers reading the Bible with their grandchildren—and, at other times, turned to a rather anemic neo-Nazarene style for religious works such as* Christ and Nicodemus *(1878) or* The Rest on the Flight *(1908).*

The letter below was written to the painter Emil Lugo (1840–1902), a good friend of Thoma's who was also strongly influenced by the Barbizon School.

[26] Wilhelm Leibl, Excerpts from letters to his mother from Berbling, from 1879–1880, in Friedenthal, *Letters*, pp. 89–91.

. . . The aestheticians and critics . . . I don't want to know any-
thing about them, and when I need some good discussion of art, then I'll
go to a man whose concept of art I understand, whose works prove that
he was not speaking hot air. They are simpler, more straightforward,
more understandable words than those used by modern eccentrics. They
[these words] explain to me all that words can explain about matters of
art: take for instance, the words spoken by Dürer, Leonardo, Alberti.

An indication of how the simplest concepts have gone off the track
is the sentence: "Art can either give much more than nature or it can
give much less." This is hot air. How can art, this work of man, be com-
pared over and over again with infinite nature? Since art is something
entirely different, indeed, nothing else but the expression of human life
and feeling, in opposition to the enormous chaos of nature, one could
perhaps consider art as a sort of rough order in the confusion of impres-
sions that the mind receives from the world. When it [art] is the expres-
sion of a human soul, then it is good, but it also can be a work of mere
superficial skill, and then it is not art in the true sense, no matter how
"artistic" it may appear.

What particularly strikes me in a modern exhibition is the element
of accident which is present in most pictures; what is lacking is a spirit
of order and forcefulness. Good pictures always look as if they had grown
organically, as if nature had produced them, or as if they had been built.
But most pictures in exhibitions are arranged, they appear to me as
though they had been manufactured by pastry-cooks or rug-weavers, and
many history paintings look as though they had been made by theater
directors. In comparison with this art of arrangement, so conceited about
its own tastefulness, naturalism, which tries to imitate a bit of nature
with seriousness and love, does indeed have something which leads to-
ward creation. Taste is of no importance in art; any milliner can have it.

Art will create according to its own dictates—not according to ex-
ternal laws and directions, but according to laws which are embedded in
the soul of man. Thus it is obvious that art springs directly from the
natural world, because human nature is entirely rooted in the natural
world. Truth in art will basically be nothing but the revelation of the
nature of the soul. Art testifies to the mind that discerns truth, to the
mind that creates according to its own laws; this is so in the plastic arts
as well as in music and poetry.

There will always be artists who have the capacity to understand
the nature of their own souls, and they will again find a valid expression
in art. They will find the right form and become lawgivers. He who cre-
ates according to his own idea—that is, the real idealist—will not care
whether the artist of "arrangement" or the naturalist is willing to recog-
nize him. He will also be laughed at!

In art, too, one needs a natural, childlike sense in order to be truthful. Children are genuine and honest. Only complete honesty is capable of creating great and enduring things for mankind. This holds true for art, as it does for all other fields.

Those who feel they must discover the law of art as a "canon" in existing works are no doubt right, for these deserve serious consideration and there is always enough hidden meaning in them which manifests itself in such a variety of ways that it is difficult to take account of all of it. But it is not at all certain that much can be achieved by such reconstructions, for the human mind must always find a new artistic expression. It seems to me that we, the wild weeds of a country lacking in art and culture, cannot link our searching tendrils to the works of Rubens, Van Dyck, and others whose masterly skill is enormous.

We beginners must have the courage to let people laugh at us when we try to confront nature with our own eyes. This apparently seems more ridiculous than a dwarf's walking proudly in the armor of a giant.

But what did I get myself into? In the beginning of this letter I inveighed against phrases and empty words about art and now you will laugh and say "he himself is now falling into the same senselessness." . . .

Aren't you coming to see us once again? I would take you to the Taunus; [27] I have discovered that there also are beautiful clouds and flowering meadows but I don't let anyone know about it except you. My wife, however, always comes home with her arms full of meadow flowers and she sends you her regards. And so do I, with old friendship. Write soon.

<div style="text-align:right">

Your

HANS THOMA [28]

</div>

MAX LIEBERMANN: 1847–1935

A Confession of Artistic Faith

Max Liebermann was the initiator of the movement in Germany corresponding to that of the Barbizon School in France, and, later in his life, created a fusion of Realism and Impressionism, always within the framework of deeply felt genre and peasant themes. He studied at the Weimar Art School, and then in Paris he came under the influence of the Hungarian disciple of Courbet, Michael Munkacsy (1844–1909), as

[27] A wooded mountain range in the German province of Hesse-Nassau, famous for mineral springs and health resorts.

[28] Hans Thoma, Letter to Emil Lugo, Frankfurt, June, 1880, in Cassirer, *Künstlerbriefe*, pp. 367–368, 370.

well as that of the French Realist himself. But most important was his encounter with the painters of the Forest of Fontainebleau. Liebermann spent the summer of 1873 in Barbizon, and, although he never met Millet personally, the works of the latter made a deep and lasting impression upon him. His style became increasingly open, painterly, and overtly Impressionist as the years advanced, yet his subjects—laboring peasants, groups of flax-spinners, shoemakers, seamstresses—remain conveyors of a humanitarian viewpoint, reminiscent of the works of the young Van Gogh and of the contemporary Dutch "Barbizonist" painters of the poor and humble: Josef Israëls (1824–1911), Anton Mauve (1838–1888), and Jacob Maris (1837–1899). Liebermann himself spent a good deal of his time in Holland, where he painted many landscapes and figure pieces; among the best known are The Courtyard of the Orphanage in Amsterdam *of 1881 and* The Old Men's Home in Amsterdam *of 1880. Some of his least ambitious, most objective paintings, like the broadly painted portrait of the scientist Rudolf Virchow (1894), or the stark yet broadly painted* Woman with Goats *of 1890, are his most successful. Liebermann's name was connected with artistic unorthodoxy both early and late in his career: his* Jesus in the Temple, *painted shortly after his return to Germany in 1878, created a scandal because of its seemingly irreverent attitude and coarse treatment; there was even a two-day debate about it in the Bavarian Parliament. In later years he became a spokesman for the Impressionists in Germany—he owned a fine collection of their works and wrote a book on Degas—and in 1899 he was elected the first President of the revolutionary Berlin "Sezession," thus allying himself with the most radical art movement of his time in Germany. Because he was a Jew, Liebermann's works were removed from public exhibition by the Nazis, and many of them were either sold or destroyed.*

The following statement on art was written in 1922, when Liebermann was already a revered "old master."

It is an undisputed and indisputable axiom of aesthetics that an idea must precede each form, each line, each brushstroke; otherwise, although the form may be correct and calligraphically beautiful, it cannot be considered artistic, for only the living form is artistic, the one produced by the creative spirit.

Thus all artistic form is *per se* idealistic form, and there can be no sense in speaking of naturalistic form, unless one means by it the matter which expresses the form. Instead of idealistic-naturalistic, we ought to settle for Schiller's terms: naïve and sentimental. For if there is only idealistic form—that is, form preceded by an idea—then there can be no naturalistic form opposed to it. If the terms idealistic and naturalistic are meant to express the different relationship of artists to nature—one artist being more intent on reproducing nature than the other—then the terms

naïve-sentimental are much closer to what is meant by them. To use again Schiller's wonderful words: "the artist is either himself Nature or else he will seek after it. The former makes the naïve, the latter the sentimental artist." All artists are naïve and therefore there is only a difference of degree between the sentimental and the naïve artist. Between the idealistic and naturalistic artist there is a difference of nature.

I am speaking about the forms of genius—that is, about forms that cannot be learned. That is why I skip the correct academic form, which can be learned and must be learned just as grammar must be learned.

It is self-evident that form is the basis of all plastic arts. But it is much more: it is also its goal and culmination. Without it—to mention specific painters—the paintings of Titian or of Tintoretto, of Rubens or of Rembrandt, of Goya or of Manet—would be Persian carpets. They would be living paintings but not paintings that live. For they would have no souls.

But what infuses form with a soul? What makes a few hieroglyphics on a piece of paper or a few colored spots on the canvas give rise to the highest spiritual feeling within us?

What else but the spirit, which infused life into the chalk, into the brush! Only the spirit creates reality.

This realization, which since the time of the classical art critics, since Lessing, Schiller, and Schelling, belongs to the stock of our aesthetics, is in our own times both misunderstood and misused. It is used not only to excuse the most foolish and most absurd statements, but also to pass them on as models. Thus we read in scholarly books (or in those which would like to become such, not to speak of the works of the sensation-seeking scribblers) that until now art had reduced seeing to a "mechanical photography," and that Expressionism was the first to replace the painting of observation by the painting of imagination.

But isn't every painting, as soon as it is a work of art, a painting of the imagination? A painting of mere observation would be nothing more than a photograph. Painters of reality $\kappa\partial\tau'\,\dot{\epsilon}\xi o\chi\acute{\eta}\nu$ [par excellence]—Courbet or Leibl, Menzel [29] or Manet—paint representations of reality that are their own subjective reality, as they see it.

It is one of the most serious and hence least excusable aesthetic errors to assume that the more faithfully a painter represents reality, the less visionary he is, that the Realist or the Impressionist merely copies nature, while the Idealist or the Expressionist gives his interpretation of it.

[29] Adolf von Menzel (1815–1905), renowned German painter, whose work was characterized by an interplay of scrupulous objectivity and inventiveness. Menzel started out as an artist of exceptional honesty and originality, often painting scenes from contemporary life with colorful freshness, but in later years he turned more and more to stereotyped historical subjects, especially from the life of Frederick the Great, treated in a more conventional manner.

It is not the more or less faithful rendering of Nature which is the criterion for the realistic as opposed to the imaginative painting: the greatness and the power of the artistic personality are the decisive elements. The exact rendering of reality of the camera makes a work of art just as little as the distortion of a horse into a rhinoceros.

Whether an artist approaches objective reality as closely as possible or retreats from it is entirely indifferent. Whether he is or is not an artist, whether he is a copyist of reality or a creator of something new, it is his reality that is the decisive element.

"Art must always remain within the realm of appearance," Goethe wrote to Schiller. . . . Behind the most realistic as well as the most fantastic of his characters there is the metaphysical, the invisible, which we cannot see but only feel.

To make visible the invisible: that is what we call art. The artist who renounces attaining to the invisible, that which is behind appearance —whether we call it soul, spirit, or life—through his representation of reality, is no artist. But the artist who would like to sacrifice the representation of appearance in favor of a stronger expression of his feelings is an idiot. For how would we be able to understand the supernatural without the natural?

All plastic art (this is true for poetry) is a simile. Where, except in nature, can symbols for similes be found? The artist's imagination must take its symbolic material from the senses, and these in turn must take it from nature. If there were no reality, there could be no art, just as there would be no sunshine if our eyes did not see it.

If then, the artist must take the material for his tropes from reality, it becomes evident that his relationship to reality determines his art.

An artist's imitation of nature is always a new creation that remains based on nature and consists in the representation of what he and no other person sees in or through nature. But artistic seeing does not only mean optical seeing; it also means seeing in a visionary sense. The artist gives a concept of nature which is *his* concept of nature. There is, therefore, a great difference in seeing the world with the eyes of a valet, who only sees the small faults and weaknesses of his master, and in seeing with those of an artist: only he who sees the world as a living whole is an artist. Only he who feels God's spirit in nature will be able to represent real living figures. Only the pantheist will be able to do so and that, I think, is the reason for the boundless veneration which Goethe felt for Spinoza during his entire life. The artist conceives of reality as a becoming process, not as an arrested one. When someone asked Courbet how he could paint an apple or a pear so often, he answered: because I was moved to do it. It is not the what or the how of representing the concept of living nature that makes the artist.

Feeling is all: the transformation of feelings into concepts makes

the philosopher; the giving of form to feelings makes the artist. The musician alone is independent of nature. The painter, the sculptor, and the poet are dependent upon the creatures that they have created. Having their feet on the ground, they can rise to the transcendent only through the power of thought. And herein lies the limit which neither the plastic arts nor poetry can cross with impunity: they must never distort the original image of nature to the point of unrecognizability.[30]

CONRAD FIEDLER: 1841–1895

On Judging Works of Art

Conrad Fiedler, a lawyer by profession and a friend of both Hildebrand and Marées (see pp. 176 and 155), like them spent most of his time in Rome, with occasional visits to Munich. Fiedler's art theory is rich both in the originality of its content and in its subsequent influence on the aesthetics of the future, notably upon that of Benedetto Croce. To Fiedler, art was not in any way the inferior of science, but rather its complement in gaining knowledge about the external world. Hence art had more important aims, more significant achievements than the mere titillation of the senses or stimulation of the emotions.

In his concentration upon the creative role of the artist who, rather than being a mere imitator of some external reality, constructs new, hitherto undiscovered worlds of his own, and in his insistence upon the inseparability of the visual and the conceptual aspects of the plastic arts, Fiedler's is an important voice in the art theory of the 19th century, developing a viewpoint that had begun with Kant and was to be continued and expanded in the approach of such scholars as Heinrich Wölfflin and the art theory of the 20th century.

While Fiedler usually recorded his insights in the form of aphorisms, he attempted a more consistent and organized approach to the problems of art in his book on architecture and in the present essay, first published in 1876.

It is a chief requirement of artistic talent that it shall possess an especially refined and sensitive susceptibility to certain qualities of things. In pre-eminent artists we may, indeed, occasionally meet with that profound relationship, mentioned earlier, of sensation and of a feeling for the totality of natural objects. But the presence of such refined feelings is not yet an indication of artistic talent. To possess such feelings is the

[30] Max Liebermann, "Ein Credo," originally published in *Kunst und Kuenstler*, XX (July, 1922), and reprinted in Max Liebermann, *Gesammelte Schriften* (Berlin: Bruno Cassirer, 1922), pp. 15–20. Reprinted by permission of the publisher.

main prerequisite for artistic as well as for every other mental productiveness; for he who does not seek to grasp nature with the power of his intuition will never succeed in subjugating her to his higher mental consciousness. But the artist becomes an artist by virtue of his ability to rise above his sensations. It is true that sensation accompanies him in all the phases of his artistic activity and keeps him continuously in a close relation to all things, that it nourishes in him the warmth of life by which he himself is connected with the world. Sensation continuously provides him with the material the transformation of which is the fulfillment of his mental existence. Yet, however heightened his sensations may be, he must always be able to master them with the clarity of his mind. And although the artist's creation is possible only on the basis of an extraordinarily intense feeling, nevertheless this artistic creation has been made possible by his still more extraordinary power of mind, which even in moments of the most intense sensory experience preserves unimpaired the calmness of objective interest and the energy of formative creation. . . .

In times when science offers explanations of the world, and interest in those explanations not only possesses the most gifted minds but also penetrates all educated circles, we meet with the general opinion, first, that outward appearances of objects are unessential as compared to the inner meanings which scientific knowledge tries to draw out of them; and second, that science has already arrived at a complete understanding of the external appearance of objects and looks upon this knowledge as no more than a preliminary stage on the way to its own higher knowledge. . . .

. . . Of all sciences, natural science is the most dependent upon the exact observation of the shapes and mutations of objects as well as the relationships between the parts and the whole. He who must with exactness observe objects with respect to their outward appearance, memorize them and make them his own in order to draw conclusions from his mental picture of them, would not admit that visual perception extends far beyond his own special purpose. But those persons who require for scientific purposes a rich perception of nature know that a tendency for abstract thinking makes the understanding of perception difficult. The more they advance in transforming perception into abstract concepts, the more incapable they become of remaining, even for a short while, at the stage of perception. And if they judge a work of art by the yardstick of their knowledge of nature and consider it to be a copy of nature, the meagerness of their perception of nature reveals itself at once in the insufficiency of their demands upon works of art. They believe that they are able to check upon the artist's knowledge of nature, transfer their way of looking at nature to the artistic imitation of nature, and see in it essen-

tially nothing but a scientific illustration of conceptual abstraction. In effect, since a work of art would thereby be reduced to a mere instrument of evoking perceptions and of dissecting nature as a whole into isolated fragments and features in order to make more readily recognizable that which in the world of complicated appearances is difficult to grasp, they would thus ignore perception entirely in order to find the meaning of art. . . .

As long as perception serves some purpose, it is limited, it is unfree. Whatever this purpose may be, perception remains a tool, and it becomes superfluous once the purpose is attained. If other mental activities should be recognized as justified only when employed for some definite explicit purpose, we would regard such an evaluation as a narrow-minded restriction. Man has ever felt an irresistible drive to make a free use of his powers, after once having found out that they are serviceable to the needs of life. Indeed, the products of the free use of mental capacities are honored as the highest of human achievements. That activity, however, which we should think the most natural one that man can engage in, namely, the grasping of the visible world, is a most complicated process. It is certain that man understands the necessity of educating himself to greater care in the observing of things and the memorizing of the acquired images. It is also certain that those purposes for which perception is a tool attain increased importance. Out of the drudgery of the daily needs of life, perception rises to the service of the noblest aspirations and becomes the tool of the highest efforts. But always, nevertheless, the aims of perception are predetermined and it terminates once the set goal is attained.

It is the essential characteristic of the artist's nature to be born with an ability in perceptual comprehension and to use that ability freely. To the artist, perceptual experience is from the beginning an impartial, free activity, which serves no purpose beyond itself and which ends in that purpose. Perceptual experiences alone can lead the artist to artistic configurations. To him the world is but a thing of appearances. He approaches it as a whole and endeavors to recreate it in a visual whole. The essence of the world which he tries to appropriate mentally and to subjugate to himself consists in the visible and tangible configuration of its objects. Thus we understand that to the artist perceptual experience can be endless, can have no aim or end fixed beyond itself. At the same time, also, we understand that to the artist perceptual experience must have immediate meaning, independent of any other purpose that can be produced by it.

The artist's relationship to the world, which to us remains incomprehensible as long as we as non-artists stand in our own relationship to the world, becomes intelligible to us once we consider the artist's rela-

tionship as a primary and peculiar connection between his powers of visual comprehension and the objects visually comprehended. And this relationship is based on a need which in turn is an attribute of man's spiritual nature. The origin and existence of art is based upon an immediate mastering of the visible world by a peculiar power of the human mind. Its significance consists solely in a particular form of activity by which man not only tries to bring the visible world into his consciousness, but even is forced to the attempt by his very nature. Thus the position in which the artist finds himself while confronting the world has not been chosen arbitrarily, but is determined by his own nature. The relation between himself and the objects is not a derived but an immediate one. The mental activity with which he opposes the world is not fortuitous, but necessary, and the product of his mental activity will not be a subordinate and superfluous result, but a very high achievement, quite indispensable to the human mind if that mind does not want to cripple itself.

The artist's activity is often said to be a process of imitation. At the basis of this notion lie errors which beget new errors.

First, one can imitate an object only by making another which resembles it. But what agreement could exist between the copy and the object itself? The artist can take but very little from the quality of a model which makes it an object of nature. If he tries to imitate nature he will soon be compelled to combine in his copy some very different aspects of the natural object. He is on the way to encroaching upon nature's creative work—a childish, senseless enterprise, which often takes on the appearance of a certain ingenious boldness, usually based on absence of thought. Where efforts of this kind are concerned, the trivial objection is justified that art, so far as it is imitating nature, must remain far behind nature, and that imperfect imitation must appear as both useless and worthless since already we are amply supplied with originals.

Imitation which aims merely at copying outward appearances implies that one starts from the premise that there is in nature a substantial capital of minted and fixed forms at the disposal of the artist and that the copying of these forms is a purely mechanical activity. Hence arises the demand, on the one hand, that artistic imitation should serve higher purposes—that is, that it should be a means of expressing something independently existent, not in the realm of the visible but in the realm of the invisible; and on the other, that the artist in his imitations should represent nature purified, ennobled, perfected. Out of his own mastery he should make demands of the natural model; what nature offers should serve him as a basis for that which nature might be if he had been its creator. Arrogance justifies itself and capriciousness becomes intellectual power. Man's unfettered imagination, inflated to vainglory, is taken to be artistic creative power. The artist is called upon to create another world

beside and above the real one, a world freed from earthly conditions, a world in keeping with his own discretion. This realm of art opposes the realm of nature. It arrogates to itself a higher authority because it owes its existence to the human mind.

Artistic activity is neither slavish imitation nor arbitrary feeling; rather, it is free creative configuration. Anything that is copied must first of all have existed. But how should that nature which comes into being only through artistic representation have an existence outside of this production and prior to it? Even at the simplest, man must create his world in its visual forms; for we can say that nothing exists until it has entered into our discerning consciousness.

Who would dare to call science an imitation of nature? Yet one could do so with as much right as to call art an imitation. In science, however, one sees much more easily that it is simultaneously an investigation and a formulation, that it has no other meaning than to bring the world into a comprehensible and comprehended existence by means of man's mental nature. Scientific thinking is the natural, the necessary activity of man, as soon as he wakes up from a dull, animal-like state to a higher, clearer consciousness. Art as well as science is a kind of investigation, and science as well as art is a kind of mental configuration. Art as well as science necessarily appears at the moment when man is forced to create the world for his discerning consciousness.

The need of creating a scientifically comprehended world, and with it the possibility of producing such a world, arises only at a certain level of mental development. Likewise, art too becomes possible only at that moment when the perceived world appears before man as something which can and should be lifted up to a rich and formed existence. It is the power of artistic phantasy that brings about this transformation. The phantasy of the artist is at bottom nothing else than the imaginative power which to a certain degree all of us need in order to get any grasp at all upon the world as a world of visible appearances.

But this power of ours is weak, and this world of ours remains poor and imperfect. Only where a powerful imagination with its indefatigable and sharp activity calls forth from the inexhaustible soil of the world elements after elements does man find himself suddenly confronted with a task immensely complicated, where before he had found his way without difficulty. It is phantasy that, looking far out round itself, summons together and conjures up on the narrowest ground the abundance of life which is withheld from dull minds. Through intuition one enters into a higher sphere of mental existence, thus perceiving the visible existence of things which in their endless profusion and their vacillating confusion man had taken for granted as simple and clear. Artistic activity begins when man finds himself face to face with the visible world as with something immensely enigmatical; when, driven by an inner necessity and

applying the powers of his mind, he grapples with the twisted mass of the visible which presses in upon him and gives it creative form. In the creation of a work of art, man engages in a struggle with nature not for his physical but for his mental existence, because the gratification of his mental necessities also will fall to him solely as a reward for his strivings and his toil.

Thus it is that art has nothing to do with forms that are found ready-made prior to its activity and independent of it. Rather, the beginning and the end of artistic activity reside in the creation of forms which only thereby attain existence. What art creates is no second world alongside the other world which has an existence without art; what art creates is the world, made by and for the artistic consciousness. And so it is that art does not deal with some materials which somehow have already become the mental possession of man; that which has already undergone some mental process is lost to art, because art itself is a process by which the mental possessions of man are immediately enriched. What excites artistic activity is that which is as yet untouched by the human mind. Art creates the form for that which does not yet in any way exist for the human mind and for which it contrives to create forms on behalf of the human mind. Art does not start from abstract thought in order to arrive at forms; rather, it climbs up from the formless to the formed, and in this process is found its entire mental meaning. . . .

Had man's nature not been endowed with the artistic gift, an immense, an unending aspect of the world would have been lost to him and would have remained lost. In the artist, a powerful impulse makes itself felt to increase, enlarge, display, and to develop toward a constantly growing clarity, that narrow, obscure consciousness with which he grasped the world at the first awakening of his mind. It is not the artist who has need of nature; nature much more has need of the artist. It is not that nature offers him something—which it offers as well to any other person; it is only that the artist knows how to use it differently. Moreover, through the activity of the artist, nature rather gains a richer and higher experience for him and for any other person who is able to follow him on his way. By comprehending and manifesting nature in a certain sense, the artist does not comprehend and manifest anything which could exist apart from his activity. His activity is much more an entirely creative one, and artistic production cannot in general be understood except as the creation of the world which takes place in the human consciousness and exclusively with respect to its visible appearance. An artistic consciousness comes into being in which solely the experience with appearances becomes important and leads to visual conception and in which everything steps back that is of other importance to man than the visual experience. . . .

The mental artistic activity of the artist has no result: the activity itself is the result. It expends itself every single moment in order to start afresh every following one. Only while his mind is active does man possess that to which he aspires. The clarity of consciousness toward which the individual advances at any given moment does not secure to him a lasting possession which he can enjoy at leisure. No; for each flash of consciousness vanishes at the moment at which it arises and so makes room for a new one. . . .

Artistic activity is endless. It is a continuous, incessant working of the mind to bring one's consciousness of the visible world to an ever richer development, to a configuration ever more complete. All the emotional forces serve this purpose, and all driving forces, passion, all enthusiasms, are of no avail to the artist if they are not harnessed in the service of this specific mental activity. Man allows form after form to emerge from the shapeless mass into his consciousness; yet, for all that, the mass still remains inexhaustible. It is not presumptuousness but shortsightedness to think that man's artistic activity could ever reach its ultimate, its highest aim. Only through artistic activity does man comprehend the visible world, and for as long as artistic activity has not disclosed them to his consciousness he does not know which regions are for him obscure and hidden. Whatever vantage points he has reached afford him views upon regions as yet unattained. And the more the artist extends his sway over the world, the more the limits of the visible world itself retreat before his eyes. The realm of appearance develops infinitely before him because it grows out of his ceaseless activity.

Artistic consciousness in its totality does not go beyond the limits of the individual; and it never finds a complete outward expression. A work of art is not the sum of the creative activity of the individual, but a fragmentary expression of something that cannot be totally expressed. The inner activity which the artist generates from the driving forces of his nature only now and then rises to expression as an artistic feat, and this feat does not represent the creative process in its entire course, but only a certain state. It affords views into the world of artistic consciousness by bringing from out of that world one formed work in a visible, communicable expression. This accomplishment does not exhaust, does not conclude this world, for just as infinite artistic activity precedes this feat, so can infinite activity follow. "A good painter," says Dürer, "is inwardly full of figures, and if it were possible that he could live forever, he would have always something new from his inner stock of ideas, of which Plato writes, to pour forth through his works."

Although the mental activity of the artist can never fully express itself in the form of a work of art, it continuously strives toward expression and in a work of art it reaches for the moment its highest pitch. A

work of art is the expression of artistic consciousness raised to a relative height. Artistic form is the immediate and sole expression of this consciousness. Not by roundabout ways does the artist arrive at the employment of the artistic form; he need not search for it in order to represent herein a content which, born formless, is looking for a body in which it may find shelter. The artistic expression is much more immediate and necessary, and at the same time exclusive. A work of art is not an expression of something which can exist just as well without this expression. It is not an imitation of that figure as it lives within the artistic consciousness, since then the creation of a work of art would not be necessary for the artist; it is much more the artistic consciousness itself as it reaches its highest possible development in the single instance of one individual. The technical manipulation by which a work of art is contrived is a necessity for the artistic mind as soon as that mind feels the need of developing to the highest pitch that which dwells within it. Technical skill as such has no independent rights in the artistic process; it serves solely the mental process. Only when the mind is not able to govern the creative process does skill attain independent significance, importance, cultivation, and so becomes worthless artistically. From the very outset the mental processes of the artist must deal with nothing but that same substance which comes forth into visible appearance in the work of art itself. In a work of art the configurative activity finds its way to an externalized completion. The substance of such a work is nothing else than the creative configuration.

If we ask ourselves at what final, culminating point artistic endeavor should be fulfilled, we find that, as the human mind in general in its search for cognition cannot rest until convinced of the need of reaching such a culminating point, so the artist too is forced to cultivate his visual conception itself to the degree that the visual conception itself is absolutely necessary to him. Through the power of artistic imagination visual conception of the world grows ever richer in configurative forms. However, although we are compelled to admire this creative power that leads to breadth and variety, we must nevertheless acknowledge, if we are at all able to follow it so far, that the ability to bring each configuration to a complete artistic existence is the noblest artistic endeavor. Following along this path, the artist leaves behind him that which appearances had meant to him in various stages of development. The more appearances are subjected to the powers of his artistic cognition, the more their qualities lose their power over him.

When the artist develops his visual conception to the point where "this way and no other" becomes a necessity for him, this process differs from that of the scientific investigator who regards a process of nature as a necessity. He who does not contemplate the world with the interest of the artist, if he at all feels the desire to take notice of the appearances of

objects, attempts but to investigate the conditions of their origins. Only with difficulty, however, will he come to understand that there is a need of visually comprehending appearances as such, independently of a knowledge of their origins. To quote Goethe: "Thus a man, born and trained to the so-called exact sciences, will not easily conceive, at the height of his intelligence, that there could likewise exist a phantasy that is exact, without which art is essentially inconceivable." Very few persons feel any need of developing their visual conceptions to such a degree that these take on the character of necessity. However averse they may be to any unclearness and arbitrariness in their understanding of the internal relationships of the visible world, however strenuously they may strive to order this chaos of phenomena into a necessary whole, and however far they may have advanced in their endeavors, for them the visible world nevertheless remains a chaos in which the arbitrary rules. The artist, however, cannot acquiesce in such a state of affairs. Unconcerned with other things, he does not release his perceptual experiences until they are developed into a visual conception, clear in all its parts, something that has attained a complete, necessary existence. This is the highest stage to which his productive cognition can attain. Complete clearness and necessity have become one.[31]

ADOLF VON HILDEBRAND: 1847–1921

The Problem of Form in Painting and Sculpture

Adolf von Hildebrand was a good friend of both Fiedler and Marées in Rome. As a sculptor, his works, such as the bronze Water-Carrier *(1878–1880), the marble* Youth *(1884), or the stone* Wittelsbach Fountain *in Munich (1895), embody his own theoretical demands for a return to the purity, simplicity, and clarity of classical and Renaissance art; in their acceptance of the problems inherent to stone sculpture as an art and in their rejection of illusionism, they point forward to modern sculpture. Yet Hildebrand is far better known as an art theorist, through his influential book* Das Problem der Form in der bildenden Kunst, *published in 1893. Narrowing down and limiting Fiedler's richer, more original and less academic ideas about the relation of art and the artist to reality, Hildebrand demands, for art in general but for sculpture particularly, a return to the Greek and Renaissance principles of unity of sur-*

31 Conrad Fiedler, "On Judging Works of Visual Art," trans. Henry Schaefer-Simmern and Fulmer Mood, in Karl Aschenbrenner and Arnold Isenberg, eds., *Aesthetic Theories: Studies in the Philosophy of Art* (Englewood Cliffs, N.J.: Prentice-Hall, Inc., 1965), pp. 358–360, 362–368. Reprinted there by permission of the University of California Press.

face and limitation of the spatial field. While rigid in his attempt to apply a single standard of aesthetic excellence to all art for all times, Hildebrand nevertheless provided a wholesome antidote to some of the excesses of naturalism characteristic of the sculpture of his times.

Visual Values of Space

It has been pointed out that a work of art must consist of a complex of visual elements, which, in order to produce a vivid idea of real spatial nature, must singly as well as in their mutual relations stimulate spatial ideas in us. In this mutual dependency of the different pictorial details and in their common stimulation of a total space idea is to be found the artistic unity of perception. And this is something quite apart from the biological or functional unity of Nature.

We are now prepared for the definition of a term to be used henceforth, the term *visual values of space*. By visual values of space we mean those values of an object which issue only in purely spatial perceptions tending toward the general conception of a segment of space. By purely spatial perceptions we mean perceptions independent of the organization or functioning of the object involved. Let us take a form which is given visual expression by contrasts of light and shade. Through their particular relations and respective positions, these different degrees of brightness and darkness affect the spectator as if they were actually modeling the object. As a result of our earliest visual experiences they represent to us in such cases a spatial value. Since the spatial effect of Nature is a product of different factors—such as the actual form of the object, its proper coloring, the illumination with respect to direction and quality, the observer's point of view—a concerted effect is produced existing only for the eye, by factors which otherwise are not necessarily connected. This concerted effect, or visual unity, shows the separate conditions working simultaneously, and thus enables us to grasp the spatial relations of a simultaneous exposition. Therefore, the specifically artistic force and talent of the painter rest on his ability to discover the visual values of space in Nature, and the unity of his image and its power to create in the mind an idea of space depend upon these.

Considering how totally different a thing a picture is from the natural object which it represents, the force of the illusion which it produces remains a riddle unless we understand that the picture depends for its spatial effect on no other subjective conditions than does Nature. Neither produces spatial ideas directly, but only indirectly, and that through the medium of the same class of mental processes. Since Nature and the picture both stimulate our sense organ in the same manner, we arrive, in fact, at the same resultant idea. The parallel between Nature and Art is not to be sought in the equality of their actual appearances, but rather in that both have the same capacity for producing spatial effects. The

value of a picture does not depend on the success of a deception, as does the popular value of a panorama, but on the intensity of the unitary spatial suggestiveness concentrated in it. . . .

It is in the accumulation and concentration of the effective factors in a picture that Art rises above the dissociated spatial effects of Nature. The artist watches Nature in her eternal change with this end in view. By eliminating all the weak and ineffective aspects he comes at length into an advantageous position toward Nature and her effects. And by this process of elimination he is enabled to infuse into his image the force which makes it valuable in comparison with Nature.

This means something quite different from a more or less skillful imitation on canvas of the visual perception of Nature as such. The appearance of Nature is not important to the painter because of her reality but because he finds in her the expression of his spatial intent, when he conceives her as providing space with furniture. It is only in the representation of the object as surrounded by the general space or volume of air, and not merely in the representation of its isolated actual form, that the problem of artistic appearance in its full meaning is solved. Whether several objects be perceived, or only one; whether the means of construction draw upon the manifoldness of Nature's appearance, or are confined to the form of one object, as in the sketch of a figure; the problem remains the same. The difference lies only in this: that in the first case the means are more manifold and arbitrary, in the second they are bound to the organic nature of one object. . . .

The Conception of Relief

It was pointed out in the last chapter that the artist with his problem of making a unitary picture out of his complicated ideas of the three-dimensional is compelled to separate clearly the two-dimensional appearance of the object from the general subjective idea of depth. Thus he arrives at a simple idea of volume as a plane continuing into the distance. To make this manner of presentation quite clear, think of two panes of glass standing parallel, and between them a figure whose position is such that its outer points touch them. The figure then occupies a space of uniform depth measurement and its members are all arranged within this depth. When the figure, now, is seen from the front through the glass, it becomes unified into a unitary pictorial surface, and, furthermore, the perception of its volume, of itself quite a complicated perception, is now made uncommonly easy through the conception of so simple a volume as the total space here presented. The figure lives, we may say, in one layer of uniform depth. Each form tends to make of itself a flat picture within the visible two dimensions of this layer, and to be understood as such a flat picture. Again those outermost points which touch the

panes still determine common planes even when one thinks the glass removed.

By this sort of arrangement the object resolves itself into a layer of a certain uniform thickness. The total volume of a picture will then consist, according to the object represented, of a greater or lesser number of such imaginary layers arranged one behind the other, yet altogether uniting into one appearance having one uniform depth measurement. So the artist divides and groups his ideas of space and form, which consisted originally in a complex of innumerable kinesthetic ideas, until there results a simple visual impression stimulating a strong idea of depth, which the resting eye is able to take in, without kinesthetic sensations or movements producing such.

This manner of presentation is a necessary product of the relation of our three-dimensional ideas to the simple visual impression. It is the only artistic conception of things three-dimensional; and this whether it be the representation of a single form or of a more complicated totality of forms; whether it be the work of a sculptor or of a painter. The aim —the presentation of a general idea of space by means of a visual perception—is the same for painter and sculptor, and the work of each is directed by the same subjective requirements, however different may be their means of representation.

This common mode of artistic imagination as above developed is no other than the conception of relief so prominent in Greek art. This conception of relief defines the relation of two-dimensional impressions to three-dimensional [ones]. It gives us a specific way of viewing Nature; it is a mold in which the artist casts the form of Nature. In all ages this mode of perception has resulted from the artist's insight into the unchangeable laws of art. Its absence means a deficiency in one's artistic relation to Nature, an incapacity for understanding this relation and developing it consistently. The thousandfold judgments and movements of our observation find in this mode of presentation their stability and clearness. It is an essential to all artistic form, be it in a landscape or in the portrayal of a head. In this way the visual content is universally arranged, bound together, and put in repose. Through all figurative art this idea is the same, the one guiding thought. It acts always as a general condition and requirement to which all else is subordinate, in which everything finds a place and a unity. Just as in the two-dimensional all directions are measured with respect to the vertical and the horizontal and thus become easily comprehensible, so the single ideas of depth obtain definite values only when they appear in relation to a general unitary idea of depth. The harmonious effect of a picture depends on the artist's ability to represent every single value as a relative value in this general conception of relief. It is only thus that his work attains a uniform standard of measurement. The more clearly this is felt, the more unified and satisfactory is

the impression. This unity is, indeed, the Problem of Form in Art, and the value of a work of art is determined by the degree of such unity it attains. It is this unity which gives consecration to the representation of Nature. That mysterious satisfaction which we obtain from a work of art rests alone on the consistent application of this conception of relief to our three-dimensional impressions.[32]

FERDINAND HODLER: 1853–1918

The Theory of Parallelism

Ferdinand Hodler was born in Bern, Switzerland, and worked mainly in Geneva. Influenced by his teacher, Barthelémy Mann, a friend of Corot, his earliest works were characterized by a crude and provincial naturalism. But gradually he developed a more original and sophisticated style, chiefly of landscape painting. In the late eighties Hodler went through a crisis resulting in a complete rejection of naturalism and a turn toward the more intellectual and symbolic style characteristic of his mature period. He attracted the attention of Puvis de Chavannes when he exhibited his large, decidedly symbolic painting, Night, *in Paris in 1891. Like Purvis de Chavannes (see above, pp. 27 to 29) and Seurat and his followers, Hodler attempted to create a language of direct psychological communication in art by means of linear directions and relationships. His theory of parallelism, evolved during the eighties and concurrent with the Neo-impressionist and Symbolist reaction against the naturalism of the Impressionist movement of the seventies, seems to have consisted mainly of the rhythmic, almost musical repetition and contrast of directional lines and curves throughout his large paintings. His canvases are far more stridently colored than those of Puvis de Chavannes and his contours more involuted and wiry, linking Hodler with the sinuous, self-conscious linearism of* Art Nouveau. *In his two best known works,* Night *(1890) and* Day *(1900), his figures seem frozen into over-stylized, melodramatic gestures. The abstract domination of his theory of parallels seems to force these too precisely described nudes into exaggerated postures that verge on the ludicrous.*

The passage below, explaining his theory, was probably written in about 1900, and together with a lecture given at the University of Freiburg in 1897, constitutes Hodler's only theoretical pronouncement.

I call all forms of repetition parallelism. Whenever I feel most deeply the charm of things in nature, there is always an impression of

[32] Adolf [von] Hildebrand, *The Problem of Form in Painting and Sculpture,* trans. Max Meyer and Robert Morris Ogden (New York: G. E. Stechert, 1907), pp. 53–56, 58–59, 80–84.

unity. If my road happens to take me into fir woods, where the trees rise high toward heaven, I immediately consider the trunks, which are to the right and left of me, as innumerable columns. It is one and the same vertical line (that is, color-patch principle) repeated many times that surrounds me. Now, should these tree trunks detach themselves clearly from a darker background, should they be placed against the deep blue sky, that impression of unity is determined by their parallelism. The various vertical lines have the effect of a single big vertical line or of a flat, level plane.

When one looks over a green field where only one kind of flower meets the eye, where for instance, the bright yellow of the dandelion blossom is contrasted with the green grass, one will receive an enchanting impression of unity. I notice that the effect will be greater, the impression more intense in this case than when a variety of flowers is spread before our eye, different in color as well as in form.

In all those cases in which parallelism is not found to be the only cause of this delight, one can still point to certain elements of order in nature. Thus, for instance, all budding leaves of a flower have the same form and are grouped around one center.

A tree always brings forth leaves and fruits of the same form. If Tolstoy in his essay, "What is Art?" says that no two leaves of the same tree can ever be exactly alike, one might declare even more correctly that nothing resembles a plane tree leaf more than the leaf of a plane tree.

I must further add that in almost all the examples I have just described, the repetition of color is associated with that of form. Budding flower petals as well as tree leaves are generally of the same color. Thus we also recognize the same principle of order in the structure of animal and human bodies, in the symmetry of the right and left halves of the body.

When we compare our own modes of expression with these phenomena in nature, we are surprised to see the recurrence of the same principle.

We know and we feel at certain moments that what unites human beings is stronger than what separates them. . . .[33]

[33] Ferdinand Hodler, cited in Fritz Burger, *Cézanne und Hodler* (Munich: Delphin-Verlag, 1913), pp. 55–56.

Index